style
surf*ing*

'I just surf right out of my wardrobe, becoming whoever or whatever I want to be. I am a figment of my own imagination.' TuTu

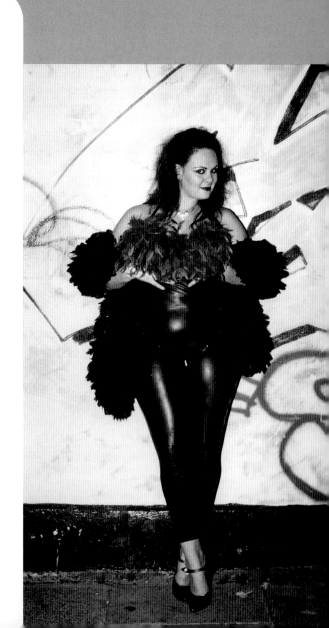

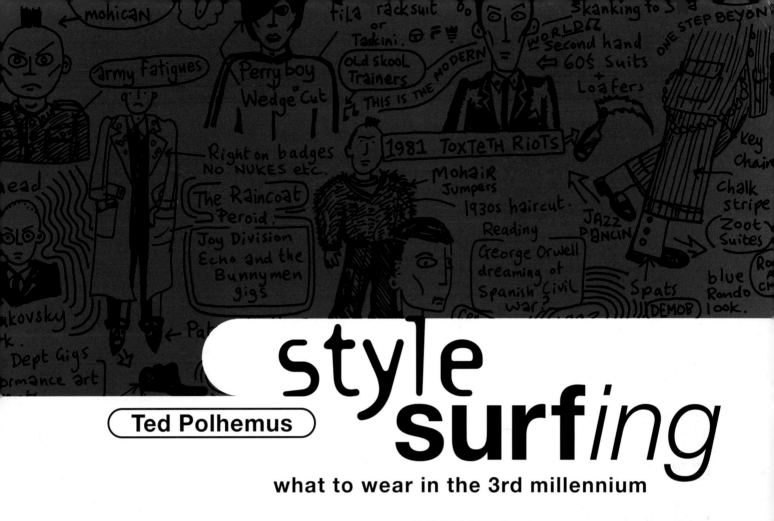

Ted Polhemus

style surfing

what to wear in the 3rd millennium

with 250 illustrations, 145 in colour

Thames and Hudson

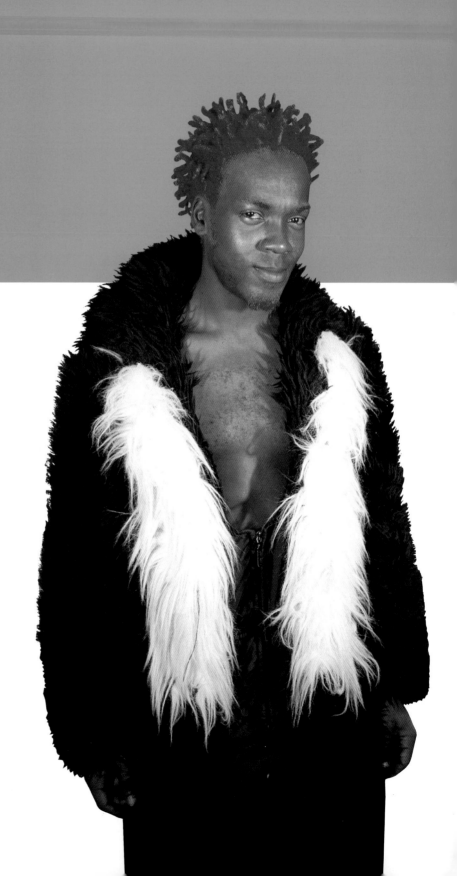

All dressed up and ready for the next millennium.

page 2: Performance artist and club organizer TuTu. See feature pages 118–19. Photograph **Ashley**

page 3: Drawing (detail) **Mark Wigan.** See feature pages 60–1.

this page: Dale, a nurse. See feature page 45. Photograph **Eva N.**

opposite, top left: 'Motorkink', Soho, London. Drawing **Joe Brocklehurst**

opposite, right: 'Living Icon' Lady Lazer, in Miami. See feature pages 138–39. Photograph **Ted Polhemus**

© 1996 Thames and Hudson Ltd, London

Text © 1996 Ted Polhemus

Designed by Avril Broadley

British Library Cataloguing-in-Publication Data

A catalogue record for this book is available from the British Library

ISBN 0-500-27895-4

Printed and bound in Singapore

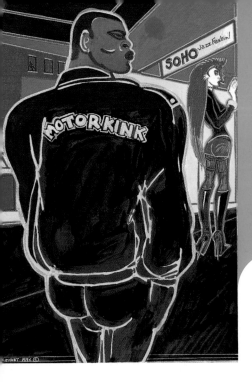

contents

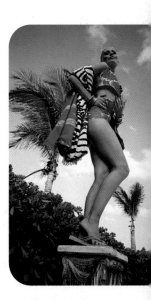

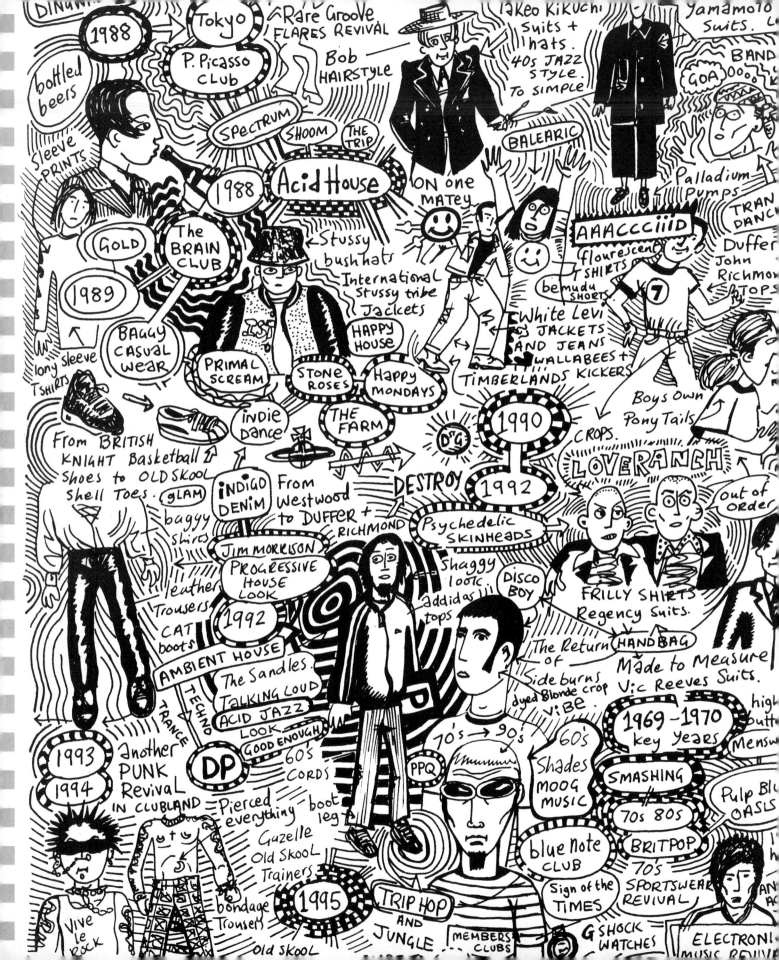

Style surfing
introduction

Why do we – you and I, all the people who appear in this book, or that strange person you spotted last week in the supermarket – dress as we do?

The significance of this question was underlined for me recently when I was strolling down London's trendy Neal Street in Covent Garden with my teenage niece and nephew from small-town America. We passed a young woman who was wearing an amazingly short, fluorescent pink mini-dress, together with the most precarious pair of platform boots imaginable. Wide-eyed, deadpan, rational and yet ever curious (a bit like Mr Spock in *Star Trek*), my nephew asked me, 'Why would anyone wear such a pair of boots?' And immediately my niece wanted to know why, on a cold, rainy day, someone should wear such skimpy, unprotective clothing?

The simplicity and straightforwardness of their questions – without, it should be said, a hint of ridicule – left me momentarily speechless. Eventually I came up with a reply that went something like this. Despite appearances, the woman's attire is functional – a rational strategy for achieving fame and fortune. For example, such a striking appearance might be a good career move if she works as a night-club organizer, a designer, a stylist, a model or a musician. Certainly she gets invited to lots of parties with free food and drink (which, as Quentin Crisp once pointed out, can sustain a human being for considerable lengths of time) and, who knows, her provocative dress might just help her to find a rich or influential mate, if that is what she wants.

Warming to my theme, I compared this woman's appearance with the apparently 'bizarre' and 'impractical' body decorations of tribal peoples – my point being that throughout human history the most seemingly illogical of adornment and dress styles have served eminently practical purposes. That far from being frivolous and absurd, style is functional in the true sense of the word. (Or, to put it the other ➤

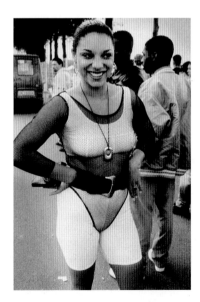

Rave/Ragga Style Surfing at the 'Fantazia' festival, Castle Donington, Derbyshire, 1993. Photograph **Ted Polhemus**

opposite: Drawing **Mark Wigan**

➤ way around, that our notion of 'functional' should be expanded beyond immediate concerns of keeping warm and facilitating locomotion.)

Central to any such argument is the idea that our dress, hair style, footwear, make-up and so forth – what the sociologist Irving Goffman collectively termed our 'presentation of self' – functions as a medium of expression. And, moreover, that such visual communication can 'say' certain things – or, at the very least, express them – more immediately and powerfully than verbal language ever can. (To appreciate this, try composing a brief, written description of yourself for a 'personal ad'. Now get out a prized photo of yourself dressed in a favourite set of clothes. Which medium communicates 'you' most effectively and fully?)

Our lives are made up of innumerable micro-moments of often trivial but sometimes enormously important visual interaction. Imagine that you are walking down a city street late at night. No one is around. And then, in the distance, a solitary figure approaches on the same side of the road. As you and this alien 'other' come closer and closer – with each step, more and more visual clues are discernible – you scrutinize and 'check out' each other.

All this visual data is cross-indexed against an enormous data bank of previous experience to arrive at a tentative conclusion (dangerous/peculiar but not threatening/boring/interesting/desirable), out of which emerges a behavioural strategy – you run in the opposite direction; you cross cautiously, nonchalantly, to the other side of the road; you more or less ignore this person as irrelevant; or, perhaps, you try to catch his or her eye. Skills in 'checking people out' and, alternatively, in the presentation of self are fundamental to our lives – in particular, in avoiding those who might cause us harm and, just as importantly, in finding people who are 'on our wavelength'. ➤

Streamlined in a rubber dress, he flies overhead. A platinum man who likes S&M. He travels the zone, all alone. Jonnie Vercoutre interviews himself...

Q: Jonnie Chrome and Silver, what is your mission?

A: To save the world. When he's not a superhero in a rubber dress or a secret agent having a quiet cup of tea in his favourite café, Jonnie Vercoutre is busy with his production Co., JEEPBOY PRODUCTIONS. To help with PR and for fun, he meets his clients in a 1959 Daimler Ferret armoured car. The motto is: ALWAYS BE PREPARED. Mr Vercoutre has a serious interest in nostalgia and militaria.

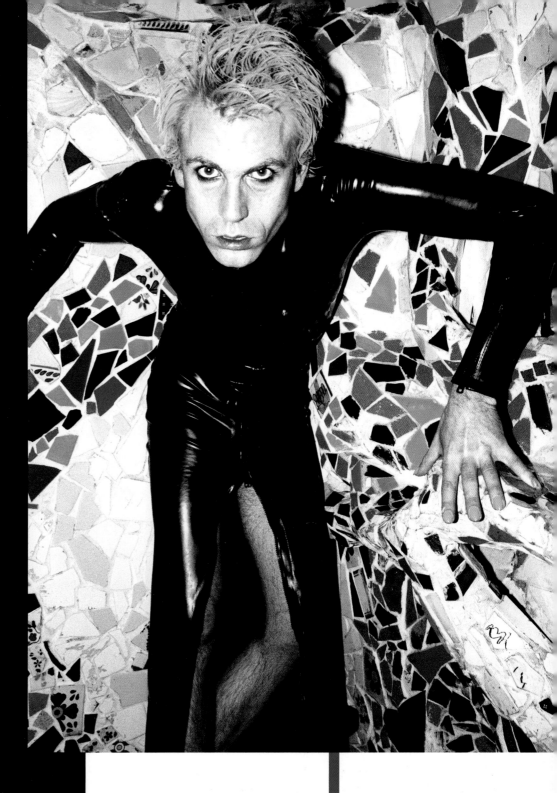

Q: What is a CYBERMOD?

A: It's *Star Wars* meet *Quadrophenia*. It's a visual fashion concept I created. My ideas have inspired Donovan Leitch of 'Nancy Boy' (a promosexual band) to write a single about me –'Mr Euro' – and to incorporate me in the live show playing various alter egos.

Q: Jonnie Vercoutre's interests and background are varied. What about Jonnie Chrome and Silver's?

A: (Jonnie Chrome and Silver) I grew up addicted to sci-fi and horror – i.e. *Joe 90, Captain Scarlet* and, of course, *Star Wars,* which was my first and greatest natural high. At 19 I worked in an effects studio. All these different influences are part of JEEPBOY PRODUCTIONS and CYBERMOD. I've also been collecting toys for a number of years and have the complete collection of 'Lone Ranger' figures. My son Sam is nine. I like his influence because he's down-to-earth and cheeky and does things very well – purely because he enjoys them. My idols in film are Boris Karloff, Vincent Price and Peter Cushing. These actors and the style of Hammer gave such depth and mystery to their varied characters.

Q: How would you describe your style?

A: I enjoy Retro Fashion but believe different styles should be mixed together to create something unique.

Q: How will your alter egos save the world?

A: By having an organized army of talented people, a production company which will find new talent through a club with a cinema and conversation room hosted by interesting and talented people, who will get the ball rolling for artists and filmmakers in England. Remember, if you're in trouble, call JEEPBOY PRODUCTIONS!

left: Mr Euro with his son Sam in the original 1940s London tea room, The Ice Cream Parlour.

right: Jonnie Chrome and Silver at the Mars Bar Café, Covent Garden, London.

cyber**mod**

Photographs **Mary McCartney**

Next G+U.R+U Now

Two Berliners – **UTA RIECHERS AND MARTIN WUTTKE** – formed clothing design group Next G+U.R+U Now in 1992 – the name a combination of the initials of their previous labels 'Get Ugly' and 'Uta Riechers'. Their 1992 collection 'Reanimated' recycled used jogging football trousers and shirts, from which totally new outfits were created – styles much in demand in the Techno/House scene and frequently worn by Techno artists in their videos.

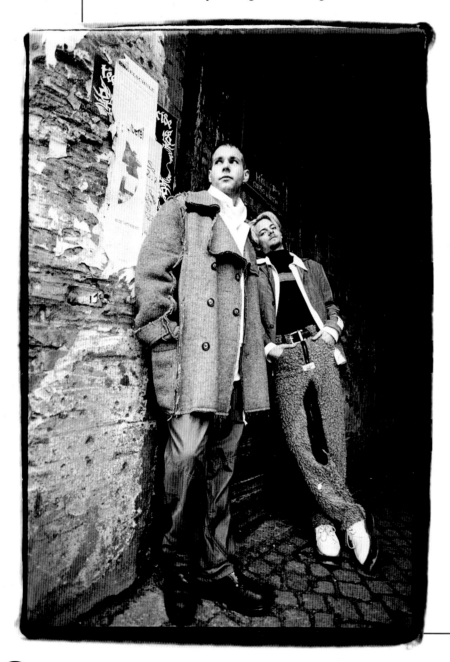

'Odd Pearls', their Autumn/Winter 95/96 collection, continued their experiments with recycling 'already lived' materials – for example, converting used parachutes and military blankets into men's and women's suits to achieve a 'Rough Meets Classic' look.

'Jelly Mutations' for Spring/ Summer 1996 was inspired by (amongst other things): 'Rain drops on pubic hair – Jellybabies – Butterflies – Silhouettes of Jam on a Baguette – Lollipops – A cruising Fred Astaire on a Picnic – and Upside down asymmetrical Hostesses'. It continued a 'living cell therapy' of transforming classics by recreating them with completely new materials.

'Our object is to create a "clash of styles" – a mental riot generating new associations besides the existing slogans and "style" definition of fashion. Rather than simply scooping up already well-known, popular consumer trends, we're creating completely new fusions of the most radically different styles in order to communicate fresh Urban Mutations.'

'Our motto: Work Your Mind – Gymnastics For Aesthetes – Suck Serious Streetstuff.'

Photographs **Dorit Thies**

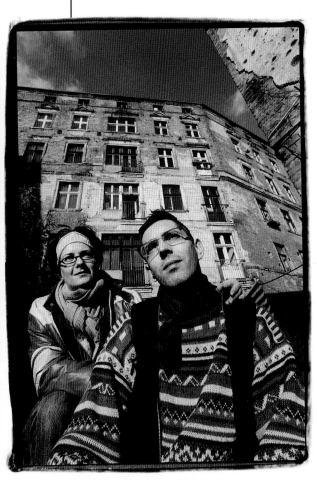

above: Uta Riechers and Martin Wuttke – Next G+U.R+U Now.

opposite: Next G+U.R+U Now designs worn by their friends **Thimo** (a fashion design student) and **Marco** (who works in a hairdresser in Berlin that also offers body piercing and pubic hair cuts and colouring).

➤ In an ever more heterogeneous, complex world finding 'people like us' is no easy matter. While once it might have been sufficient to categorize people according to easily discernible and identifiable labels – white, middle class, conservative, respectable – such categories increasingly have little real meaning or value. To evaluate effectively where someone is 'at' today you need other kinds of (often extremely complex) information – information which, more often than not, is difficult or impossible to put into words. As the hipper people in marketing have come to realize, 'people like us' are now identifiable only by extremely subtle differences of personal philosophy as expressed in 'lifestyle' and 'taste'.

Accordingly, it is the careful, subtle manipulation of our own appearance to send precisely the right signals, coupled with a sensitive, sharp 'reading' of other's appearance, that is most likely to make the identification of 'our kind of people' possible. Verbal descriptions ('left-wing', 'feminist', 'old-fashioned', 'fun-loving') have failed us; it is only differences of style that are capable of expressing the complex – yet increasingly significant – differences of personal 'wavelength' which really matter in today's world.

It would be a mistake, however, to assume that such a semiotics of appearance is a new phenomenon. Through the entirety of human development the body – suitably altered and customized – has functioned as a sign, a personal calling card. For example, the decorated body has long signalled the tribe, clan, gender, age, grade, class, caste, social stratum, profession, to which an individual belongs. Equally, in traditional societies, the unchanging nature of adornment and dress styles has served to signal a respect for the past and the desirability of the *status quo*. In more recent times, responding to and reflecting the spirit of Modernism, rapidly fluctuating fashions (this year's new look) have served to proclaim a belief in progress and change ➤

club
kids
of
†okyo

The traditional Western view of Japanese style – boringly suited salesmen and their demurely dressed wives – is knocked upside down when we see the range of styles worn by the young people who flock to the seemingly infinite number of distinctively décored clubs in Japan's capital. Tokyo is described by photographer Mark Wigan as 'the Style Surfing capital of the world'; the Club Kids come out to play dressed in clothes that come from Britain, the USA and Europe (as well as from their own designers). In a virtual encyclopaedia of the entire history of Western streetstyle, these Tokyo Clubbers cruise both history and geography – recreating the Mod look of Swinging London, *circa* 1964, in one club, the latest Techno styles from northern Europe in another.

But aside from simply copying Western styles in a straight-forward way, such Japanese Clubbers have in recent years also led the way in a creative mixing and matching of contrasting, eclectic styles that has been extensively copied in the West. Indeed, the entire Supermarket of Style that characterizes Tokyo nightlife – with its extra-ordinary range of looks, its sartorial promiscuity and play-fulness – has arguably set the tone for Clubbers everywhere.

While the epitome of globalization (drawing DJs, music and looks from around the world), Tokyo Clubland also epitomizes that other Post-Modern characteristic of stylistic 'narrow casting' – with every taste catered for, from Jungle to Fetish, Acid Jazz to Techno, Preppy to Punk.

Imitating, absorbing, modifying, subverting every conceivable style, the Club Kids of Tokyo present a *Blade Runner* vision of life in the next millennium – a world without historic or geographic boundaries, where everything is possible and nothing is quite what it seems.

Photographs and Captions
Mark Wigan

Ray Akira Mas's crew Acid Jazz Fans at Next.

Surfadelic Party 4 Trip.

Joyu DJing at Shibuya 3 Trip.

JAPAN ? –D LAUNCH PARTY

Hanacharm

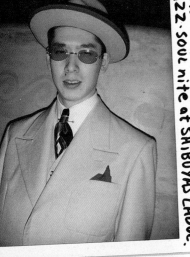

KAYO and NON at the ?–D
Launch Party DJ bar. TOKYO

body painting at a Tokyo
Rythm Kings Party

MIYAKE – Traditional Tailors
assistant from GINZA. AT U.F.Os
JAZZ.SOUL nite at SHIBUYAs LADUC.

⊙I CHAN. Hat Designer
and Dancer at GOLD Tokyo

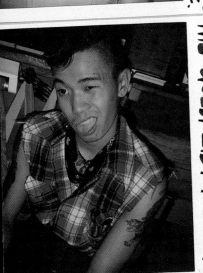

THE ROCKABILLY WITH
THE GUEST LIST ?-D NITE

Homeboys at the
OSAKA fish dance hall.

SHIN +CO DESIGNER
AT NEXT. TOTAL ART

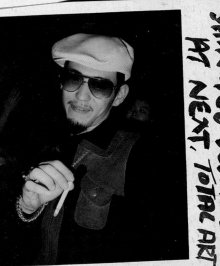

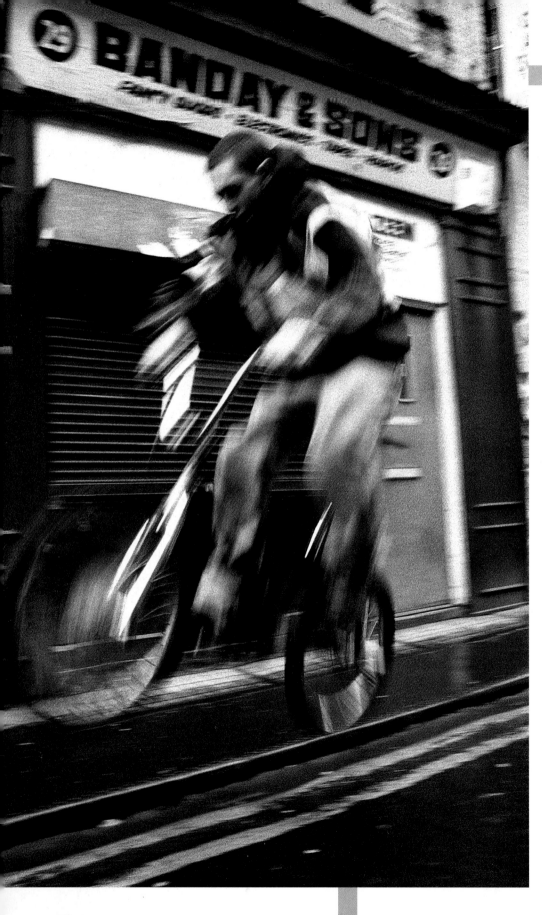

SHEEP ON BMX SHOCK!

Chris Sheep runs a skate shop in Manchester, UK – SHEEP, which sells skateboarding equipment and clothes. His clothes in these photographs all come from SHEEP, except for the jacket, which comes from a local mountaineering shop.

'I get labelled as a "Skater", as a "B-Boy", or whatever. But I don't label myself.'

'I stick to the same style – always skate-based... whatever that is... streetwear, I guess... whatever you want to call it. My style isn't a statement. It's just practical. This is Manchester, where it's always raining, always cold. You need to keep dry and warm. I need roomy jeans for skating and biking 'cause you need to move your legs around. I want clothes to do stuff in. I can't wear clothes just to look good in.'

Hates: People who try to look like they're skaters but they're not, BritPop –'We should be moving forward not backward!'

Likes: Skating, BMX riding, big band jazz, Frank Sinatra

Photographs **Simon King**

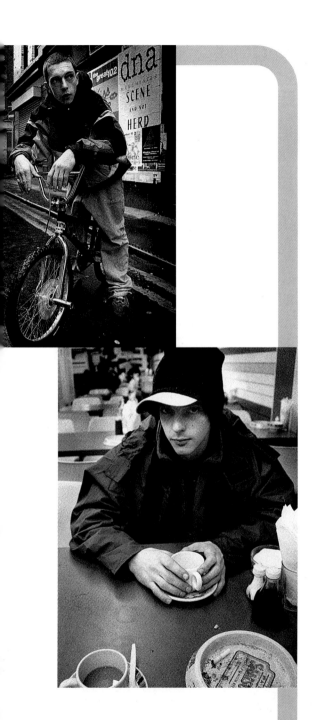

➤ for its own sake. In contrast, especially within the last fifty years and amongst the young, the rise of subcultures – styletribes like Mods and Rockers, Hippies and Punks – has reasserted the role of appearance style as a marker of group membership.

While disparate in meaning, all these style messages have in common an inherent simplicity:

'I am a male, Masai elder'
'I am an aristocrat'
'I am working class'
'I am traditional'
'I am avant-garde'
'I am a Hell's Angel'

The difference today is the complexity of the messages that appearance is called upon to convey – a complexity that makes written 'translations' of such messages either impossible or an exercize in absurdity. As in the world at large, confusions and outright contradictions abound. With one presentation of self – for example, a young woman with a shaved head, a nose piercing, black mascara and false eyelashes, a worn denim jacket, a Mod-style 'target' T-shirt, tight, black Lycra leggings, DMs, a Prada rucksack – one discerns signifying references to (amongst other things): in-your-face, Tank Girl feminism, Indian ethnicity, Swinging London, 60s futurism, sexual liberation, women of ill-repute, 70s glam, cowboys, rebels without a cause, on the road bohemians, Mods, Skinheads, Punks, Hippies and students, as well as high-fashion elitism signalling wealth.

And such words only scratch the surface of this semiologically rich façade: it would take an entire book to summarize adequately all the nuances of meaning expressed in this one presentation of self.

Nor is this phenomenon limited to such stylistically extreme examples. We are all breaking the rules – mixing sportswear with workwear, the old and the new, crossing traditional gender divides, leaping ➤

Every town needs somewhere you can hang out. A public 'stage' where you can nonchalantly lean against a lamppost or some other appropriate bit of street furniture to show off your latest threads. A place where you can check out what other people are wearing – with luck clicking in on someone whose appearance signals that they might just be on the same wavelength as you.

London has had Carnaby Street, the King's Road, Camden Market and, most recently, Neal Street in Covent Garden. In New York, in the late 1950s and early 1960s, the place to hang was Greenwich Village – now it's more likely to be St Marks Place or SoHo. LA, a city dominated by the automobile even more than most, is better known for 'cruising' than hanging out – an activity which, in extending the definition of 'clothing' to include the kind of car you're driving, tends to emphasize wealth rather than personal creativity (though the customized cars for which LA is particularly famous may serve as an antidote).

Yet, despite its automobile culture, LA also has a long history of more pedestrian hanging out. In the 1960s, then less monopolized by hookers, Sunset Strip provided a suitable location for the likes of Kooky (of TV's *77 Sunset Strip*) to comb his hair in a street-credible kind of way. In the 1970s, 'where-it's-at' shifted out to Venice Beach, as Southern Californians pioneered a new, less sedentary, more mobile kind of hanging out on roller skates and skateboards.

the exhibitionists of **Melrose Ave.**

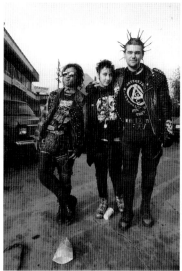
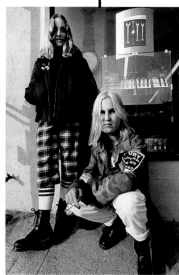
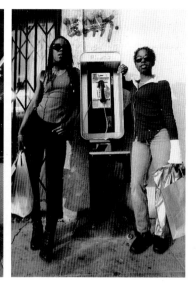

In the early 80s, when lots of interesting independent clothing designers began opening little shops on and around Melrose Ave., this part of West Hollywood became a hanging-out heaven, where everyone from fashion victims to die-hard Punks, sportswear stylists to Techno Mutants, could exhibit themselves.

The film *Blade Runner* offers a vision of LA in AD 2019 – its crowded streets a seething supermarket of style where anything goes and where you can't tell the replicants from the humans. Down on Melrose Avenue today you can see the same thing and save yourself the cost of renting the video.

Photographs **Dorit Thies**

➤ between the proletarian and the elitist, juxtaposing the natural and the artificial, mating the vulgar and the respectable... deliberately sending out confusing, even contradictory signals.

And why? Because we don't want to be categorized – to become just a stereotype. Because the world we live in is itself full of confusion and contradiction. Because (as in our politics and everything else) simple either/or categories and labels no longer suffice. Because now that the god of modernism is dead, everything is possible. Because we're all on-line, plugged in to the 'global village'. Because the past and the future have dissolved into 'the Now'. Because what's clear, clearly isn't. Because we've increasingly found that only personal appearance is capable of expressing where we as individuals are at in a kaleidoscopic and enigmatic world.

What to wear in the 3rd Millennium? Something that defies categorization. Something that says it all – leaving nothing out. Something that is 'you' – confusing, contradictory, complicated. Something, in other words, totally functional. ✦

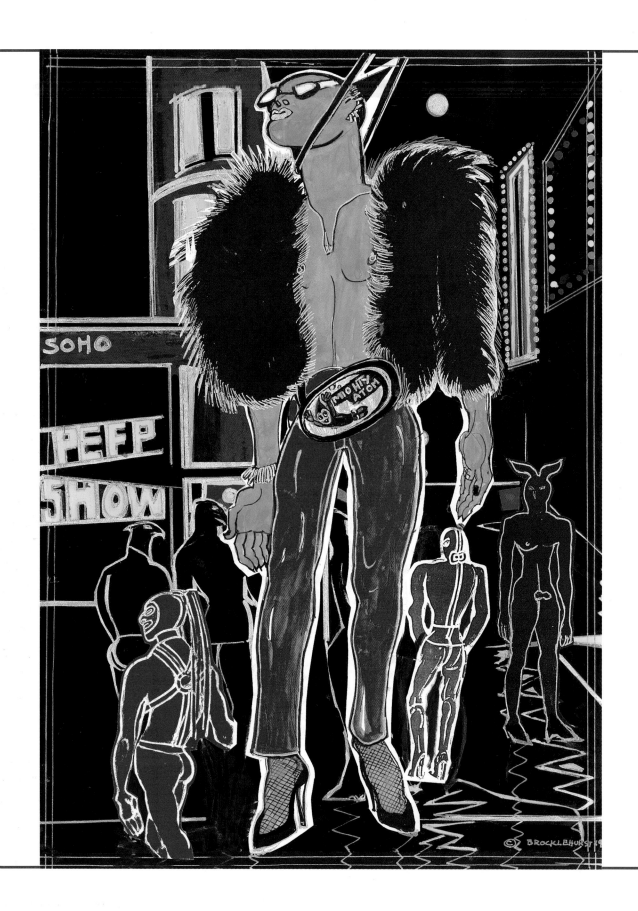

fashion & style
victims & strategists

'Mighty Atom', Soho, London.
Collage drawing **Joe Brocklehurst**

You probably found this book filed under 'Fashion'. What, I wonder, is 'fashion'?

Clothing, jewelry, shoes, make-up, hairstyles, tattoos, lingerie, military uniforms... in the bookshops I frequent all these things get slotted within this classification. 'Fashion', in other words, has become simply a catch-all term for anything to do with the body, its adornment and covering – a synonym of 'style', 'dress', 'costume' that, in the end, has no distinctive meaning at all.

It was not always so. In English and in many other languages a useful distinction has long been made between 'fashion' and 'style'. The essential difference between the two, interestingly, only becomes evident when a particular item of dress, jewelry, or footwear is placed within a temporal context. That which has a fluctuating value over time – gaining or losing value, coming in and going out – is 'fashion'. That which defies change in pursuit of the timeless is 'style'. (Of course, there are other definitions of these terms – for example, linking style to personal, individualistic difference and fashion to an accepted norm. As we will see, these definitions supplement each other and are not contradictory.)

As an anthropologist studying tribal and peasant body decoration I was time and time again struck by the pride taken by such peoples in the fact that a feather headdress, a body-painting design or the embroidery pattern of a peasant blouse remained the same over many generations – ideally (in their mind) since the very beginning of time. This fact struck me very forcefully in the early 1970s – a time when, in contrast, the streets of London, Paris, New York or Milan were every year dramatically transformed as hemlengths rose and fell, colours instantly switched from, say, navy blue to hot pink and even the ideal breast or hip size fluctuated as if controlled by some as yet undiscovered law of physics.

What was seen in negative terms in one world – ➤

➤ change – was celebrated in another. While people I knew would surreptitiously and self-consciously take their navy blue garments to a charity shop, the traditional peoples I studied were embarrassed if their dress and adornment styles were seen to have changed over hundreds or thousands of years.

This basic distinction between fashion and style established, I also noticed that there were some pockets of anti-fashion, traditional style even within my own world. Hell's Angels, for example, would never dream of proudly parading 'This Year's New Hell's Angel Look'. No, like the Amazon Indian or the Slovakian peasant, they took pride in the unchanging continuity of their chosen style – such continuity, as amongst tribal and peasant peoples, expressing the stability and longevity of their culture as a whole. Clearly the same was true of Hippies, Punks, Goths and all the other youth-oriented subcultures or 'styletribes' (which I will consider in detail in the following chapter). Likewise, both the working class flat cap (or, in the USA, denim or check workshirt) and, at the other end of the social scale, traditional Sloane Ranger or Preppy styles (consider the TV character Frasier's fastidious dress sense) were all valued precisely because of their anti-fashion steadfastness.

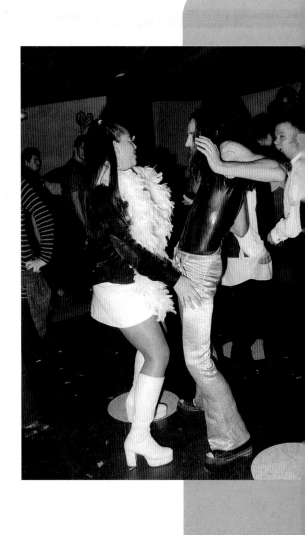

The idea that this year's new colours, materials or shapes are inherently better than last year's colours, materials or shapes is, in historical terms, comparatively recent and in marked opposition to the way change has been perceived throughout most of human history. A traditional, conservative worldview that is suspicious of change – inherently seeking to preserve the *status quo* of a tribal culture from generation to generation – is as old as our species. And the same is true of those adornment and dress **styles** which, in their unchanging continuity, vividly express and concretely reflect this attitude.

The presumption that change is to be ➤

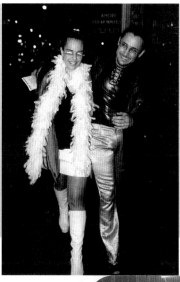

New Age Glam

Nicole Raubenheimer and Morné Ferreira – during the week he's a graphic designer, she works in a strip club. The weekend is the thing: clubbing, dancing, glam. Wherever they go, they're the centre of attention and that's the way they like it. These South Africans have been living in London together as 'just good friends' for two years.

Clubs: Club UK, Velvet Underground, Peach, Heaven.

'I found my rubber shirt at a rather bizarre rubber shop in The Angel. Picked up my flares at a Kensington Market stall and slapped together the platform trainers myself.' (Morné)

'My style is a New Age Glam outrageousness.' (Nicole)

'I've been through major changes – from frightfully boring to 80s Tacky to Late Gothic and then to early 90s Fashion Victim – and now I'm just comfortable with my individuality.' (Morné)

'Everyone has their own style. I respect that, just as I'd like people to respect my style. House music is my passion. Just be yourself and enjoy it to the max!' (Nicole)

Photographs **Klive-D**

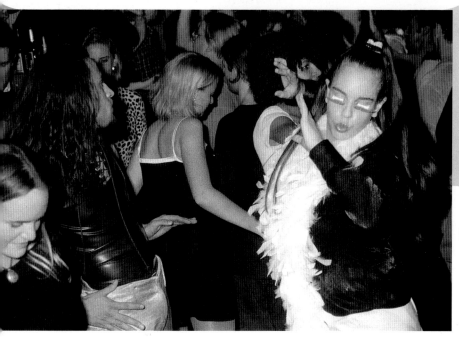

Terri King & friends

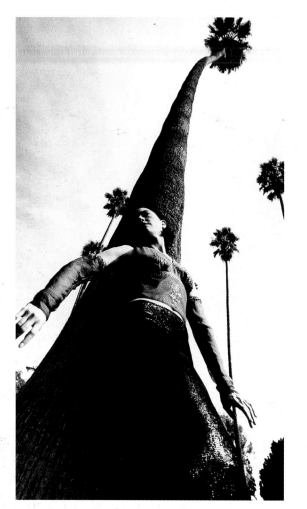

LA has its style stereotypes – the 'natural look' Baywatch babe or the Hollywood glam of Rodeo Drive – but not everyone in LA conforms to them. Originally from Charleston, West Virginia, Terri King moved to LA in 1984 and set out to design clothes that challenged the old, established LA stereotypes. As Terri says, 'I like to design clothes with a lot of character and personality. My work isn't typical LA style, which tends to be bland and uncourageous. Like me, my customers don't fit with any of the typical LA stereotypes – they're people with a strong sense of their own style, people who have something to say. I don't want to stifle that. My job, as I see it, is to help people to express themselves.'

This is no doubt why Terri has been so successful in attracting clients from within the music industry – having made custom outfits for a wide range of performers from Keith Richards to Nine Inch Nails frontman Trent Reznor.

'A lot of my inspiration comes from the past – eighteenth-century corsets, turn of the century riding jackets, Gothic-style skirts – but I try to give everything a funky, twenty-first century twist.'

While not typically LA, Terri's work is also distinct from the international fashion industry.

'I'm not interested in simply latching onto the latest trend from Paris, New York or wherever. I try to design things that have something to say – powerful, even classic looks which could be worn 20 years from now if people want. I like it when someone takes something of mine and puts it together with something from their own wardrobe to create a whole new look.'

left and opposite below: Singer Donna De Lorry and Hannah Sim wearing Terri King designs.

below: Terri King.

opposite above: Pictured with Terri are: (below) Dawne Aubert, dancer, psychology major at University of Southern California, assistant to Terri on video and magazine shoots. Victoria Gunstream (top left), a make-up artist and part-time assistant to Terri. Hannah Sim (centre), a model with 'C'La Vie', who is often photographed in Terri's designs. Lena Lecarro (right), jewelry designer and assistant at Terri's new shop 'King' on Melrose Avenue. Lena also writes a column for *LA Weekly*. She says: 'In LA pretty much anything goes and the ones who get noticed are those who combine originality with what's hot...Terri's clothes are perfect for this kind of person.'

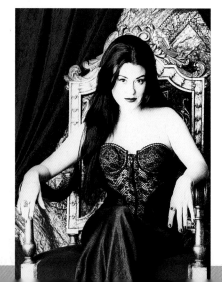

Make-up **Victoria Gunstream** Lighting for group shot **Robbie E. Caponetto**
Photographs **Dorit Thies**

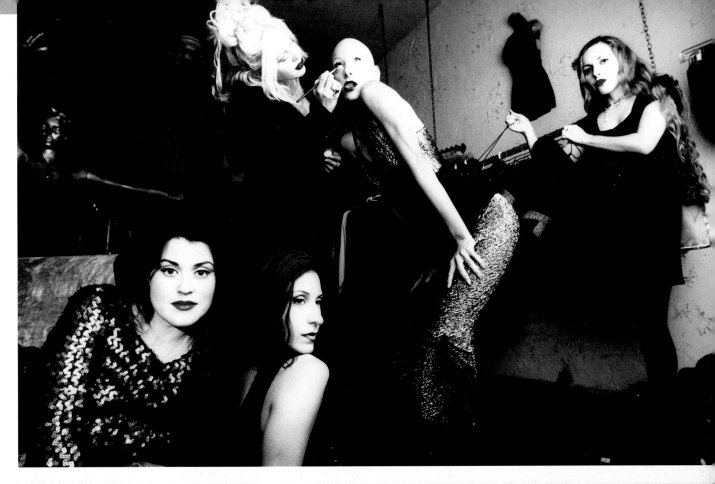

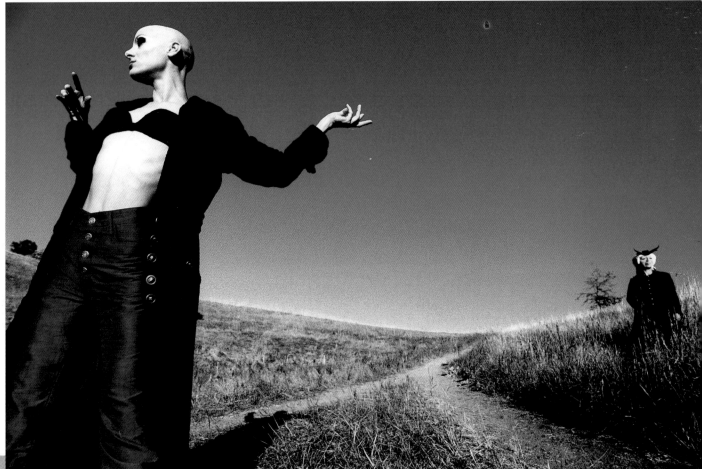

➤ welcomed because it heralds progress (the equation of 'The New' and 'The Improved') constitutes the bottom line of the revolutionary worldview that evolved and came into prominence during the transition from the Middle Ages to the Renaissance. While Modernism's pro-change/ progress presumptions clearly had profound effects on architecture, interior design and the arts, its most perfect expression came in its impact on adornment and dress. Portable, personal, comparatively inexpensive, such ever-changing **fashion** gave immediate, visual, everyday expression to the Modernist worldview. As a diarist in Renaissance Florence noted:

'In 1529 they stopped wearing hoods; and in 1532 there was not one to be seen, for the usage had gone, and instead of hoods, caps and hats are worn. At the same time they began to cut their hair short, where before everyone had worn it down to their shoulders without exception; and now beards began to be worn, where before no one could be found wearing a beard in Florence.... Furthermore, at the same time, hose began to be made in two pieces, where before they were made in one, and without any slits; now they are slashed all over and they put taffeta underneath to come through all the slits.' [quoted in Michael and Ariane Batterberry, *Fashion: The Mirror of History*, p.96]

Here we see the starting point of a perpetual cycle of new 'New Looks' and an incessant hunger for novelty that may be traced in a line from the Renaissance right up to the present day. Here is history as defined by Modernism (linear, progressive) dramatically spelled out in changes of colour, shape and fabric. Leaping centuries ahead we see the same system at work in 1947 when Dior launched his 'New Look' – its feminine curves and luxurious expanses of fabric heralding the end of wartime austerity, drawing a bold line between what was ➤

beauty:beast

Takao Yamashita (right) is one of the original founders of the 'beauty: beast' clothing design label – which has shops in Tokyo and Osaka (where it is based) and thirty stockists around Japan.

'Already, since we did the photos for STYLE SURFING, we've changed our look. Just now we look like skaters from Yokuska who've shoplifted the local branch of "beauty:beast". Three years ago we were all into the "Donald, Where's Your Trousers?" look.'

'Yes, we're "fashion victims", but this doesn't have negative

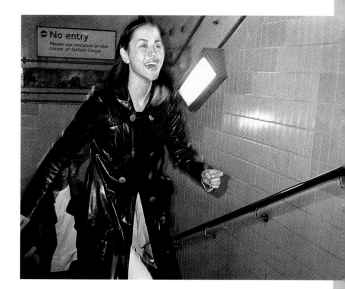

connotations for us. They're just people who take a more than average interest in their get-up. Japan is the home of the fashion victim. Now, in Tokyo and Osaka, it's the *gaijin* (foreigners) who look straight. The starting point for Japanese fashion may have been the West, but now it has evolved its

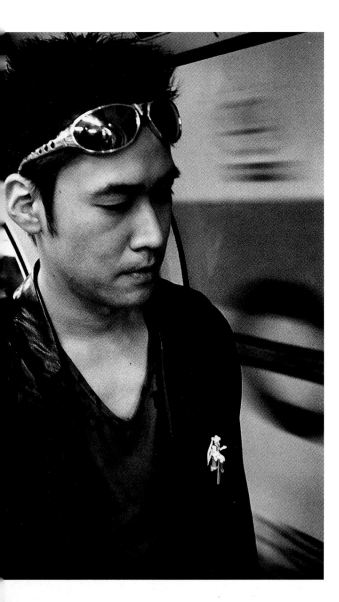

own, unique identity. You can't download cultural identity. The Global Village of the modern psyche is still a long way off.'

Ujihara Ikuko (left) is a model with the Elite Agency, which is also in Osaka. She says, 'I like London because everyone manages to look great while, at the same time, looking as if they don't care how they look. In Japan we are all constantly fretting over the details of our dress.'

Photographs **Adam Howe**
Logo design **Simon Taylor** at **Tomato** (London)

➤ and what would be, marking time, celebrating progress.

And, as in the examples given by the Renaissance Florentine diarist (the shift from hoods to caps and hats, short hair replacing long hair, the sudden popularity of beards, hose made in two rather than one piece, the craze for slashing), Dior's 'New Look' demonstrates the other principal characteristic of fashion, its singularity. That is, as well as 'the *new* look', fashion is also identified by '*the* new look' – a consensus focused on a particular 'direction' which first appears within the collections of the most exclusive and expensive designers and which then, with time, 'trickles down' to define the desirable look for the fashionable mainstream. To *not* conform to what is decreed to be in vogue is to be condemned to the ranks of the *un*fashionable – to be outside of history and progress, to be left behind.

Twenty, thirty years ago all this seemed clear. While shifting towards youth and accelerating the speed of its cycles, fashion maintained its firm grip on most people's approach to dress and adornment throughout the 1960s and into the 1970s. Like the Renaissance bourgeoisie in Florence showing off their bright taffeta through the slashes in their garments or like the woman in Europe or the USA in the early 1950s buying a department store 'New Look' style dress, the women struggling to raise their hemlengths another inch in 1965 wanted their dress to proclaim, 'I keep up with the times', 'I'm progressive', 'I'm forward looking', 'I'm trendy'.

The 1980s, however, witnessed a dramatic change in our attitudes towards change – and therefore towards fashion. Suddenly, to describe someone as 'trendy' was a put-down rather than a complement. Suddenly, anyone who reflexively jumped on the latest bandwagon – throwing out anything in navy blue because *Vogue* said that hot pink was 'in' – was branded a 'fashion victim'. ➤

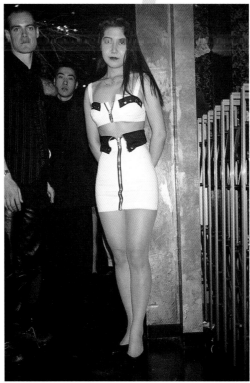

By day they dress demurely, boringly for their unexciting office jobs. When work is finished, however, they flock into the office lady's room to cram themselves into tight-fitting, 'Body Conscious' clothes for the night ahead.

As well as being sexy, it's important that these carry a high-fashion

BODY CON GIRLS OF TOKYO

designer label for, despite the provocativeness of their appearance, the girls are at heart some of Japan's foremost 'fashion victims' – frantically changing their look to keep up with the latest trends, often dressing from head-to-toe in the work of a single, 'in' designer.

Their appearance transformed, it's off to clubs like Juliana's or Maharaja (outside which these photographs were taken), where – perched exhibitionistically on high platforms – they dance to Techno-music while throngs of Japanese 'salarymen' stare up in lustful admiration. (Some surveyors of Japanese culture see in this the motivation for the 'Body Con' phenomenon: an inversion of the traditional Japanese power structure in which women have little control over men.)

While 'Body Con' girls may come into their own in the environment of Tokyo nightclubs, they are not to be confused with the huge numbers of Japanese 'Clubbers' (see 'Club Kids of Tokyo' on pages 12 and 13) who sample and mix a wide range of the latest clubwear – styles that may cost just as much but that owe less to the dictates of high fashion and more to the dynamics of international youth/club culture.

The 'Body Con' craze began in the mid-80s in Osaka and reached its heyday in the early 90s – by which time it had spread to most major Japanese cities. (The photographs reproduced here were taken in 1992.) While no doubt jaded by excessive media exposure, the decline of 'Body Con' probably also reflects the fact that Japanese young people as a whole are increasingly less willing simply to subscribe to the dictates of the high fashion industry – and more inclined creatively to cruise the playful poss-ibilities of Clubland International.

Photographs **Norbert Schoerner**

➤ Suddenly, someone who only a few years before would scramble to keep up with/ahead of the trends would boast, 'I've had this for *ages*'. Suddenly, everyone in the know wanted 'timeless classics' – be they an undatable Jean Muir black cocktail dress, or a pair of 'original' Levi 501s to be worn with 'original' Doc Martens boots and an 'original' Perfecto black leather jacket as worn by Marlon Brando in *The Wild One*. Suddenly, in other words, fashion went out of fashion.

Not that the 'fashion industry' readily acknowledged this shift in its objectives and function. The fashion journalists flocking to Paris, Milan, London and New York still, by and large, sought to discern the latest single 'direction'. But as the differences between designers became more and more pronounced – most evolving a distinctive and little-changing 'signature style' – the idea became increasingly more difficult to sustain.

What had happened was that the defining feature of dress had shifted from fashion, with its emphasis on constant change and a singular 'direction', to style, with its emphasis on constancy and ➤

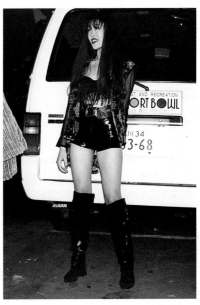

➤ pluralistic diversity. Thus, to take as an example the two most important designers in Milan, the difference between a dress by Armani and a dress by Versace was immediately recognizable, while the location of either of these designers' creations within a specific season became more difficult to pinpoint – the message, 'I'm an Armani/Versace type of person' (respectable and elegantly understated in the first example, fun-loving and ostentatious in the second) was more fundamental than the message, 'I'm avant-garde'. (None of which, of course, made the clothing industry or designers any less important. Far from it. All that had changed was the function of their product: now increasingly defining *where* you were – your lifestyle, what tribe you belonged to – rather than *when* you were – that is, whether you were ahead of or behind the times.)

And the shift from fashion to style – from a singular, ever-changing theme towards a wide-range of diverse, distinctive, classic 'signatures' – has continued in full force into the 1990s and gives every indication of carrying on well into the next millennium. This transformation is succinctly noted by Peter York in his book *Modern Times* (p.10):

'Fashion had its own establishment, a kind of Vatican, in the fifties and sixties and in this set-up they had dictators who set the lines for everybody to follow.

The lines were set like edicts in the way of the old world… They were set by magazine editors for magazine readers. Vogue used to announce the colour of the season and up and down the land shops presented clothes in banana beige or coral red or whatever.

In the fifties there were actually lines for fashion. Dictates about the shape a woman's clothes should be, irrespective of the shape of her. And then came the sixties. Remember the mini…

And the point was that everyone wore it, your ➤

Devi & Pam in **Brixton Market**

Devi's and Pam's parents moved from Mauritius to London when Devi (the elder of the two sisters) was one year old. Both share a passion for second-hand clothing shops and – as in these photographs – hunting down unusual items in London's Brixton Market.

Devi, a data analyst for a market research company, has long been interested in Gothic styles of dress and music. 'But I've never actually considered myself to be a Goth – I don't like being pigeon-holed and, anyway, I enjoy too many different things to limit myself that way. If I had lots of money I'd buy some original Victorian dresses, corsets and shoes. I'm drawn to these old styles, but then I also like futuristic fetishy clothes in materials like PVC, sometimes mixing it all up in one outfit. While I'm constantly adding different things to my wardrobe, my basic style has remained the same for many years and I expect that to continue into the future. Keeping up with the latest fashion doesn't interest me. The things I like never go out of date.'

Pam, a cultural studies student and a poet, has recently been incorporating traditional Asian styles into her look. 'I'm exploring my roots more now. Like most Asians living in Britain, I used to wear only Western clothes. Now, if I get dressed up to go out in the evening, I might wear a sarong skirt with an Indian print, maybe paint henna patterns on my hands, perhaps even wear a "tikka" (traditional Indian forehead design). But then I'd mix this with things like a pair of chunky, 12-eyelet DMs (Doc Martens boots), a little satin top and my black leather jacket. I like to jump around between cultures, mixing up lots of opposite looks – the grungy and the elegant, the Western and the Asian, the old and the new. Because I'm younger, my style is a bit less settled than my sister's, but I'm certainly not a fashion victim – I won't go out and buy something just because it's trendy. I feel that it's all about balance and reconciling the vast differences between the East and West, not only materially, but spiritually, too.'

Photographs **Francesco Cavaliere**

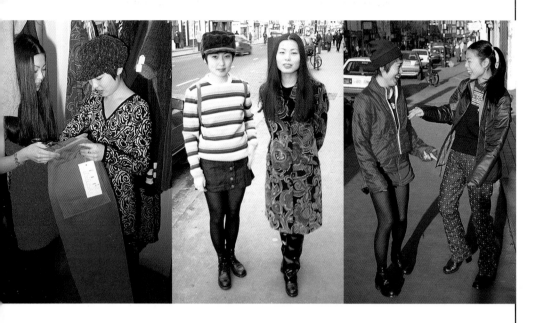

'BritPop is really in here, while Acid Jazz is currently the big thing in Japan. But personally I really like BritPop, so I'm happy here – but I must say that I was expecting to find more fashionable people and clubs.' Yuka

'London has the edge.' Shinobu

It used to be said that young people in Japan simply copied styles from London and Europe. Do you think this is true?

'Some Japanese copy but certainly not me! I try to choose items of fashion according to my own taste.' Shinobu

SHINOBU & YUKA GO SHOPPING

Shinobu, 23 (above centre, right), and Yuka, 20 (above centre, left), are Japanese students studying English in London. They came to Britain in March 1995. Here they go shopping in Camden Town in north London.

Would you wear these clothes in Japan?

'Yes, of course – very funky – but it is difficult to choose because some of the clothes in this shop are quite different from our tastes.' Shinobu

'But I'd buy them here. Clothes are really expensive in Japan.' Yuka

Do you find that London is very different from Japan in terms of fashion and music?

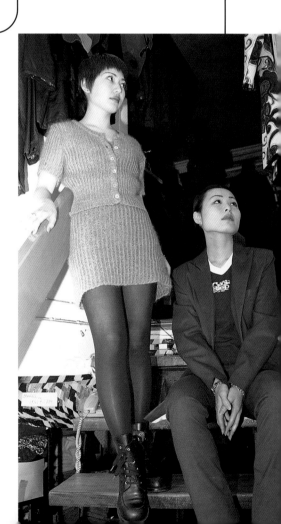

What are your favourite clubs here in London?

'Midweeker at the Borderline.' Yuka

What kind of music do you like?

'Sixties and Seventies music, Indie music, The Zombies and The Chemical Brothers.' Yuka

'British and American Indie music.' Shinobu

Do you think your style will be very different in the year 2000?

'Hard to say, but whatever it is I hope that it will be a mixture between Europe and Japan.' Yuka

'No idea! How much are these crocodile trousers?' Shinobu (She buys them on the way out.)

Photographs **Klive-D**

➤ sister, your auntie, the gym mistress, everyone. For truly THERE WAS NO ALTERNATIVE.'

Note the use of the past tense. Now, as is immediately evident from watching people on any city street, at the supermarket, in a night club or even by flipping through the pages of *Vogue* or *Elle*, there are plenty of alternatives. And plenty of people who frankly don't give a damn whether banana beige is 'in' or 'out'.

How we choose to present ourselves to the world visually, on one level the most superficial of phenomena, always has its roots and motivations deep down in the bedrock of culture – in the bottom-line *Zeitgeist* of an age. With its roller-coaster ride of constant change and linear progress, fashion perfectly expressed that set of beliefs and attitudes which came to be known as Modernism. In the 1970s and 1980s, however, as more and more people began to see the yellow brick road of Modernism as a dead end, fashion also lost its allure.

The shift from fashion to style was triggered by that much talked about shift from Modernism to Post-Modernism, which has so characterized recent times. In the early 1960s, when I was growing up, the world seemed to be a place of constant improvement and tangible progress. Technologically, economically, sexually things were deemed to be getting better every day. We couldn't wait for tomorrow; and this sense of purposeful direction and improvement had everyone happily dancing to the same tune – a conga line of futurists stretching all the way towards a bright, new dawn. In such a world those vivid 'new looks' that I saw spread across the pages of *Life* magazine were desirable and exciting because they provided a tangible glimpse into a brave new, ever-improving, sexy, affluent and more liberated world. Any day now we would all dress like/act like/be like the people in the photographs, with plenty of leisure, no old-fashioned inhibitions ➤

and money to burn.

Our Post-Modern world is a very different place. We are now more inclined to question the value of change for its own sake and to have doubts about the inevitability of 'progress'. At the same time, instead of focusing around a single 'direction', our world has splintered and fragmented into a plethora of lifestyle options which coexist, rubbing shoulders with each other like commuters on a Tokyo subway. Things aren't as cut and dried as they were. Where once there was a clean, obvious direction, now there is a maze (a Rave) within which we all seem to be moving in different, often contradictory, lines – cutting across time and space as well as each other's tastes in the process. It's all very confusing – and yet undoubtedly all very exciting at the same time.

The question, then, is this: if fashion arose as an expression of Modernism, what approach to dress and appearance is appropriate to the Post-Modern condition? It will take the rest of this book to flesh out a comprehensive answer to this question, but perhaps an initial clue is provided by the dress styles found in that most Post-Modern of films, *Blade Runner*.

Whereas previous Modernistic cinematic visions of the future (*Things to Come*, for example) tended towards the fashionable ideal of everyone dressed more or less uniformly in some newer than new style, *Blade Runner*'s characters are conspicuous in their diversity, in their nostalgic inclinations and in their playing with style both as a personal 'statement' and as an ironic commentary on the state of the world in AD 2019.

Our hero, Deckard, looks like a secondary school English lit. teacher *circa* 1955, wearing a soft brown sports jacket and rust-coloured tie. His sidekick, on the other hand, looks like a 1940s Hispanic pimp with white bow-tie, fedora and goatee. The replicants they're tracking down blend into their ➤

swimwear ➤ clubwear

Throughout the history of Western dress, garments designed specifically for sports have more often than not eventually come to be worn more generally. Gunilla Kjellnäs is a Swedish designer based in Stockholm who is intent on speeding up this process – as in these photographs, creating a swimsuit that can instantly be converted into clubwear.

'In my own life I like playing sports – tennis, jogging, aerobics, frisbee, swimming – and I also enjoy going out clubbing at night. So it was a natural progression for me to think about making designs that could be worn for both activities. I want to break down the walls that divide up our lives between work, sports activities and parties.'

'I'd like Swedes to use more colour in their dress. It's only "legal" here in Stockholm to be bright and colourful in sports. What are they afraid of? Colour has a good effect on people's lives – look at light-therapy! Who says they look better in black, beige and white, compared to brighter colours? I also believe that, traditionally, there are too few styles that an active, sports-minded person can dress up in and feel comfortable. I'm trying to design garments that are both sporty and potentially "dressy" at the same time.'

'I don't believe in taking fashion trends too seriously – changing everything just because some fashion magazine tells you to. People should have more faith in their own taste and desires. If you find a look that is "you", just enjoy it.'

Photographs **Jonas Ekströmer**

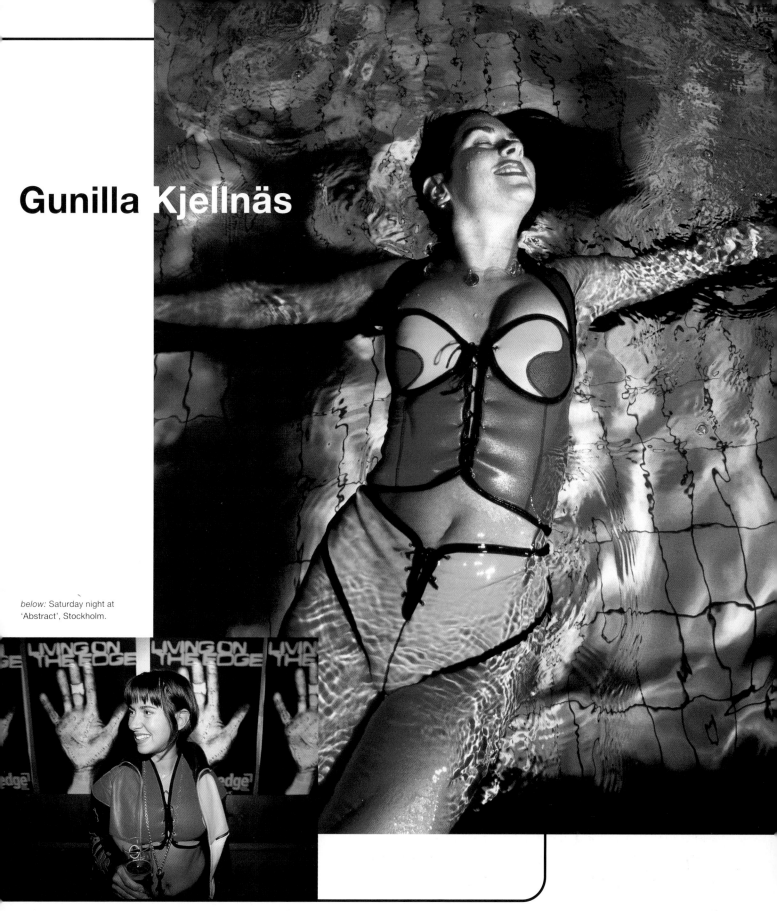

Gunilla Kjellnäs

below: Saturday night at 'Abstract', Stockholm.

Where do you get your clothes? 'Darryl K's, Screaming Mimi's.'

How would you describe your style? 'Loose.'

Do you dress differently on different occasions? 'Absolutely.'

What's your style history? 'Constantly changing – I'm a chameleon. In particular I have a hair thing that happens every three weeks.'

Do you go to certain clubs? 'No, bars.'

Hobbies? 'What's a hobby? Fashion is my life.'

Where do you get your style ideas from? 'Books.'

Are there famous people you especially admire? 'Audrey Hepburn, Marilyn Monroe, Bardot (when she was 20).'

Are there any styles you strongly dislike? 'No comment.'

Musical interests? 'R&B, Jazz.'

Do you see your style as a statement? 'No. I just go by how I feel. I'm not trying to impress or change the world.'

What do you think you'll look like in the year 2000? 'I can't wait to see my hair colour!!!'.

Photographs **Mils**

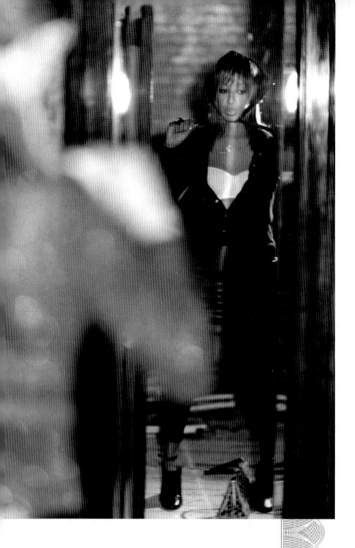

Patti Wilson

STYLIST NYC

> surroundings like the Post-Modern chameleons they are: Pris, the intergalactic, post-Punk space hooker in short fake fur coat, stockings and suspenders, bleach blonde hair, dog-collar and spray-on raccoon eyes; Rachel, on the other hand, in glamorous 30s-style fitted suits, hair pulled back in a bun, elegant, perfect red fingernails and lips. Out on the street hordes of traditional, Far Eastern-style peasants and film-extra lookalikes (as if strays from some other movie) pass two perfectly attired Punks *circa* 1977 who, with their badged, leather jackets, spiky top hair, wrap-around shades and pale skin, look exactly like Sid Vicious on a particularly bad day.

What then is the 'New Look' of AD 2019? The answer, of course, is that there isn't one. Will everyone look completely different in AD 2020? Perhaps. But we are more inclined to see each of these characters' styles as something that has evolved more slowly, more intuitively as a statement of 'real' (yet playfully, knowingly unreal) identity in a world gone mad with change, chaotic diversity and hype. Yet, at the same time, these style 'statements' are clearly not meant to be taken literally and this is at least as true of the humans as it is of the replicants – Dekard isn't an English lit. teacher, his sidekick isn't a pimp.

Who is real? Who is a replicant? Who cares? Life is a fancy-dress party. Enjoy. ✦

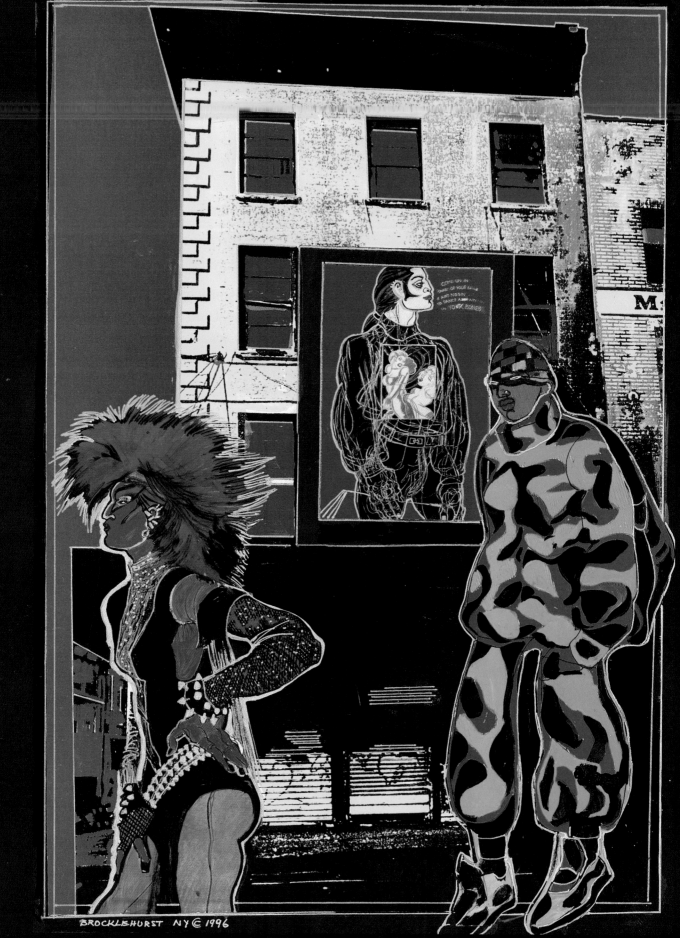

BROCKLEHURST NYC © 1996

tribal styles
& personal visions

To jumpcut directly from the determined march of fashion to the polymorphous perversity of Post-Modern style is to miss out an important direction in the contemporary history of appearance – a direction that might best be characterized as Pre-Modern.

To put it in cinematic terms, before *Blade Runner* came *The Wild One,* with its vision of a world that is not fragmented into personalized parody but instead splintered into stylistically distinctive tribe-like gangs. The film is misnamed: these are wild ones, riding and dressing in unison, a collective that is more than the sum of its parts. It isn't just the classic timelessness of the style (the fact that one can still find Bikers dressing almost identically to those of the late 1940s who are depicted in the film), but also the social functions of such dress (the way in which it signals 'We' rather than 'I') that identifies it as style rather than fashion.

Much more ancient than fashion, this tribal approach to appearance undoubtedly dates back to the earliest days of human existence. It was tribal life – with its co-operative effort, the accumulation of information from one generation to the next and the stabilizing influence of cultural tradition – that gave our ancestors a clear advantage over all other animals. Like present-day tribal peoples, the early *Homo sapiens* (and perhaps even its predecessors) in all likelihood made use of a shared, distinctive appearance style to give concrete expression to tribal life – marking group boundaries, denoting adulthood by means of rite of passage rituals involving some modification of the body and underlining the unchanging continuity of its culture.

The uniforms of the Biker gangs in *The Wild One* mirror all these original functions of style. Drawing a line between 'Us' and 'Them', marking the moment of initiation into the group, stridently anti-fashion, the Bikers' black leather jackets, greasy jeans, chunky motorcycle boots and gang insignia convey tribal ➤

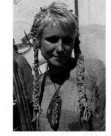

Tribal styles: *top to bottom*
Hardcore Ravers, 'Fantazia', Castle Donington, Derbyshire.
Mt Hagen New Guinea tribeswoman, Commonwealth Institute Festival of Music and Dance, Holland Park, London.
Jacket worn by a member of the National Chopper Club of GB photographed at the Tattoo Convention, Dunstable.
Australian 'Freak' in London en route to the Glastonbury Festival.
Photographs **Ted Polhemus**

left: 'Urban Camouflage', South Street Seaport, NYC. Photo collage drawing **Joe Brocklehurst**

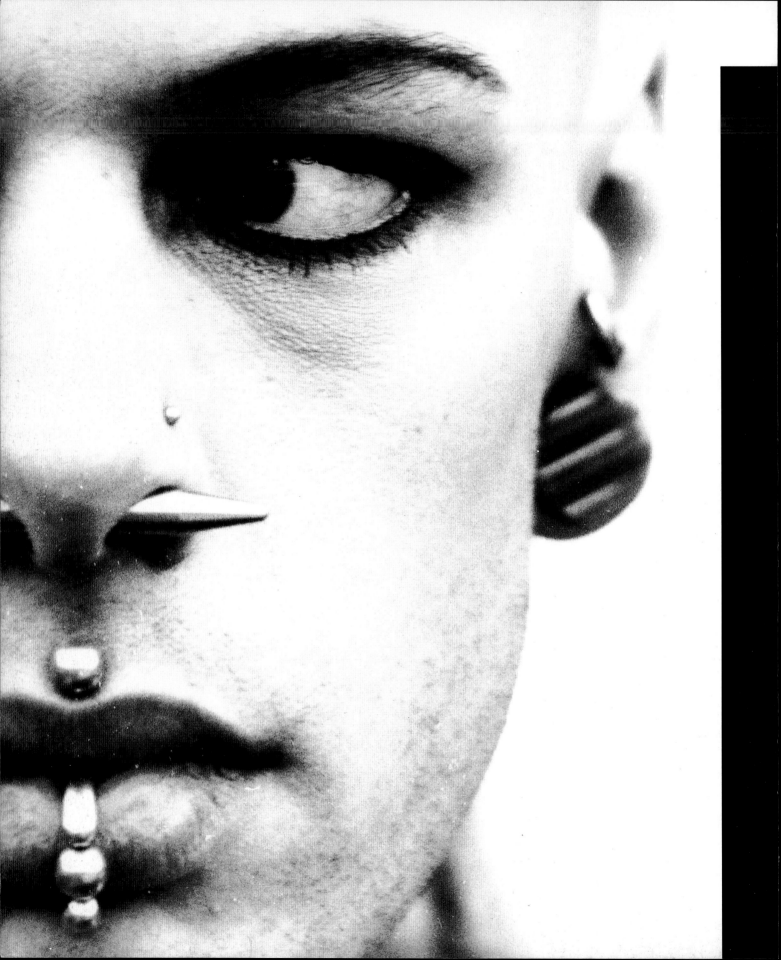

flesh ✛ steel ✛ hair

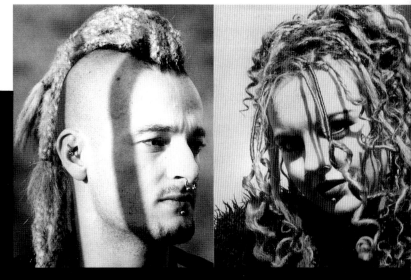

Dave Deacon (*opposite and below right*) is a professional body piercer. Struggling to keep up with the ever-growing demand for his skills, he works freelance and with 'Cold Steel' in Camden, London.

'I've had some 50 piercings myself over the years, but I now only keep jewelry in about 25 at one time. My hair is done by Andrew Gregory. The style and colour keeps changing all the time – I've been through every colour, worn dolls' heads and pieces of wood in my hair, shaved, with extensions. You name it, I've done it. The perpetual fluctuations of my hair styles are just the opposite of the permanence of my other body decorations.'

'To me, a Modern Primitive represents someone willing to experiment with personal, social and moral beliefs in a way that makes the experience of the decoration itself the most important aspect of their modification. That is, it goes beyond being just a decoration – it's part of a meaningful ritual. It's not just fashion.'

'I will always be looking for new experiences, both physical and psychic. Pain and fear are just states of mind to be indulged, ignored or explored at will.'

Eva N. (above right) is Spanish but has lived in London since 1992. Her work in photography and video has taken her from night clubs to an operating theatre in the exploration of ritual, body worship and the frontiers which are beyond the physical. A personal involvement with body decoration has also resulted from this work – especially body piercing and experimentation with new forms of hairstyling. Her own hair is done by Andrew Gregory.

'I wouldn't draw the line anywhere.'

Andrew Gregory (above left) is the assistant manager of a well-known London hairdresser. He works half of each year in London, the other half in NYC. He draws inspiration for his work from the Fetish, Glam and Gay scenes.

What does he think he'll look like in the year 2000? 'Extreme... I never want to blend in.'

Photographs **Eva N.**

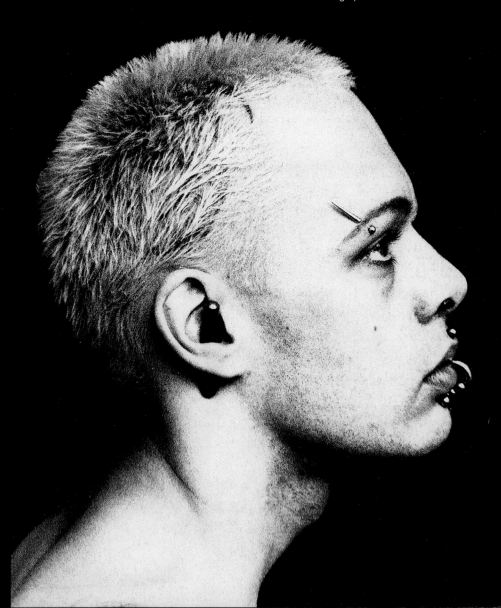

➤ identity as effectively as the distinctive body-painting designs and feather ornaments of a tribe in the Amazon, Africa or New Guinea. In both instances appearance serves primarily to signal group rather than personal identity and to underline cultural continuity rather than fashionable fluctuations.

The tribal styles of *The Wild One* – and the real-life Biker groups that it portrayed – were shockingly out of step with the modern world. Defiantly rejecting every tenet of Modernism (change, progress, personal expression, optimism, globalization), the wild ones turned the clock back all the way to the time when traditional values and group affiliations defined human experience. And where the Bikers and other seminal groups of the 1940s led, all gangs have followed – their 'colours' (as with the Bloods and the Crips of Los Angeles) a vivid reminder of the extent to which our modern world has been subdivided by tribal identities and loyalties.

Still, this tendency would only warrant a footnote in a history of appearance were it not for the fact that the collective, tribal approach to style has spread far beyond the bounds of actual gang membership. For more than fifty years the modern media has made it possible for a substantial number of such closely knit gangs to grow into internationally recognized subcultures – *styletribes*.

While the members of a gang (like the members of a Third World tribe) all know each other and have a fixed geographic territory (a 'turf'), the members of a styletribe may well live in different cities, even different countries and are typically strangers to one another – recognizable only by a common style 'uniform' which symbolizes a shared system of values and beliefs (that is, a culture). Though Pre-Modern in their pursuit of a tribal identity, ironically styletribes could only exist in the modern-day 'global village' where disparate neighbourhoods, cliques, clubs and 'scenes' are effectively linked together ➤

'If I had to put

Clare Rose lives in Newport, Wales with her cats 'Summer' and 'Sister'. She likes clubbing (going to Lakota in Bristol or Wobble in Birmingham when she can afford it – TJ's in Newport when she can't), House, Techno music and *Vogue*.

'At 15 I attempted to be a Gothic. Sat in my room listening to The Cult, The Mission, Sisters of Mercy. Sat by the mirror backcombing my hair and smudging my lipstick. Then at 16 I bought a pair of 13-hole Doc Martens, ripped my army trousers, sprayed my T-shirts with car spray and started listening to Nirvana and Mudhoney. It was sort of "Grunge" with an attitude of distinction. But it was really just me on a new stage of my journey.'

'I wanted to be a fashion designer, but to my surprise I realized I was the design. Then I wanted to be a photographer, but I realized I was the photograph.'

'My heroes are Kate Moss – she's an angel. Courtney Love – I love her dirty old shoes, her chewed down painted nails. And Barbie. She may be plastic, but she has everything a woman wants – lots of hair, a fantastic figure and a wardrobe full of shoes and clothes.'

'I hate: shellsuits, white towelling socks with red and blue stripes at the top, gold rings and gold chains, people who wear grey (isn't life depressing enough anyway?), fat people in tight clothes, perms, men's grey slip-on shoes. White furry bras really suck!'

'In the year 2000 I'll still hope to be bright, with a strong image that has progressed with the times. But, who knows, I could end up wearing a shellsuit with gold chains around my neck, curly permed hair – and feel great with it.'

Photographs and Collage
Kate Owens

a label on myself I'd say I'm a Hippy – if there is such a person. I'm not dreadlocked or smelly. I'm bright in a new 90s way, with just a touch of glamour.'

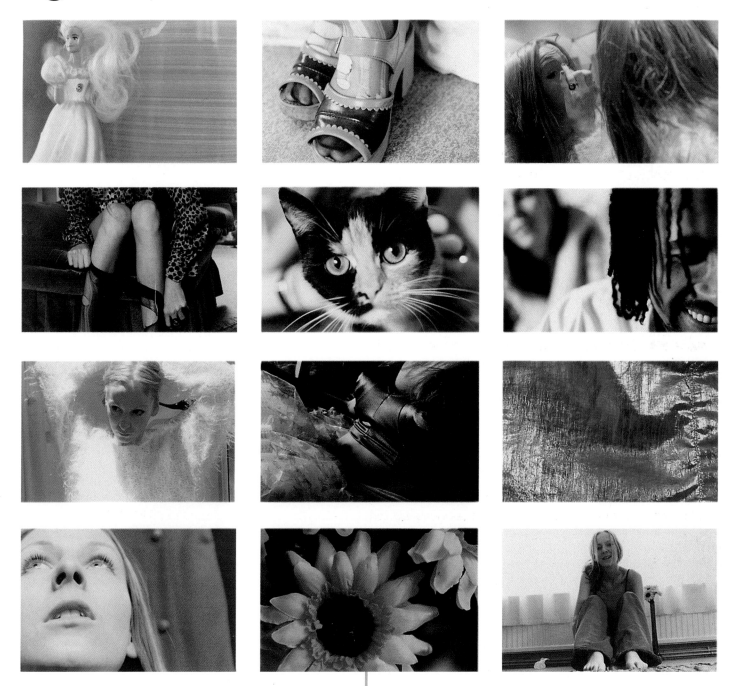

➤ by a national and international media eager to report on the latest 'youthcults' and (*sic*) 'fashions'.

This transformation of local gangs or cliques into geographically diffuse subcultures has been especially evident wherever some form of popular music has been linked to a particular group and visual style. For example, in 1940s America, young Black 'Zooties' with a delight in over-sized zoot suits and in 'swing' jazz transcended the boundaries of particular urban neighbourhoods to achieve national recognition. Subsequently, in their influence on dress and music in the Caribbean and amongst the young White 'Zazous' of Paris, they achieved an international identity and following. Wherever jazz grew in popularity, so too did the sartorial style of the jazz musicians and their original fans – a process replicated over and over again in more recent times (especially since the advent of MTV) within Rock, Country & Western and Pop.

Since the 1940s a proliferation of distinctive styletribes – Beats, Rockers, Mods, Surfers, Hippies, Skinheads, Punks, New Romantics, Rappers, Skaters, Ravers – has followed a similar course: the stylistic experiments of a small group projected across neighbourhood and national boundaries until anyone anywhere who wanted to could join in simply by dressing and fixing their hair or make-up in a similar way. By the late 1960s there were probably more Western young people using their appearance to signal subcultural affiliation than were using the latest fashions to signal, 'I'm trendy'.

The reasons for this shift are many and varied. The growth of the international media and the music industry, as already mentioned, no doubt played an important part. (How else could would-be Punks in Edinburgh, New York or Prague discover what a tiny little clique not numbering more than 200 had initiated in London?) But while this may help to explain how the growth of styletribes came about, ➤

Hass founded R.A.P.

(Real Artistic People) in 1984. Originally a clothing stall in London's Camden Market, R.A.P. has grown both into a shop and a casual design range that has come to sell worldwide.

Inspired by visits to New York, LA and South America, Hass draws on styles associated with Black American Rap, Funk, Soul, Reggae and jazz musicians. But he gives these his own twist, mixing them up, for example, with looks derived from Brazilian football fans and his own native Morocco.

Since establishing 'Larash' (a new shop) with business partner Vicky, Hass has 'surfed' in the direction of Europe for inspiration – experimenting with 'Gabicci' Italian styles and 70s and 80s ski patterns to create the R.A.P. O.G. (Original Garment) label.

Interests: Capoeira (Brazilian martial art), world music, chilling out with new daughter and good friends.

Hates: Copycats, mushrooms and needless waste.

'The O.G. label is all about capturing moods and fashion temperament. We sensed a retro "thing" and this time we were lucky. Life's a cauldron, bubbling with ideas. Sometimes you spoon out something tasteless. Other times, the cream.'

Photographs **Klive-D**

r · a · p

> it doesn't explain why. Why, in other words, should hundreds, then thousands and eventually millions of people in the so-called 'First World' want to return to a 'tribal' way of life?

The attractions of the Pre-Modern sprang directly from the 'success' of Modernism. The ever-increasing pace of change, social and geographic mobility, increasing secularization, the incessant expansion of the middle class, an emphasis on individual opportunity regardless of race, gender, class or ethnic background – all these characteristics of modern life have conspired to diminish the significance of our more traditional cultural groupings as defined by class, religion, region of origin, nationalism, ethnic background, gender or race.

While this project undoubtedly has a long way to go, it is obvious that you and I are much closer to being modern 'World Citizens' than our grandparents were – our identities less restricted by background and the circumstances of birth, more open to self-definition and personal inclination. But while welcoming the benefits of this transformation (more equal opportunities, less discrimination), we must at the same time note the problematic effects of modern 'mass culture'.

By nature a tribal species, we increasingly find ourselves either individualized, or homogenized, undifferentiated and without a clear sense of community. As Margaret Thatcher famously suggested, 'There is no such thing as society: there are individual men and women and there are families'. Unlike her, however, most of us find such a situation at least a little unnerving, threatening or vacuous.

To fill the vacuum we have increasingly used style differences (of furniture, cars, interior decor, kitchens and cuisine, as well as of appearance) as a marker of 'people like us' (PLU have/don't have strip-pine kitchens, PLU eat/don't eat sushi, PLU wear/don't >

Antediluvian Rocking Horse

Based in Melbourne, Australia, Paul Wain and Susan King make up 'live unit' Antediluvian Rocking Horse, which produces 'multi-layered soundscapes incorporating TV, radio cut-ups and recorder sounds'. They also publish and distribute information on behalf of The Zero Workers Disassociation.

WHERE DO YOU GET YOUR CLOTHES? 'All clothes are found.' (Paul) 'Clotheslines and Launderettes.' (Susan)

HOW WOULD YOU DESCRIBE YOUR STYLE? 'Self-similar.' (Paul) 'Uncensored.' (Susan)

WHERE DO YOU GET YOUR STYLISTIC IDEAS FROM? 'Chapel Perilous.' (Paul) '60s house and garden magazines, fairground attractions, children's encyclopaedias' (Susan)

WHAT DO YOU DO? 'We plot the lost.'

WHAT STYLES DO YOU PARTICULARLY DISLIKE? 'Hippies, Goths and Fascists.'

DO YOU SEE YOUR STYLE AS A 'STATEMENT'? 'The Antediluvian Rocking Horse style philosophy is to make the aesthetic become the statement, the reverse also being true.'

Photograph **Simon King**
Drawing and Logo **Susan King and Paul Wain**

➤ wear Levi 501s.) Picking up on an increasingly subtle and sophisticated semiotics of style – an encoding of deep, rich meaning within surface appearances, a dialectics of design – we have found a new way of cross-cutting the undifferentiated social mass to create a sense of community. Thus, while my grandparents would have been wary of inviting a non-WASP to dinner (but I would not), I would feel wary of inviting someone who wears a shell suit, drives a Suzuki jeep, eats chips with curry or has a home furnished throughout in Laura Ashley. (And if ➤

➤ I just offended some of you, then this just proves my point.)

While such consumer-based styletribing now characterizes all age groups (in the process driving the final nail in fashion's coffin), it is especially evident – in your face – amongst the young. Because young people typically lack control over their home environments, they are forced to focus their stylistic identity on their appearance. At the same time, it is teenagers who most dramatically feel the full force of the social vacuum. Emotionally distanced from the families they were born into, while not yet having developed a family of their own, young people naturally find the sense of belonging that the styletribe affords particularly enticing.

Weaving subcultures from stylistic and musical affiliations, young people have for more than fifty years been successful in marking out clear communities within the social desert of contemporary life. Faced with the formless, undifferentiated mass of modern urban and suburban life, they have effectively created a new form of 'tribal' identity – one which, uniquely, can leap across continents and differences of background that only a generation ago would have proved insurmountable.

This drive towards tribalism in the face of modern mass consumer culture has coincided with another cultural revolution – a startling inversion of the social order. Where in all previous eras it was taken for granted that anyone would logically want to 'dress up' the social ladder, in the 1950s (especially in the US) a small but influential group – notably the Beats and the white Hipsters – began 'dressing down' in stylistic imitation of the underprivileged (in particular, the 'blue collar' white working class for the Beats and Black jazz musicians for the Hipsters). Confronted with postwar prosperity and the omnipresence of the bland, lowest-common- ➤

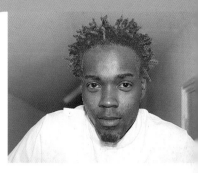

style **nurse**

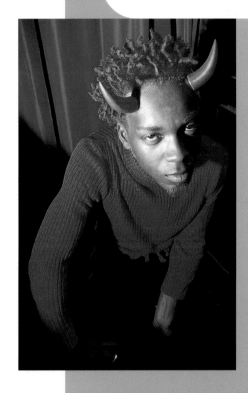

When **Dale's** on shift as a nurse, he's a traditional hygienic and conformist dresser, taking his influences from *Casualty* and the Persil ads. (The hair aside, that is.) Out of work, he's driven by what he describes as 'the need not to conform'.

Likes: Swingbeat, Hip Hop and 'sitting on the fence'.

Dislikes: 'Attaching to anything.'

Photographs **Eva N.**

below: Rocker T of Skadanks.

opposite, left to right: Rocker T; Jack Lefelt and Gravy sales manager Bert Alex; Rocker T and Jack Lefelt discussing the finer points of design.

➤ denominator 'consumer society', these nonconformists initiated a search for real-life, nitty-gritty authenticity that was to become one of the principal features of Western culture in the second half of the twentieth century.

Dress, as always, reflected and precisely articulated this social revolution. While previously fashion and style had inevitably been characterized by a 'trickle down' process, whereby the less well off strove to imitate the rich, now styles born 'on the street' (meaning streets on 'the wrong side of town') would 'bubble up' to gain prominence amongst middle-class young people – Beats in the 1950s, Hippies in the 1960s, Punks in the 1970s, 'Wiggers' (meaning 'White Niggers') in the 1980s and 1990s.

Once again appearance-style was attempting to respond to a problem of modern life – the way in which postwar consumer society, with its suburban standardization, ever-accelerating cycles of change and advertising hype had made authenticity a precious commodity. As the Coca-Cola company correctly realized, an increasing number of people were desperately searching for the 'Real Thing'.

Largely untargeted by advertising and outside the domain of the consumer society, the poor and underprivileged – be they Black ghetto dwellers or down-and-out rural Whites – were seen as the last preserve of a way of life untainted by the aura of unreality and inauthenticity that now spread like a thick smog over the prosperous modern world. And, like the relics of saints, the denim workwear of rural Whites, or the sharp suits and shades of 'with it' Black urban males, were seen as fetish objects with the power to revive the afflicted.

Although originating amongst the young and the nonconformist, both tribal style and 'dressing down' rapidly became hallmarks of mainstream Western ➤

NYC poet, skateboarder, actor, promoter, professional pontificator and clothing designer, **Jack Lefelt** founded the 'Gravy' label in 1993, together with his graphic art designer brother, Todd.

'If you ever make it out of this place, the rest of your life is gonna be gravy. GRAVY is all about comfortable, slick, performance wear for the urban jungle. Putting on gravy is like icing the cake.'

'We get our ideas from all over the place – Bob Marley, Hunter S. Thompson, David Bowie, Henry Kissinger, Cindy Crawford, going to the toilet. We mostly wear our own GRAVY designs, but we like to mix it up with other things – vintage stuff from my grandfather's closet, things we pick up from the brothers who sell old clothes out on St Marks Place.'

'Like us, most of our customers are into action-orientated lifestyles. GRAVY is about form, function and comfort. Loose lifestyle, loose attitude, loose gear. No tight clothes because no tight ass!'

'Nightlife might necessitate a shave, a scrub up and a dapper shirt, but we try to stick to our guns and suit up as little as possible.'

Singer with the band Skadanks by night, skateboarder by day, Rocker T also finds time to design clothes for GRAVY. Like Jack and Bert, he is pictured here wearing GRAVY designs. He says, 'Music, skating and fashion go hand in hand. Skaters definitely are a worldwide crew. One love. That's it!'

Photographs **Jon Holderer**

➤ culture. Nowhere is this more evident than in 'High Fashion'. Once exclusively synonymous with wealth and status, the clothes shown in the salons of internationally renowned designers existed in a world deliberately set apart from the poor (and the young). From the 1970s onwards, however, 'common' fabrics, such as denim, and plebeian garments, such as black leather motorcycle jackets, were paraded with reversed ostentation and inverted snobbery on the most exclusive of catwalks.

Such upmarket emulation, coupled with incessant media attention, has undermined the original intentions of both 'dressing down' and 'tribalism'. Denim jeans, for example, once a potent link with the common man, could no longer sustain such symbolism when they were tarted up and sold with a big price tag by the likes of Gloria Vanderbilt and Gianni Versace. Likewise, Adidas trainers and hooded track suits could no longer serve as a marker of subcultural identity for the B-Boys of the South Bronx once they had become the standard attire of advertising executives and middle-class white kids hanging out in suburban shopping malls.

In the end, rather like Western tourists in pursuit of traditional cultures in Asia, Africa or South America, we have undermined and driven to near extinction the very authenticity that we so desperately sought – the cowboy (the original working-class hero) reduced to an ad for cigarettes, or a Ralph Lauren mannequin; the Biker's 'Perfecto' black leather ➤

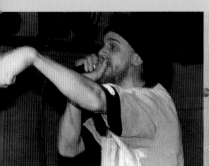

➤ jacket (the original marker of the subcultural outsider) reduced to a fashion accessory.

Yet, on the surface at least, dressing down and tribal style – together with the social revolutions that brought them into existence – seem an ever more central and all-pervasive feature of life at the tail-end of the twentieth century. Workwear is ubiquitous, while showy, formal 'dressing up' seems almost as suspect as it was in Paris in the aftermath of the French Revolution. New styletribes appear to spring up like mushrooms – Techno, Cyberpunks, Riot Grryls, Zippies – while old subcultures – Hippies, Punks, Mods, Goths and Ravers – are revived and – mingling with the new kids on the block – transformed, fused or narrowcast into ever more specialized microtribes. Even the middle-aged and the middle class have gone 'tribal' – our homes and our lifestyles categorizing us as 'Mediterranean Rustics', 'Traditionals', 'Sixties Retros', 'Cosy Countries', 'Neo-Classicists' or 'Post-Moderns'.

Indeed, 'tribal' has become one of the buzz words of the mid-1990s. Festivals like Glastonbury in the UK and Lollapalooza in the USA are increasingly described as a 'gathering of the tribes' (by, it should be said, pundits such as myself). Picking up on this usage, one of the largest and most successful outdoor rave-type events of 1995 actually billed itself as 'UK Tribal Gathering' – seeking a 'reunification of the scattered tribes of dance'. And as I write, Channel 4 TV in Britain has launched a huge series under the banner 'TribeTime' – a handy umbrella which includes within it everything from Biker gangs in Denmark to VW enthusiasts in Britain, Generation Xers in California and Clubbers in Ibiza.

Apparently, we are now all 'tribalists'... or are we? When I was researching my book *Streetstyle* and the exhibition of the same name, which was staged at the Victoria & Albert Museum in London, I found that the nearer I came to the present day the harder it ➤

a curiosity for all things **fantastic**

Catherine Defoe

currently works in a top West End (London) music venue and night club, but is hoping to expand into something a bit more creative.

'Basically my style comes from a curiosity for all things fantastic. If it's distinctive, I like it... there are no rules to expression.'

'It's not fashion that matters – constantly struggling to keep up with the latest trends. Fashion can be fun, but it's really style that counts. As long as you can wear something straight off the peg and your own unique personality shines through, then that's style. It's not what you wear, but who you are.'

'I can usually get my clothes and jewelry on discount from some great friends, who run shops like 'SH...' and 'BOY' and to whom I'm eternally grateful.'

'I find the idea of Modern Primitives, or any subcultural tribes, rather romantic in theory, but I wouldn't necessarily label myself as such. Like any "gang", it can become a uniform, too confining. The moment it stops being fun, or you cease to learn from it, then it's time to move on. Don't be fool enough to get stuck in a rut!'

Favourite clubs: 'I don't really have any favourites – I just go where the party is.'

Do you expect your look to have changed radically by the year 2000?

'I'd like to think I'd be radically cool and way ahead of my time, but I really can't see any drastic changes in the next four years – but then again...'

Photograph **David Turner**

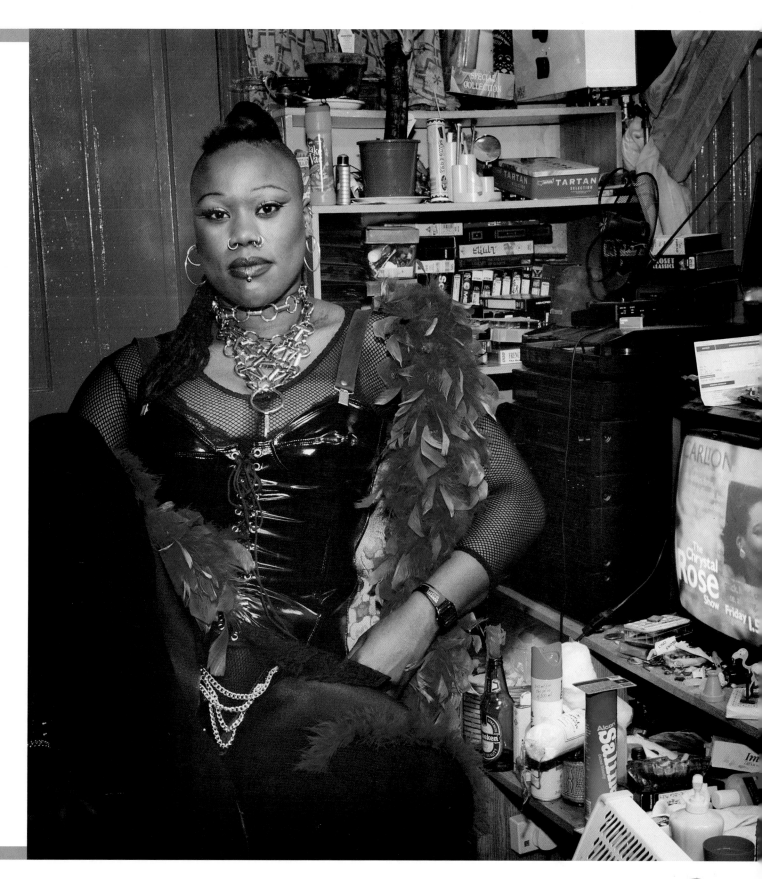

➤ was to find people who would agree, 'I'm a Raver', 'I'm a Techno', 'I'm a Cyberpunk' , 'I'm an Indie Kid', 'I'm a Riot Grrrl' – or any of the other contemporary 'tribes' that so fascinate the media. People were 'into' this or that (usually some increasingly obscure – at least to me – musical form), but were unprepared to acknowledge actual, sign-on-the-dotted-line, all-encompassing membership.

Yet when 'stylewars' occurred (for example, the much reported – no doubt media-inflated – street fights of the Punks and the Teddy Boys), everyone clearly knew which side they were on. I'm sure the same was true in 1964 when the Mods and Rockers had their famous clashes on the beaches of Britain's seaside resorts. No one was halfway between being a Mod and a Rocker – all taking part in the festivities would, I'm sure, have readily told the world which group they belonged to (and gone on to tell how the opposition was crap). Perhaps it is simply that no one today is quite sure which side they're on because – in the ecumenical spirit of tribal 'gathering' and fusion – no one is taking sides.

Whatever the reason, ever since the word 'tribal' came into common usage (around the time of Punk's international lift-off), things have gotten progressively less tribal in any true sense of the term. Various *styles* proliferate at a rate that is increasingly difficult to keep up with – Techno, Hardcore, House, Garage, Jungle, Ragga, Handbag, etc., etc., etc. – but few, if any, of these carry with them the sense of belonging and commitment that must constitute the bottom line of true tribal identity. No Jungle fanatic goes out and gets a tattoo to mark his or her devotion to this musical movement (while many a Punk or a Teddy Boy did just that).

A Masai or a Maori *is* a Masai or a Maori – they're not *into* it. Likewise in Britain in 1964, you *were* a Mod or a Rocker – you didn't tentatively, whimsically stick your toe in the subcultural pool to check out ➤

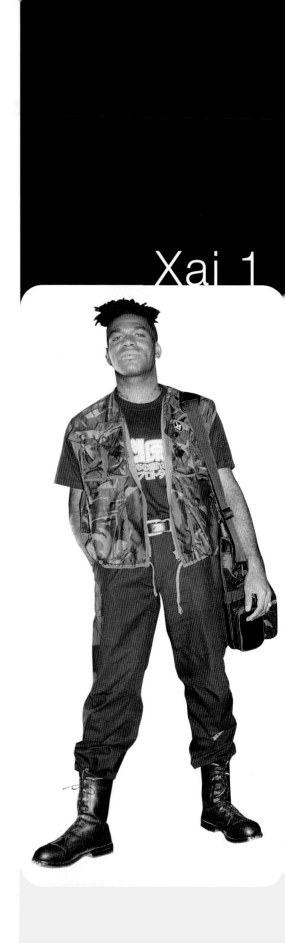

Xai 1

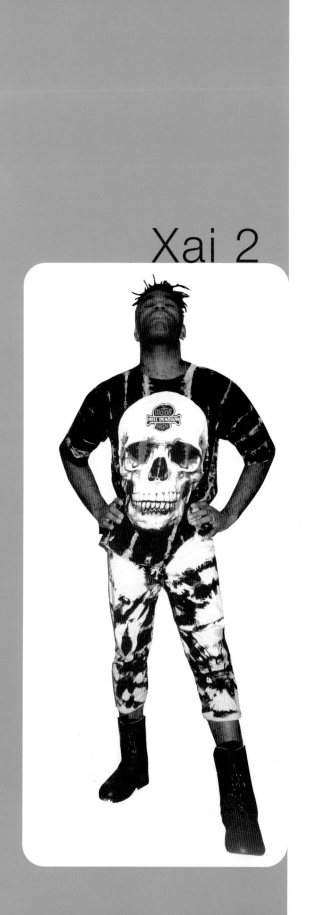

Xai 2

the temperature. You plunged right in, head first.

And so, an irony. In this 'Tribal Age' it's actually damn hard to find anyone who admits to being a member of a tribe. And it's also damn hard to find any labels which do more than simply identify categories of music or appearance style: there is Techno, but I have yet to find a group of people willing to call themselves Technos, there is Jungle but a dearth of Jungleists, there is Industrial but no Industrialists.

Let me tell you about my friend Xai. He's Black, British, 25 and I met him in the local supermarket. He wears (sometimes) a grey suit jacket, a 'jungle forest/army camouflage pattern' sarong and 'Boogia Boots', and has lip, ear and nose piercings and a 'Punky/Dread' style hairdo. His grandparents came from Jamaica, his great-great-grandparents from Africa – but his cultural identity looks more to European Techno culture than to his Black roots. He's 'into Industrial or Post-Industrial – including Techno-music' – and for the last year has been trying to get funding for a magazine (to be called *Electrified & Twitching*) to explore the lifestyle which goes with this music, as well as the way that 'technology is making it possible to assimilate different genres to form a melting pot of different styles'.

Is Xai an Industrial/Post-Industrial Techno? 'No, man, I don't want to put myself into a bracket.' Why not? 'Because everyone wants to do their own thing these days… categories are too limiting. I am who I am.'

It is, in other words, far easier to fit Xai within the Post-Modern possibilities and categorical looseness of *Blade Runner* than it is to cram him within the Pre-Modern, tribal collective bracketing of *The Wild One*. And he's not alone. ✦

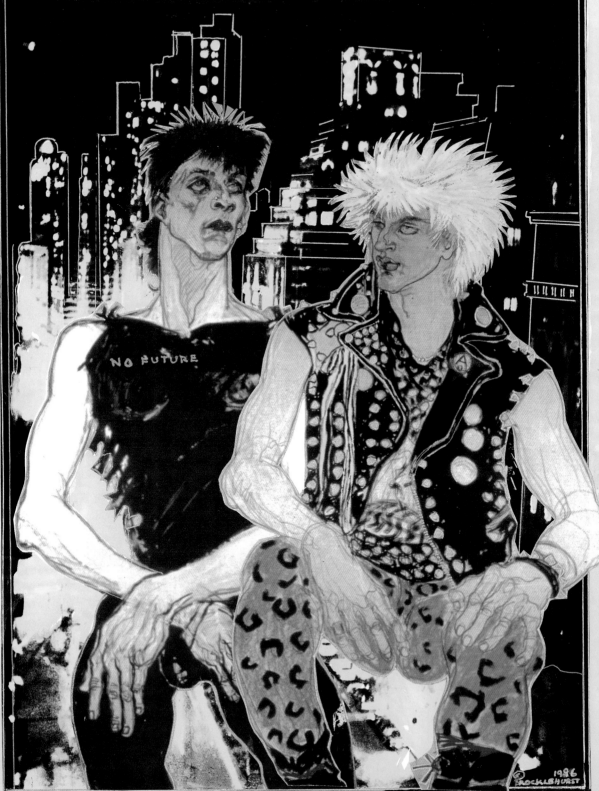

no future

left: 'Iggy & Tony - London Punks beamed up on 72nd Street, NYC'. Photo collage drawing **Joe Brocklehurst**

below: Pop 'Punk' revival, 1993 - mohair tops designed by Joie, Union Jack trousers by Jimmy Jumble for Sign of the Times. Photograph **Jeremy Deller**

'It's only a phase… a fad… fashion.'

This is the parents' fervent hope. But their Beat/Biker/Hippy/Glam/Punk offspring's hope is just as fervent and precisely the opposite: that their 'tribe' will endure – its style, values and philosophy timeless, permanent, 'forever'. (One reason why permanent body arts like tattooing have had such powerful subcultural appeal.)

Indeed, a great many styletribes have endured the test of time – a remarkable feat within the broader context of an ever-changing world. Forty years on, there are still Beats and Bikers (neither their influence nor their charisma diminished). In London, The Edwardian Drape Society (T.E.D.S.) brings together 50- and 18-year-old Teddy Boys to carry on the tradition. Mod revivals are a hardy perennial from London to Tokyo. Hippies may now be more commonly known as 'Travellers' or 'Freaks' but the Age of Aquarius still shines on the horizon. Surfers continue to wait patiently for the perfect wave and the Goths, like Dracula, show no sign of giving up the ghost.

Yet in another sense, far from being outside time, all subcultures are born of and consumed by history – each arriving right on cue in the appropriate era, each relegated to yesterday's news when the spotlight moves on, each interweaving in a 'generational' lineage. From the jazz Hipsters sprang the Beats and, in a sense, the Bikers. (At the time that *The Wild One* came out, it was seen as a 'Hipster' film, with some validity since the jazz world had the original patent on nonconformity.) Subsequently, the Hippies evolved from the Beats. Their relationship with the Bikers was always problematic ('Peace & Love' was not always a key Biker value) and yet the separate strands did begin to weave back together, first in 1964 in the contacts between Ken Kesey's Merry Pranksters and the Hell's Angels and then in the influential pairing of Peter ➤

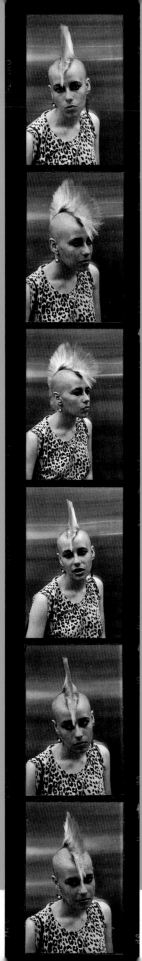

➤ Fonda and Dennis Hooper in *Easy Rider* (1969). When this scruffy, long-haired, dope-smoking all-purpose nonconformist mutant fusion became too entrenched (practically mainstream) it triggered another generation into putting a new, anti-Hippy spin on the Hipsters' jiving nonconformity. And Punk was born.

I'm tempted to add 'Etc.', but Post-Punk the linear sequence, instead of evolving on into The Next Big Thing, explodes into galaxies of alternative 'alternative' possibilities which spin off in every conceivable direction. New Romantics, Futurists (Romantic Glam), Oi! (Punk + Skinhead), Goths, Football Casuals, Psychobillies (Punk + Rockabilly), Travellers (Hippy + Punk), Pervs (a continuation of Punk fetishism), Modern Primitives (an extension of Punk experimentation with 'tribal' body decorations) and assorted Rappers (from 'Old School' to 'Militant' to 'AfroCentric') being only a few of the better-known options that sprang up in the wake of Punk. And at the same time, a plethora of different, pre-existing subcultures – Mods, Teddy Boys, Rockabillies, Skinheads, Glam Rockers, Psychedelics, Rhinestone Cowboys, Traditional Westerners, Headbangers, Rude Boys (now in the form of 'Two-Tone') and so forth – experienced energetic revivals. Like a tree trunk that suddenly divides and subdivides into a tangle of branches, the linear history of subcultures suddenly splintered into a confusing jumble of simultaneous possibilities.

To put it another way… the aftermath of Punk saw a transition from the more or less orderly linear history of Modernism (a 'history' perceived of as such) to the simultaneity of parallel universes (multiple channels on a TV set waiting to be 'surfed') that characterizes the Post-Modern Age. While up to and including Punk a 'story' unfolds, Post-Punk it becomes harder and harder to discern an intelligible dramatic 'narrative'. While previously the options ➤

> were limited, the choices simple (Hipster/Square, Mod/Rocker, Hippy/Punk), now – Post-Punk – a veritable Supermarket of Style came into being, with 'tribal' options lined up like tins of soup on a supermarket shelf. History had ended. Now everything was possible. And all at the same time.

Why should Punk have had such a dramatic effect – bringing down the system rather than simply becoming yet another link in the chain of subcultural history?

Most obviously, because Punk was such a hard act to follow. Stylistically, what could be more extreme and (to the mainstream) more alarming then the sight of towering green mohicans, ripped, sleazy fishnets, pervy rubber or PVC, safety pins thrust through cheeks, dog collars, steel-capped 16-eyelet DMs and infantile 'bum flaps'? Ideologically, what could have cut more deeply into the thin-skinned sensibilities of 'normal society' than the Punks' battle cries of 'No Future', 'We Are All Prostitutes', combined with 'Pretty Vacant', 'Up Yours', bored, cynical disdain?

Just as the Surrealists might be seen as rendering all subsequent developments in modern art an irrelevant afterthought (Duchamp's exhibited urinal mocking the entire notion of 'art'), so the Punks' creativity, international scope, extremism and sheer vividness cast a shadow from which no subsequent styletribe or 'youthcult' could quite emerge. Imagine that you are the teenage son or daughter of one of the original Punks: how can you possibly out-rebel your parents? How can you possibly be more shocking than Sid Vicious or Siouxsie Sioux were in 1976?

And Punk's power was further magnified by the way and the extent to which the media came to deal with it. Although initially caught out by Punk (unsure how to categorize it, dismissive of its significance), the international media soon realized the selling ➤

opposite page, below and page 56: Punks on the King's Road, London, 1980.
Photographs **Ted Polhemus**

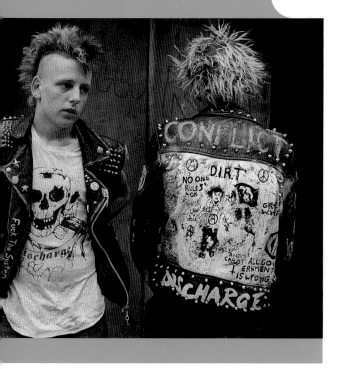

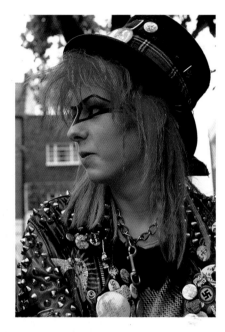

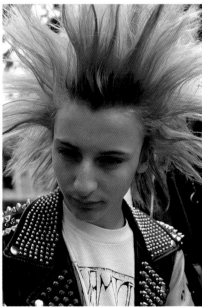

➤ power of Punk's outrageousness. When mohicans, Punk dancing and Johnny Rotten's manic leer became old hat, an entire media industry set out to spot the next 'youthcult' – eventually creating subcultural mountains out of all sorts of idiosyncratic, exhibitionistic molehills. (By the early 1980s the London *Evening Standard* newspaper was actually running a 'Cult of the Week' feature, complete with identifying cartoon.)

Such intense scrutiny and simplistic stereotyping had their own effect – undermining the very authenticity and sense of belonging that had been the original impetus of subcultural identity. (Consider the way in which the New Romantics, in theory The Next Big Thing after Punk, were more a hyped-up media event – arguably, even a pure media creation – than a true subcultural force.) In short, the media attention which Punk generated – but which spread far beyond it – both tipped the odds against genuine street credibility and triggered an explosion of Post-Punk multiple-choice 'cults' that fractured any existing subcultural narrative.

But Punk's Samson-like power in toppling the edifice of subcultural history stemmed from its own intrinsic characteristics, as well as the media circus that followed in its wake. Despite the stereotype (mohican, safety-pins, plastic rubbish bags, DMs, etc.), Punk was never a single stylistic entity. As with the 'Learn-Three-Chords-And-Start-A-Band' approach of its musicians, its stylistic approach was founded on principles of individualistic DIY innovation. Such deliberate amateurishness spawned a rich eclecticism – embracing anything from old school blazers to dog collars, charity-shop peculiarities of previous decades to children's plastic sunglasses, army surplus vests to Amazonian face-painting, discarded bits of consumer packaging to customized motorcycle jackets.

And all this, more often than not, got jumbled ➤

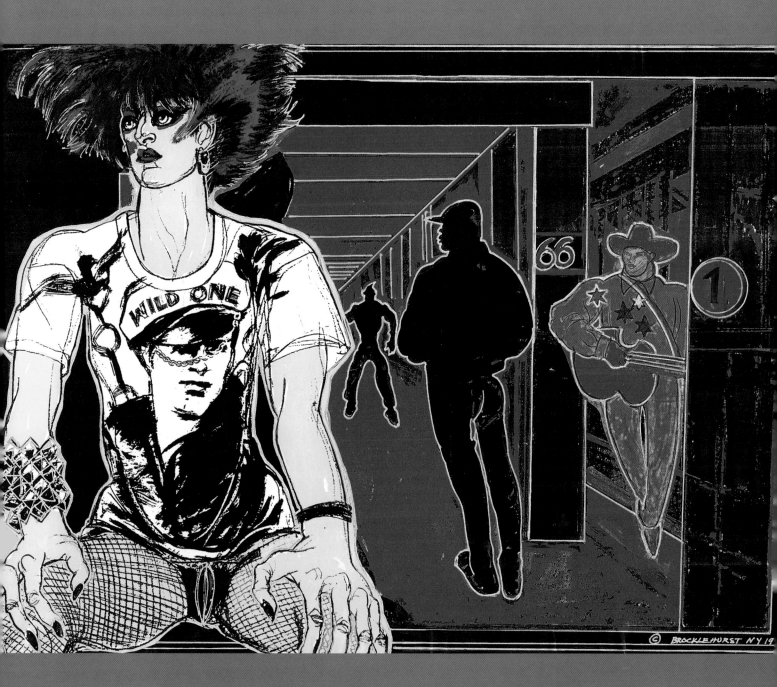

'Angie Serenaded by Singing
Cowboy', 66th Street Subway,
NYC. Photo collage drawing
Joe Brocklehurst

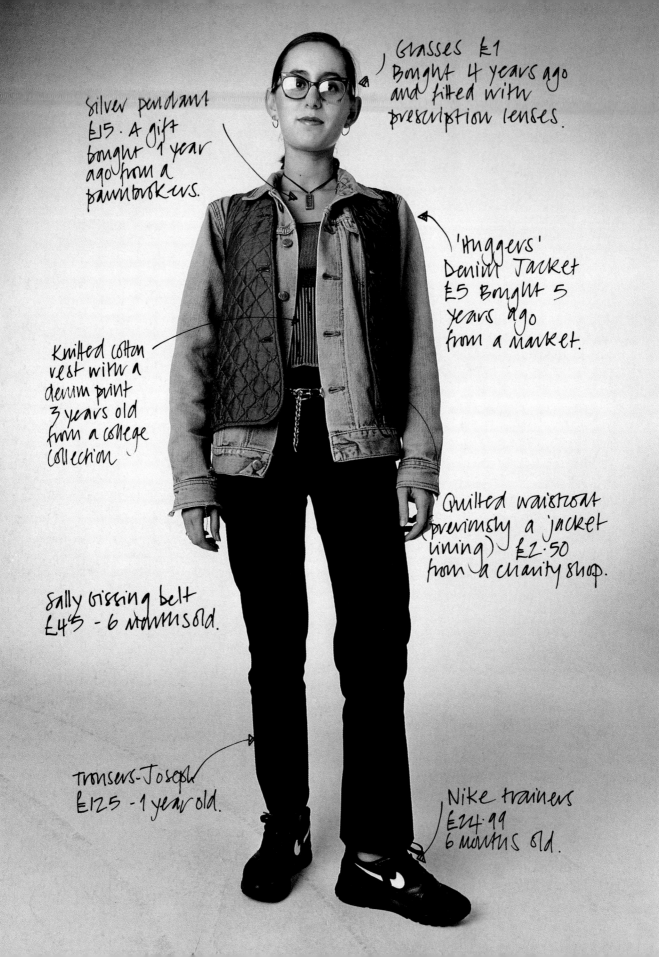

Glasses £1
Bought 4 years ago
and fitted with
prescription lenses.

Silver pendant
£15. A gift
bought 1 year
ago from a
pawnbrokers.

'Huggers'
Denim Jacket
£5 Bought 5
years ago
from a market.

Knitted cotton
vest with a
denim print
3 years old
from a college
collection.

Quilted waistcoat
(previously a jacket
lining) £2.50
from a charity shop.

Sally Gissing belt
£45 - 6 months old.

Trousers-Joseph
£125 - 1 year old.

Nike trainers
£24.99
6 months old.

mix 'n' match

Spanish by birth, **Susana Vázquez Listón** has lived most of her life in England – studying fashion design in Newcastle and working currently as a designer for John Richmond.

'I've experimented with dress and my appearance since I was a teenager. Some people find a single style or subculture through which to express themselves – Mods, Punks and so forth. I've never really belonged to any particular group. Mix 'n' match best describes me – taking the elements I like from many different areas. Neither am I a fashion victim. My tastes have always been too varied for that, my look always too much a reflection of my personality, which I would never describe as outrageous.'

'My clothes come from many different sources: designer shops, markets, high-street stores, charity/second-hand shops. I try to bridge high fashion and streetstyle.'

'As a designer my aim is to create a "total look" based around a central concept or theme and aimed towards a particular market. Yet I'm aware, of course, that today's consumers are more likely to buy individual garments than a complete outfit – like me in my own personal style, mixing and matching this with all sorts of things. It's important, therefore, that each piece in a collection can stand up in its own right. For most people today fashion is a paradox. The problem is how to dress in a way that shows you're aware of the latest trends, while expressing yourself in a unique, individual way.'

Photograph **Steve Lazarides**
Sketches **Susana Vázquez Listón**

together. The French use the word *bricolage* to describe a way of making something new from assorted – found, at hand – bits and pieces; it is a very apt way of describing the Punks' approach to dress (and, indeed, to music, politics, philosophy). The objective was/is to mix together the most diverse, unexpected, absurd and downright contradictory combination of styles. Scavenging from 'primitive' tribal peoples, clandestine fetishists, a host of other styletribes (Bikers, Skinheads, Glam Rockers, Teddy Boys), 50s kitsch, 40s glamour, tacky sci-fi movies, military uniforms, etc., etc., etc., the Punks assembled for themselves individualized, unique looks that defied classification. Punk, in other words, was – from the start – such a rich ragbag of alternatives and contradictions that no coherent Next Big Thing could possibly have evolved from its eclectic diversity.

Ironically, therefore, while Punk carried the subcultural ethos of tribalism to its visual, logical and literal conclusion, at the same time it stomped on, gobbed on and generally stuck up two fingers to the very spirit of conformity that is the cornerstone of tribal identity. It is, in other words, Punk that makes the leap from *The Wild One* to *Blade Runner* (or, from *West Side Story* to *The Rocky Horror Show*) – replacing subcultural order with 'Anarchy in the ➤

'Avoid categorization. Subvert. Break taboos. Remember you have to destroy to create…

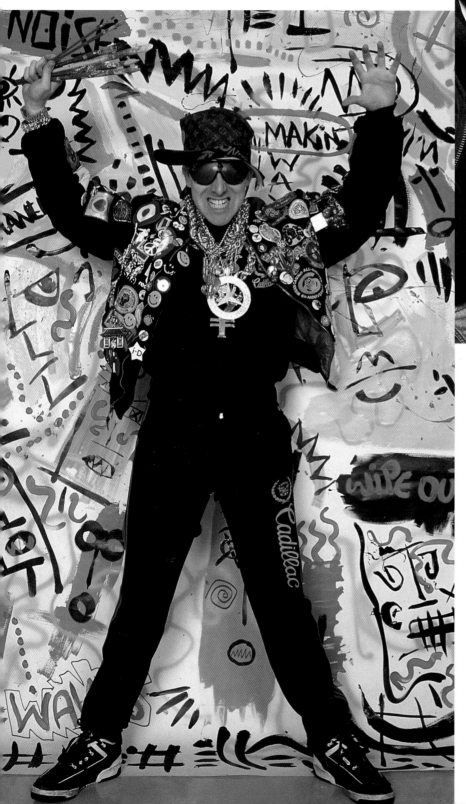

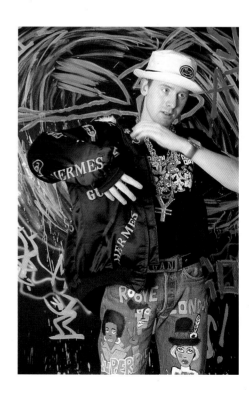

... Love, Peace, Anarchy and Soul to everyone in the worldwide underground'

Mark Wigan

'1977 – Manchester Art College during the Punk explosion: I kept to my "anachronistic" Soul Boy style, preferring allnighters to gigs, though visits to the Russell Club and the Electric Circus proved that something big was happening. Made up a scrapbook on PUNK sketching the details of the Punk styles. The whole of youth rebellion had become assembled in the Punk look and during the early 80s the fancy-dress parade began. I plundered second-hand shops and jumble sales for 40s 50s and 60s suits. Creating my own hybrids from Mod, Rockabilly, Skinhead, Clockwork Orange Droog to 1940s Spiv.'

'Soul Boys, Bowie and Roxy fans, Punks and art students came together to produce the "trendy" London club scene and by 1983 we're in the thick of it. I contribute drawings documenting the "scene" for i-D Magazine, host parties, put on exhibitions and produce T-shirts. The warehouse scene mixes Soul, Funk, Hip Hop, Jazz and Swing. The places to be are the DIRTBOX, the WAREHOUSE, the MUD and the WAG. By 1986, with artist Yuval, I'm painting murals at London's and New York's Limelight clubs. Hip Hop and sportswear are a big influence and I create my own URBANITE hybrid style by customizing black MA1 bomber jackets and picking up B-Boy clothes in New York. In 1987 Rare Groove and 70s style hit the clubs. And then came ACEEEED. Old Punks, Hippies, Indie fans, Goths, football Casuals – everyone comes together. The warehouse scene goes massive. 1989 – as an antidote to huge Sunrise-type raves we set up the BRAIN, a small club in Soho. A chance to have different music each night of the week.

Everyone was "havin' it" in Ibiza. We took them to Iceland. You have to do the unexpected in Clubland! Next we're off to set up a second front in Style Surfers' Paradise, Tokyo.'

'The 90s – with Sean McLusky I produce (possibly) the most influential club of its time, LOVE RANCH. Live, raunchy Punk and Glam bands on-stage, while 800 go mad to progressive house. We switch from Westwood, Richmond, Duffer of St George, white Levis, leather jeans, frilly shirts, 1969 Regency, 1974 casual, almost on a weekly basis. At MERRY ENGLAND club we get kitted out as Cavaliers from the English Civil War. 1995-6 I'm playing with a 1950s art teacher, 1920s Surrealist, 1968 Paris Rioter Hybrid.'
© Mark Wigan 1996

Kerry Baldry

Experimental filmmaker Kerry Baldry produces short films using an old Fuji Single Eight camera. Her work has appeared on BBC2's *The Late Show* and has been screened at numerous art galleries and film festivals around the world.

At present Kerry is reading Timothy Leary's *Chaos and Cyber Culture*, *Mavericks of the Mind: conversations for the new millennium* by Brown/Novick and *The Cult of Information* by Theodore Roszak.

Kerry gets her clothes from 'No Such Soul', 'Hyper Hyper', 'The Big Apple', Vivienne Westwood, Agnes B and 'Red Or Dead'. She listens to Serge Gainsbourg, Roy Orbison and Pulp. She drinks at the Coach & Horses and the Freedom Bar in Soho.

Photographs **Mark Wigan**
Drawings by Mark Wigan appear on pages 3, 6, 94, 136–7.

From i-D magazine

TOP SECRET FILE
i-D OPERATIVE: WIGANOVSKI
MASTER OF DISGUISE,
ALL-ROUND ATHLETE
PROFESSIONAL TERRORIST
AND FASHION SPY.
EXPERT IN TRIBAL DANCES
AND CUSTOMS.
EYES BLUE, HAIR RED

KONSPIRATSIA SPY FILE

WIGAN NORTHWICH

THE NORTHERN SOUL / OPERATION M.U.F.C HOOLIGAN AFFAIR

DIDSBURY SPRINGBANK

OPERATION JESUS OPERATION MOHICAN

PARIS TOWER HILL

ART TERRORISM THE BIZZARE ARTY CULTS EXPOSE

KILBURN SOUTHWARK

SET SWINDLE THE SOUL 'N' GOGO MASSACRE

LOCATION CRITERION BRASSERIE
SOUNTRACK POGO PUNK
(KONSPIRATSIA INC.)

➤ UK' (and far, far beyond).

In a broader and all-pervasive context, it was also Punk that (at least in terms of popular culture) emphatically put the sign of the 'Post' before the 'Modern': its chilling battle cry of 'No Future' heralded the end of history – the dead end of the yellow brick road of 'progress' and coherent 'narrative', which previously had been discernible only to (then) obscure cultural theorists. Trashing history (e.g., the juxtaposition of ancient 'primitive' body decoration, classic 1950s Biker jackets and tacky sci-fi futurism) and meaning (e.g., the iconography of Nazi swastikas, bondage gear and school blazers reduced to visual play), the Punks ushered in the Post-Modern condition – where there is 'no reality beyond appearances' (Neville Wakefield), where 'spectacle' (Guy Debord) and 'simulation' (Jean Baudrillard) is everything and where history explodes into 'sheer heterogeneity, random difference, a coexistence of a host of distinct forces whose effectivity is undecidable' (Frederic Jameson).

But instead of wringing their hands and despairing of this state of affairs, the Punks decided to celebrate it. (Which marks the key difference between the Post-Modern theorists and the Punks – and, as we shall see, their illegitimate offspring, the Clubbers.) In precise and deliberate contradiction of the back-to-nature, get-real Hippies, they converted everything they touched into plastic – both in the sense of the artificial and in the sense of the infinitely malleable – thereby creating a Post-Modern world in which anything may be transmuted into everything and nothing is what it appears. (And they cast their jaundiced eyes over the plastic world they had created and saw that it was good – or, at least, amusing.)

In 1976, Andrew Logan and Derek Jarman held a party in their ramshackle (and then unfashionable) ➤

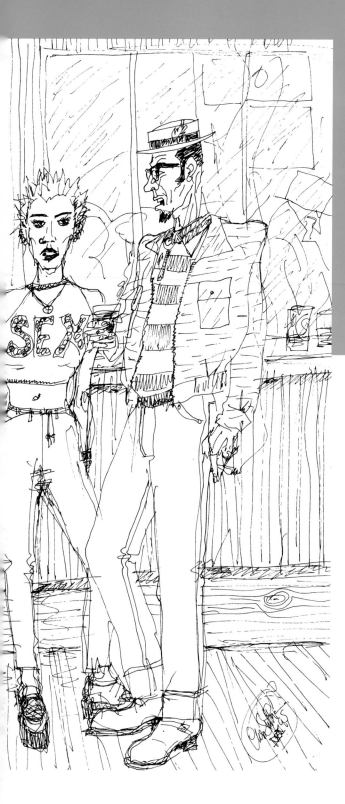

➤ warehouse overlooking the Thames near Tower
Bridge. The Sex Pistols came and gave their first
ever public performance. Energized by these
associations, Jarman enlisted the assistance of the
likes of Jordan (of Malcolm McClaren's and Vivienne
Westwood's shop SEX), Adam Ant and Toyah Willcox
to create his film *Jubilee*.

Started before Punks were even much known as
Punks, this extraordinary film defies the stereotyped
conformity that the media subsequently strove to
impose upon the budding subculture. Here is Amyl
Nitrite (Jordan), with her face criss-crossed with
black lines in the style of Picasso, hair spiked up to
defy gravity and yet wearing twin-set and pearls.
Here is Mad Medusa (Toyah Willcox) in a pink plastic
boilersuit adorned with a fifteenth-century lace ruff,
her hair dyed orange but cropped like a marine. Here
is Crabs (Little Nell) in diamante tiara, old school tie
and not much else. Here is Queen Elizabeth I (Jenny
Runacre) in jewelled, lace-embroidered splendour,
surfing history to pick her way through the rubble.

Here also, graffitied on a wall behind an opening
scene where flames and thick smoke billow from a
baby's pram, is the word 'POST MODERN'. Quite
rightly. Eclecticism, the end of history and of narrative
– losing the plot – confounding any distinction
between past, present and future, the collapse of all
meaning except the wall-to-wall pastiche,
fragmentation and what Neville Wakefield has so
poignantly termed 'The Twilight of the Real'… it's ➤

a 'bargain bin kind of girl', sampling and mixing in New York City

A producer with VH1 cable TV, **Mary Wharton** is one of NYC's most dedicated and prominent Clubbers – her current favourite clubs, Twilo, The Tunnel and Bar D'O.

'My hobby is shopping! It's not easy being trendy in NYC, so if you want to keep up (or start your own trend) you've got to be vigilant. I mostly shop at thrift stores and sample sales. Partly because I'm a bargain bin kind of girl, but also because you can find things at a thrift store that nobody else has. You can develop your own sense of style by taking a bunch of things that were not meant to be worn together and putting together a fabulous ensemble – for example, a designer item like a blue vinyl Anna Sui top with a $15 plastic skirt from a knock off store in the Rag District.'

'I love all sorts of music – jazz, blues, rock & roll, Hip Hop, Trip Hop, Acid House, Techno – from all eras – but I listen to House Music the most.'

'I don't think I'm trying to make a statement with my style. I just like to run with all aspects of life and I think that dressing in certain ways can be a lot of fun. When you know that you look good, you feel good. I like to be positive in myself and that shows in my style.'

Photographs **Jon Holderer**

➤ all there in Jubilee. And, of course, in Punk's vision of the next/last millennium.

A Post-Punk-Mortem: 'No Future'… on the surface, so negative, so terminal, so bleak. Yet we can also hear in the Punks' infamous battle cry a triumphant note of liberation.

In the 1950s, the 1960s (arguably in all of Western culture since the Renaissance), the present – the potentiality of Now – was always eclipsed by the chimera of an omnipresent, ever brighter Future. Modernism denied the reality and the possibility of the here and now by insisting that the grass would always be greener over the next hill. Interestingly, the Hippies (despite their explicit rejection of the modern, consumer world) also shared this addiction to futurism in the form of the Age of Aquarius, which so invitingly glowed with promise just over the horizon.

Our reading of Punks' 'No Future', now as then, simplistically focuses on images of endless dole-queues and *Mad Max*-style Armageddon. But 'No Future' can (and could always) be equally read as 'No Futurism' – a stepping out from the inhibiting shadow cast by the glare of a brighter tomorrow that both Modernism and the Age of Aquarius imposed. In this, as in its creative bricolage, its rich eclecticism, its determined fragmentation of consensus, its spirited deconstruction of hackneyed images and ideological platitudes, Punk – for better as well as for worse – paved the way for the next millennium.

In the two previous chapters I have sought to emphasize the distinction between, on the one hand, fashion as an expression of Modernism's celebration of constant change and perpetual novelty and, on the other, tribal style as an expression of a return to an ethos of traditional values and group solidarity. Uniquely, Punk managed to undermine both of these opposing forces – injecting a third option: for at the moment we all became Post-Punks (and we did), we simultaneously became Post-Moderns. ◆

Nostalgia mode

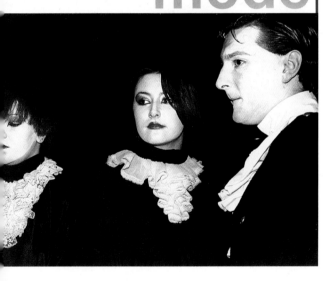

opposite: New Romantic Retros
at 'A Style for the 80s' evening at
a London club, December 1979.
Photograph **Ted Polhemus**

'At some point in the 1980s, history took a turn in the opposite direction... and things began to run in reverse.' Jean Baudrillard, *The Illusion of the End*

Baudrillard was only off by one year. In London in 1979, a few British Post-Punks took over a Soho night club – 'Billy's' – on Tuesdays for what they called 'Bowie Night'. This was a revolutionary event in at least two ways. Firstly, it initiated a long (still continuing) history of 'one-nighter' clubs in venues which, on other nights of the week, carried on catering to *au pair* girls and disco-dancing guys with gold chains. More importantly for our present purposes, 'Bowie Night' marked the 'Reversal of History' that Baudrillard and a host of others would strive to identify for years to come. (And no, in pin-pointing this great event to youth/pop culture, I'm not being facetious. The days when history – or even its reversal – was made by politicians or by events in High Culture was surely long gone by 1979.)

Attending 'Bowie Night' were young people who had been through Glam in the early 1970s, had then plunged headlong into the whirlwind of Punk in 1976 but who, tiring of this, decided that the next move should be in reverse: back to Bowie and the glamour which Punk (now typically indulging in a ragged scruffiness that one day would be known as Grunge) had by and large turned its back on. (A contributor to this volume, Mark Wigan, has pointed out that a club in Manchester called 'Pips' had set aside one section for the playing of classic Bowie and Roxy Music back in 1978. While historically interesting – and yet another reminder of the way the north of England is so often unfairly neglected in comparison to London – the point I am making here is one of eventual effect rather than initial discovery.)

An immediate success, 'Bowie Night' soon had to move to larger premises. Still on a Tuesday night, it was now located in a club in Covent Garden that was – appropriate to this new retro spirit ➤

➤ – decorated in the style of Britain in the Second World War and known as 'The Blitz'; and those who flocked to this club (for lack of a more imaginative name) became known as 'Blitz Kids'.

Without realizing the irony, many of those who had been there at the Soho club Gossips in the beginning favoured the tag 'Futurists' – ignoring the fact that a revival (even of something which had once been forward-looking and ground-breaking) can hardly qualify as futuristic. At any rate, the name that eventually stuck was New Romantics – broad enough to embrace even this orgy of eclecticism, signalling a sharp break with the Punks, focusing on imaginative, impractical, flamboyant escapism and, in the direction of that escapism, predominantly looking back rather than forward. A perfect label, in other words, for the Post-Modern Age that the New Romantics heralded.

By the end of 1979 the New Romantics were well established in London club life and, beyond, in the music industry. On the final club night of that year the dress code of the invitation prescribed 'A Style For the 80s'. A few of us mistakenly interpreted this as futuristic PVC space suits and got it completely wrong. Those in the know – those seeing the Post-Modern writing on the wall – came dressed in all manner of antiquated attire. There were elegant ballgowns from the 1940s, tango-style gigolos from the 1920s, a dapper Count Dracula from nineteenth-century Transylvania, pre-Revolutionary French aristocrats and (the couple who won a bottle of champagne for their efforts) a pair in authentic Elizabethan dress.

From her corner on the King's Road, Vivienne Westwood – shifting full tilt out of her original Punk vision and now calling her shop 'Seditionaries' – came up with her famous 'Pirate' look. Dashing, outside the law, rooted in a time long gone, stylistically adventurous and prone to wearing ➤

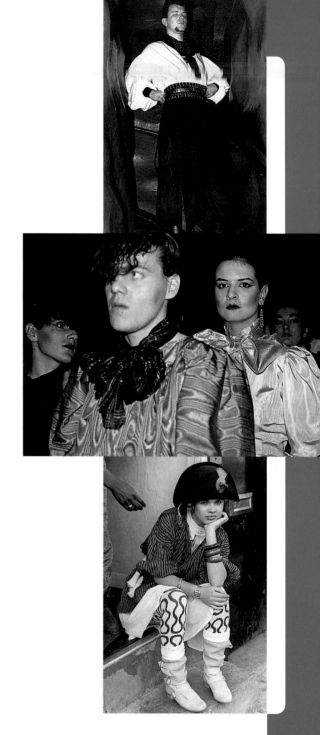

previous page and above, centre: New Romantics at 'The People's Palace', London, 1980.

top: 'El Gaucho de las Pampas' – Chris Sullivan hosting his 'St Moritz' club, 1980. See pages 72–3.

bottom: A 'Pirate' outside Vivienne Westwood's shop, 'Seditionaries' on the King's Road, 1980.

Photographs **Ted Polhemus**

➤ shirts with enormous sleeves, this mythological pirate was the perfect New Romantic. Playing the part to perfection – a pirate straight out of Disneyland or central casting – Adam Ant became the first truly Post-Modern pop star (George O'Dowd and his 'Culture Club' being just a bit too sincere and genuine for this title.)

While the New Romantics would remain for some time the undisputed masters of the Post-Modern quality of pastiche and deliberate inauthenticity, they were only one of many 'cults' that in the early 1980s brought Post-Modernist nostalgia firmly within the sphere of popular culture. Of particular importance in this regard were the British Rockabillies. A small group of ex-Teddy Boys in the late 1970s, these dedicated revivalists of original American Rockabilly music and style (think of early Elvis, Jerry Lee Lewis or Carl Perkins) found themselves in the1980s engulfed in an epidemic of nostalgia focused, not on their own country's history, but rather on a mythologized America of the 1950s – symbolized by Levi 501s, customized cars, classic ads for Coca-Cola, bowling shirts and gaudy jukeboxes. Meanwhile, another cult – the Swing jazz revivalists – saw their penchant for formal sartorial elegance adopted by the likes of Bryan Ferry.

From yet another subcultural angle (one which grooved especially well with the Reagan/Thatcher swing to the right), the 'Preppies' (and in the UK, the 'Sloane Rangers' and 'Young Fogies') affected a style reminiscent of 'old money' in a time of *nouveaux riches*. Initially only one half of the ever-growing army of 1980s 'Yuppies' (the other stylistic option being that of the 'Less Is More', matt-black Minimalists), the Preppies, Sloanes and other 'Young Fogies' had triumphed over the opposition by the end of the decade. Modernism (even if now essentially a revival movement itself, inviting everyone back to the Bauhaus) simply couldn't resist the ➤

'200 years of peace and prosperity in Switzerland created the cuckoo clock. 200 years of pestilence and plague created the Renaissance in Italy. I was brought up in Switzerland, but I'm 100% Italian.'

Marcella Martinelli

'I started experimenting with clothes at the age of 13. The nuns at my convent school regularly sent me to the chapel to ask for forgiveness. In my late teens I studied at the London College of Fashion – discovering Gothic style.'

'Dressing down was a real effort, but I tried especially when visiting relatives in Switzerland – yet, despite this, I would get stopped at customs and asked all kinds of strange questions. (Like why was I so pale and why did I wear black!)'

'As the years passed, my corsets, tight skirts and high-heeled pointy boots, long black-blue hair became more psychedelic. Then rock 'n' roll. Finally, more casual. I now love wearing sharply designed suits, but I also like baggy pants and skinny T-shirts.'

Photograph **Daniel Faoro**

Time warp

One of Britain's great, unsung institutions, Kensington Market has been a warren of tiny shops and stalls since the 1960s. Offering a cheap, affordable way for young designers to sell their work, it has seen most waves of international streetstyle and clubwear come and go. And come again. For, increasingly, the atmosphere and the clothes on offer are firmly rooted in nostalgia mode – ironically, in many instances, a flashback to precisely the same styles available in Kensington Market back in the 1960s and 1970s.

For example, 'Americana' (right) sells original Funk clothes from the USA. 'Rock a Cha' (opposite page, bottom) specializes in the kind of flamboyant men's suits associated with the early days of the Rockabilly movement. At 'The Jewel in the Lotus' (opposite page, centre) you can get the sort of Hippy/Psychedelic gear that first made Kensington Market a must for would-be street-credible British, European and American youth when it first opened. There's also still plenty of those American Indian (opposite page, top), Gothic, Rocker, Country & Western looks which can't even be counted as revivals because – at least in the more obscure corners of this timewarped supermarket of style – they never went away.

Like Portobello Road and Camden Markets, Kensington Market continues to offer tangible proof of London's extraordinary capacity to preserve and give new vitality to all the world's streetstyles of the past fifty years.

Photographs **Ted Polhemus**

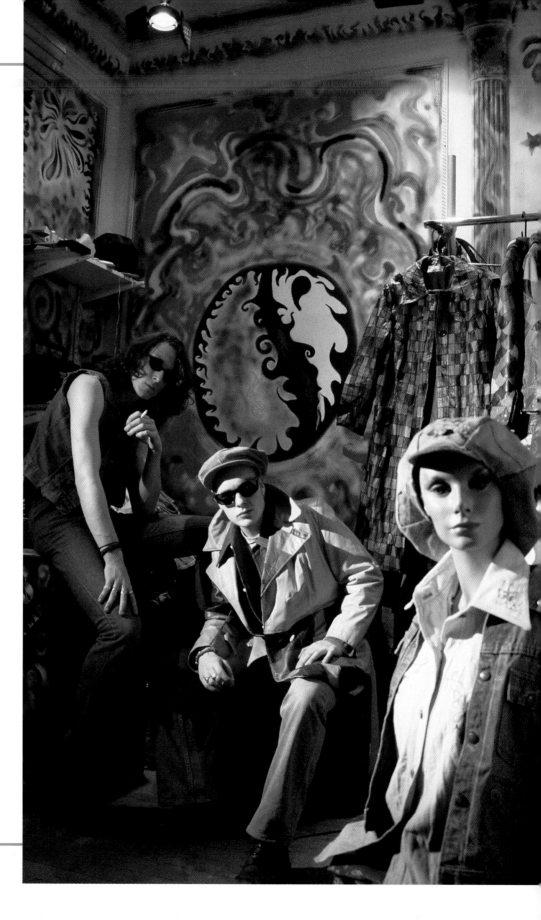

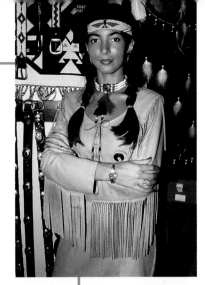

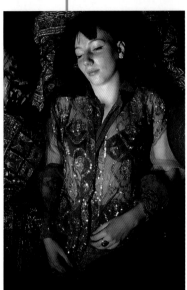

➤ compelling force of the retro *Zeitgeist*. From this point on, the only real battle was that between straight retroism and Post-Modern possibility: the former undisguised historicism, the latter striving to remix the past to come up with a 'new' result. And it is this choice which remains with us.

People have always looked back. What is unique about the New Romantics and their heirs is the fact that here were *young* people lurking in the shadow of history – specifically, the history of youth culture itself. Back in the 1950s and the 1960s, as everyone knows, if those who were young looked back, it was only in anger, with a curled lip of disdain. Yesterday was the time of one's parents – the time when everyone was uptight and inhibited. Tomorrow we would show them a brave new world. Post-Punk, however, with everything done that could be done, with rebellion jaded and limp, with George Melly's *Revolt Into Style* complete, with only the 'No Future' future beckoning, the only way forward for youth was into reverse.

By the late 1980s it was clear that youth culture would never again reach an escape velocity to propel it beyond the gravitational force field of previous youth cultures. Aside from the reasons that have already been mentioned, the demographics were stacked against such a possibility. My generation, the baby-boomers – by sheer dint of numbers – had the whole of their culture (regardless of age) eating out of their hand. If you wanted to sell anything (records, cars, ice cream, banking services) you had to aim at the largest target audience, and they were the newly invented 'teenagers'.

In the 1980s the Baby Boomers were still the largest demographic blip, but now they had entered middle age – so 'Adult-Oriented Rock' and all the other leftovers of a bygone age prevailed. And they did so by virtue of the same economic logic that had only a few decades previously occasioned the ➤

➤ 'youthification' of Western society. Just as the Baby Boomers had once forced their culture (including those older then themselves) to look forward into the future, now – in the naturally reminiscent mood of those who are past it – they forced everyone (including those younger than themselves) to look back whimsically, nostalgically on a mythologized Golden Age.

Young people, increasingly an insignificant statistical minority, simply didn't count for much. 'The Teenager' was still an enormously important part of contemporary culture but now this icon of rebelliousness had become a historical figure – Brando in *The Wild One*, James Dean in *Rebel Without a Cause*, Peter Fonda or Denis Hooper in *Easy Rider*. As Peter York commented in an article in *The Face* in 1982: 'It's over now, the age of teen, and no one wants to admit it… Everyone's done it, ask your dad' (June 1982, no. 26, p.11).

Punk was the last, brave spasm of youth's dying energy and when it was over Western culture slumped back into its traditional middle-aged easy chair and switched on the telly to watch documentaries about how great the 1960s had been. There would still be youth and youth cults, to be sure, but from now on they would be defined by what had gone before.

And how could it be otherwise? While my generation had no discernible history of 'youth' to reflect upon, respond to or recontextualize, today's youth have been suckled on and swaddled within fifty years of youth culture. Whatever today's youth do, they must do it within this historical context – an all-pervasive, wall-to-wall edifice of everything from Bikers to Punks, *Beach Blanket Bingo* to *The Great Rock & Roll Swindle*, the Beatles to Becky Bondage, *The Avengers* to *The Young Ones*, James Dean to Sid Vicious. Add to this the impotence of their demographics and dwindling spending power and ➤

a man for all reasons
Chris Sullivan –
director of the Wag Club (which is located in the heart of London's Soho), a radio presenter for GLR (Greater London Radio), a fashion designer/stylist, a DJ, a musician and song-writer, a writer/ journalist, a video promo director/film maker and an artist (many of his drawings appear in this book), Chris Sullivan needs a wide range of styles to suit each of his different occupations and moods.

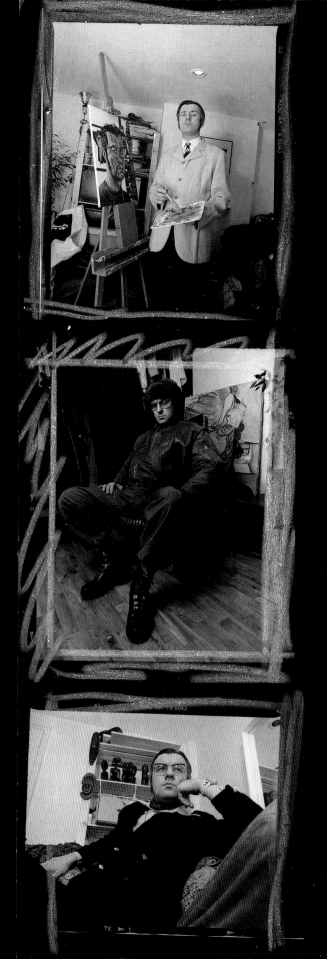

Since coming to London (from Wales) he has been one of Britain's most influential trendsetters and club organizers.

'My first foray into the sphere of personal style was my adoption, in 1972, of the original Skinhead-Suedehead (almost Preppy) style of Two Tone mohair, 4 button, 14" single vented suit, button-down Ben Sherman shirt and wingtip shoes. This gave me a taste for the suit and the effect it created which has stayed with me ever since. Having been lucky enough to have experienced my adolescence in the 70s, I was able to indulge myself in the 34" wide, high-waisted "bags" (trousers) of the Northern Soul movement and in the 40s and 50s revivals of the mid-70s. Aroused by the sheer perversity of the early "SEX" bondage look, I immersed myself in the early Punk scene until it became a trend invaded by middle-class wannabees. As a reaction, I flirted with the jazz Funk/designer scene. Then in 1978, still appalled by "PunkRock", I founded the "Boy's Weekly Rocker" movement. We all dressed as our favourite "Boy's Weekly" magazine hero – Blackbeard The Pirate, Buffalo Bill, Clark Kent, etc. This developed into a scene in itself and became known (much to our chagrin) as the "New Romantic Movement". Actually there was little romanticism in us – just a collective drive towards being different from the norm, individual. My favourite vibe at the time was the "El Tipico" English gentleman, replete with spats and monocle. In the early 1980s, as a reaction to the preponderance of male make-up and effeminacy in the New Romantics, I pioneered the rebirth of the BIG SUIT – based loosely on the zoot suit – and in the process managed to amass one of the UK's largest collection of hand-painted ties. As a reaction to the big suits, I then moved into the silk/mohair, early 1960s single-buttoned suit. From there I digressed to a New Edwardian style, complete with moustache, beard, frockcoat and

large Disraeli-type bows. My hair grew and by 1988 it was in the form of a braid halfway down my back. This allowed me to move from an Oriental look to English eccentric, from Rasputin to Buffalo Bill with fringe jacket and knee-high moccasins. After I'd exploited every possible expression my long hair, beard and moustache could achieve, I gradually cut it into a bob whereby I could realize my penchant for Medieval/Richard III-inspired outfits. As it got shorter still, I passed through a 1900s vibe, a 20s feel and now, as my hair is cropped, I've gone back to my roots, wearing 4 button tonic jackets, brogues, button downs – my large sideburns also allowing me to carry off an almost 70s vibe with velvet suits, round collar shirts, etc., or a British businessman circa 1960s, with three-piece suit, detachable collar and bowler hat.'

'Basically, I have always been "Style Surfing" – touching the high points of dress over the last century, using, adapting, mixing them up.'

Photographs **Steve Lazarides**

The Cavern

is a shop in London's East End specializing in vintage clothing from the 1960s and 1970s, famous for its colourful front and outdoor mannequins. It opened in 1990 to coincide with the start of 'The Age of Aquarius'.

Deirdra Crowley, co-owner of The Cavern and pictured here in sharp original Mod style, studied fashion and design at college.

'I was always especially drawn to the 60s and 70s. That was a time of very positive energy and I always feel that the energy is reflected in the clothes, which are innovative, imaginative and colourful. Both in my private life and when I'm working in the shop, I always enjoy wearing the clothes from that period.'

Izumi Omori, a Japanese artist, worked at The Cavern until she had a baby and moved down to St Just on the Cornwall coast.

'At the time the photos were taken I was very pregnant but, as per my usual style, very colourful. I would describe my style as a mix of now and late 60s – putting together the different eras but also drawing inspiration from around the world. I buy my clothes from The Cavern, India, Japan and, of course, second-hand shops everywhere. My clothing style and my work as an artist always influence each other – especially in the use of bright colour. I've been a rebel, a Punk, but my style, like my art, is always progressing. By the year 2000 I'm hoping to be at peace both within my art and within my style.'

Photographs **Steve Lazarides**

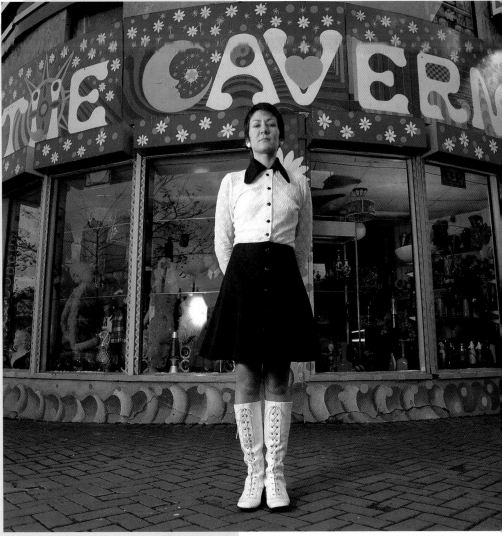

Deidra Crowley

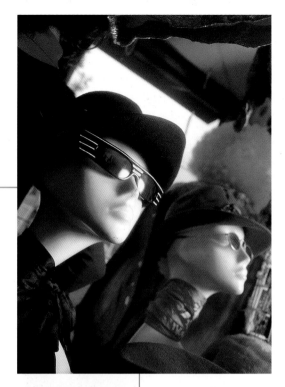

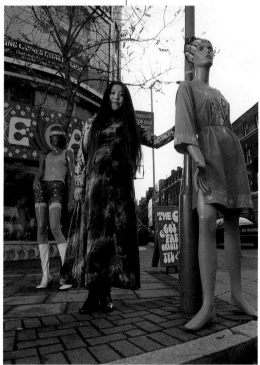

Izumi Omori

➤ you get a formula for a youth unable to define itself in its own terms, unable to express itself except in variations on yesterday's signifiers of 'youth'.

Thus the big news youth cult of the late1980s, the Ravers, would wear 'Smiley' T-shirts, get off on 'Acid' (the drug) or 'Acid House' (the music) and re-celebrate 'The Summer of Love' (originally, 1967) in 1988. Thus Woodstock 2 would, inevitably, be only a faint, media-enhanced echo of Woodstock 1. Thus (to move on slightly in the story of our ahistorical times) Blur would be 'reminiscent of the Beatles'. Thus the Rolling Stones would go on and on and on, playing to kids who weren't even born when they should have retired. Thus half (or more) of current pop music is made up of 'covers', 'samples' or 'remixes' of previous pop music. Thus teenagers would wear clothes that only made sense as an ironic commentary on those of their parents. Thus the Beatles (even if one quarter deceased) would storm the charts with a song originally recorded decades ago. Thus, in short, the present has become a remake of the past. (And thus, needless to say, 'youthful rebellion' becomes a most unlikely event – if not a complete contradiction in terms.)

This process of the snake eating its own tail – this recycling of our culture in general and of youth culture in particular – has begot endless 'revivals' and 'retro' cults. The former are especially prevalent within the world of (sic) 'fashion', where 'The Mods are Back' or 'The Return of Punk' alternates with nostalgic revivals of entire decades in quick succession.

It is in the nature of fashion (arguably it is its 'job') to undermine original meaning – transubstantiating ethnic styles, military uniforms, fetishistic perversity or the visual identity of youthful styletribes into 'just fashion'. Accordingly, Zandra Rhodes' 1977 'Punk Look', with its tasteful rips torn in expensive fabric held together with safety-pins, took Punk imagery ➤

➤ and quite literally tore it apart from its original Punk message. But when Gianni Versace then revived Zandra Rhodes' imitation 'Punk Look' in 1994, a new, truly remarkable level of semiological absence was reached: stripping away historical as well as subcultural meaning. Why revive (fashionalized) 'Punk' in the mid-1990s?

In the same way, fashion has reduced whole decades – The 40s, The 50s, The 60s, The 70s – to a visual shorthand that possesses no historical roots: aesthetic codes bereft of (or, to think positively, set free from) actual, substantive events, decoupled from both time and place. In fashion's version of history, only fashion existed previously. Perhaps this was always so. But what really is remarkable is the extraordinary extent to which fashion today exists and moves 'forward' by recycling itself. Remarkable because, in doing so, it defines itself as anti-fashion – blatantly undermining its intrinsic message of perpetual novelty and progress. By its own rules, yesterday's fashion should be as worthless as yesterday's newspapers. Yet by its own practice, 'The Future' is an edifice built of old, long-discarded bricks.

On a smaller, more cultish scale we encounter the proliferation of Retro groups such as the Neo-Teddy Boys, Neo-Beats, Neo-Mods, Neo-Hippies, Neo-Punks and so forth. Unlike the revivalists of the fashion industry, these born-again youth culturists determinedly, microscopically, pursue the precise recreation of the authentic original – deconstructing the residue of media-based stereotypes to attempt a resurrection of the 'real' style and posturing of the particular subculture that intrigues them.

But however sharp and obsessive their attention to detail, can a 1990s gathering of Teddy Boys, Mods, Dead Heads (fans of the Hippy group, The Grateful Dead) or Psychedelics be truly authentic? How real can you be when you're chronologically ➤

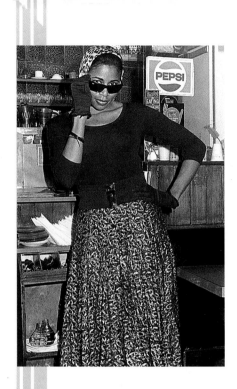

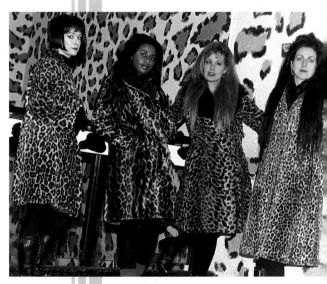

above, left to right: Pandora Gorey, Brenny Lewis, Elsa Rand, Jed Moore.

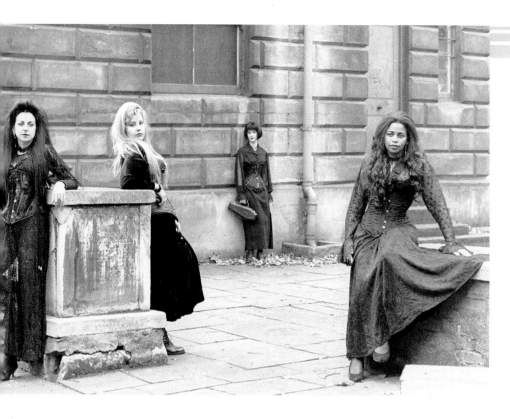

GOTHIC A *GO GO*

Pandora Gorey, Elsa Rand, Jed Moore, Brenny Lewis – four women (two American, two British) who share common obsessions: for Gothic styles, for tracking down rare bargains in second-hand clothing shops, for music groups 'The Damned' and 'The Phantom Chords' and for dressing up and showing off. They met as members of 'The Vampyre Society', but their stylistic interests range much further than the Gothic. Here, for example, we see them in various 'Retro Looks' from the 1940s, 1950s and 1960s. By day working in an office selling insurance (Pandora Gorey), as co-managers of clothing shop 'Twice The Siren' (Elsa Rand and Jed Moore) and as civil servant (Brenny Lewis), like vampy vampires they come out to play – dressed to kill/thrill – at night.

'Any town I'm visiting, if I see a second-hand shop, I'm in there. I aim towards the 50s, but somehow end up more often than not in the 30s – or wavering between the two.' (Jed)

'I don't mind being pigeon-holed as a Goth or Gothic, but it's not quite right – I'm actually into a much broader retro thing, with influences ranging from Louise Brooks, Vivien Leigh in *Gone With the Wind*, Jean Harlow, Marilyn Monroe, or Dorothy in *The Wizard of Oz,* to Morticia Adams.' (Pandora)

'I can't stand the 70s revival look: I went through flares and platforms once and I'm not about to go through it again just because it might be fashionable.' (Brenny)

'I like lots of different eras – the 30s, 40s, 50s – some tacky stuff and some classy stuff. I try to mix it all up. Some of the clothes I wear now I've had since I was a 14-year-old Punk. The old styles never go out of fashion.' (Elsa)

'We're not revivalists – getting into the 50s or whatever just because that's what's in fashion. We take timeless classics, mix and match to adopt them to our needs.' (Pandora)

Photographs **Francesco Cavaliere**

this page and next: New Psychedelics in Kensington Market, London, early 1980s.

➤ out of sync by thirty years or more?

Mini 'Heritage Parks' within a world which (as Baudrillard has pointed out) is rapidly becoming one gigantic theme park, these painstaking attempts at historical exactness (Mods in present-day Tokyo dressed in original British Mod clothing and riding original Mod Lambrettas) vividly pinpoint the semiological fault-lines of 'The Post-Modern Condition'. Like Yul Brynner as the gone-amuck replicant in *Westworld,* or the synthetically cloned dinosaurs of Jurassic Park, these subcultural replicants gun down and trample to death any presumption that our present 'reality' can be written without quotation marks.

As in the case of the two, perfectly recreated Sid Vicious clones who briefly, but tellingly, make an appearance in *Blade Runner*, these subcultural Retros (whether they intend to or not) demonstrate the viability of one of the few remaining forms of subversion: the jerking back of the camera frame to reveal that (as H.G. Wells realized) time travel can have the effect of annihilating the present.

But whatever the dangers, and whether we like it or not, today we're *all* Retros. All subversives of 'Real Time'. All replicants residing in Nostalgia World.

My local pub was built more than a century ago and originally possessed splendid etched-glass frosted windows and brass fittings. In the early 1980s (in a bit of remarkably bad timing) all this was ripped out so that the place could be re-fitted to resemble an American bar, with cool blue neon and potted palms. Suffering from a distinct lack of customers, the pub was once again gutted and refitted in the early 1990s. Now the style is 'fake old' (worm-holed wood surrounds on state-of-the-art refrigeration units for imported bottled lagers) and the name has been changed from 'The Railway' to 'The Rat and Parrot'. The other pub on my street, 'Arkwright's Wheel', was actually a Chinese ➤

new psychedelics

Following in the wake of the New Romantics, the early 1980s in London saw an explosion of exotic style cults – mostly revivals of street/club looks from previous eras. Bright and vivid, fun-loving and sexy, the New Psychedelics had a particularly strong and lasting impact – the looks that they resurrected cropping up through the 1990s in high fashion, as well as in the more adventurous nightclubs.

The original Psychedelics first surfaced on the West Coast of the USA and – more noticeably – on the streets of 'Swinging London' in the second half of the 1960s. Championing a futuristic, unisex look (the males all dazzling peacocks), they bridged (and were inevitably confused with) the Mods on the one hand and the Hippies on the other.

The New Psychedelic revival of the early 1980s came at a time when, as in the mid-1960s, the world's attentions were firmly focused on British youth. The same could be said of the mid-1990s when 'BritPop' once again has international appeal and the result has been a kind of New New Psychedelic revival, with all manner of British youth styles from the 1960s blended together. Although often mislabelled 'Mod', the swirling patterns, hallucinogenic colours and space-aged designs of the Psychedelics have become a key component in the Style Surfer's vocabulary – a symbolic representation of that cocktail of youth, sex and optimism known as 'Swinging London'. Never a subculture in the true sense of the term, simultaneously futuristic and nostalgic, 'Psychedelia' fits comfortably within the Post-Modern wardrobe.

Photographs pages 78, 79 & 80
Ted Polhemus

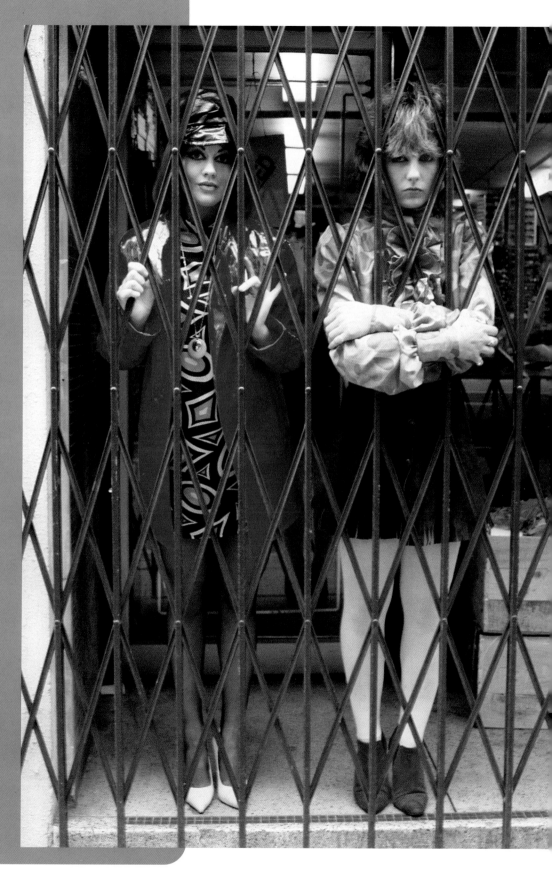

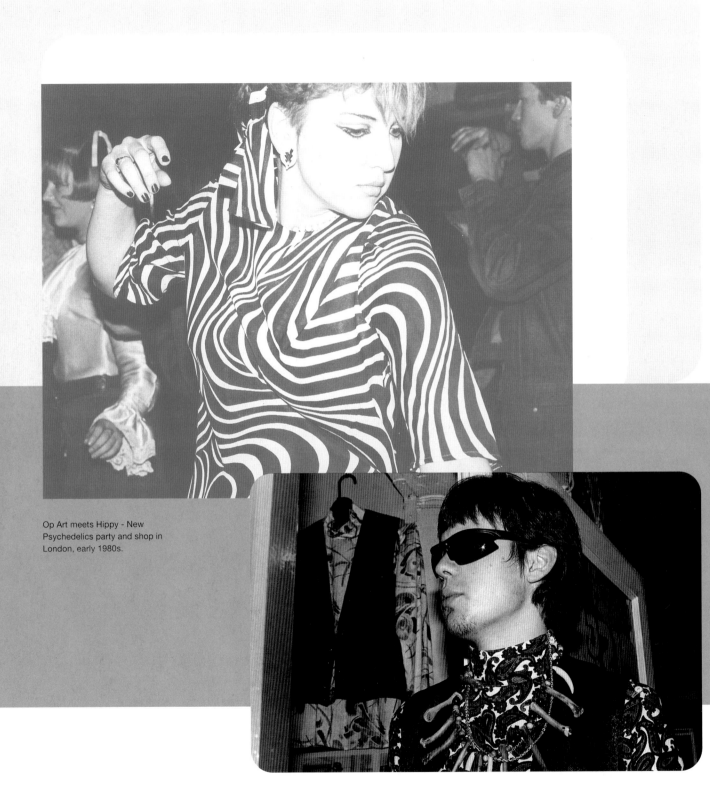

Op Art meets Hippy - New
Psychedelics party and shop in
London, early 1980s.

➤ restaurant until a few years ago. Now it's an 'old' pub complete with antique farming implements and turn-of-the-century photographs covering its walls. The local furniture shop – which once sold matt black and chrome 'High Tech' – now sells antique pine computer tables which are meant to resemble old-fashioned roll-top desks. A new office complex is neo-neo Georgian. My neighbours have an 'Old English' kitchen, a '50s Retro' living room, drive a beautifully reconditioned Volkswagen 'Beetle' and wear original 'Red Tag' Levi jeans from the 1960s which cost more than twenty times that of a new pair of 501s.

Why are we so determined to live in the past?

The answer, of course, is that the present and the future seem to have little to commend them. Harsh realities (economic, ecological, viral, political, social, cultural) bear down on us. Yet at the same time, the current *lack* of reality – 'The Twilight of the Real', to use Neville Wakefield's phrase again – bears down on us even harder. Unable and unwilling to face up to the future, seeking something authentic, we turn back upon a mythologized past. As Baudrillard puts it: 'When the real is no longer what it used to be, nostalgia assumes its full meaning' (*Simulations*).

And its full force. Sitting in 'Arkwright's Wheel', drinking a bitter 'brewed in the traditional way', wearing my 'original' Levi 501s (which are advertised with black and white images from the Wild West), munching crisps which have been prepared 'in much the same way as in a previous era' and watching the Beatles performing on the video jukebox in clothes transported from 'Swinging London', I begin to wonder what time it is.

But such time-travel jet-lag aside, what's really worrying is the way in which the cycles of revival continue to speed up. In 1994 a club in London called The Wag began an '80s Night' which attracts (in ever greater numbers) a range of customers ➤

bullseye²

T-shirt designed by artist Jeremy Deller, 1993.

'The point of the double target was to update the Mod symbol and then sexualize it. I liked the idea of the lineage – W.W.II Spitfire ➤ Mod ➤ 90s Pretty Girl. Three things that I take great interest in!'

Photograph **Jeremy Deller**
Model **Claire**

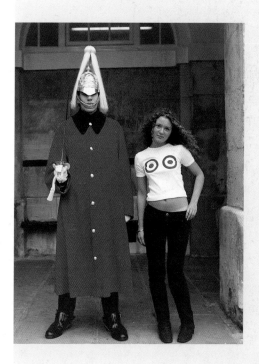

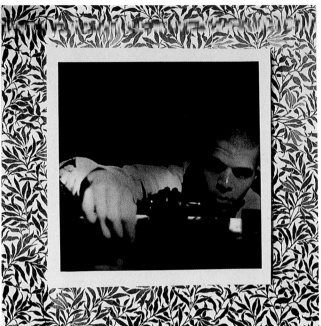

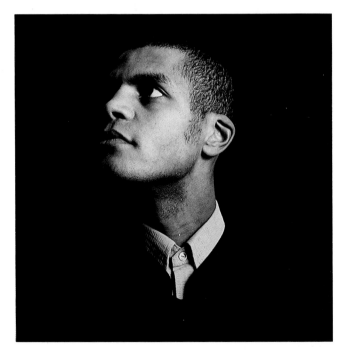

1964➔ There are those who jump on the latest 'revival' bandwagon and there are those who stay true in the groove of a particular 'retro' era that holds an inexplicable fascination for them. **Steve Cato** is in the latter category. It started as a pure Mod thing – the sharp suits, trilbies, scooters and music of the year he was born, 1964. Gradually the look, the music and the attitude got a bit more 'curved' to embrace the psychedelic possibilities which blossomed in the

late 1960s and early 1970s. But this gradual evolution aside, he's found his place in history and means to stick to it. He's not, in other words, a fashion victim. When asked what he thought his style would be like come the 1st of January 2000, he replied: 'The same as the 1st of January 1982. I can't see any change. I saw a friend whom I hadn't seen for 14 years and he thought it was wicked that I looked the same as I did 14 years ago. People say it's "retro" – I say it's in your heart. It's not a fad – it's with you all your life. A lot of people lately have jumped on the 60s or the 70s as a revival style. Why buy copies when you can buy the real thing in second-hand shops? There's a new BritPop wave now, with a retro image – a kind of Mod thing. I've been one since the early 80s. For all these others, it'll be a passing phase. For me it'll never change. I can't change and I refuse to change.'

A popular DJ working late-night bars in the Manchester area, he feels that good music and good style are two sides of the same coin. 'I simply couldn't handle having a job where I had to compromise my style of dress. If I wore other things I'd feel as if I had betrayed myself. In everything in life, it must come from the heart – there must be passion and integrity. The original Mods appreciated this and I guess that's why I've always been drawn to them.'

Photographs and Collage
Kate Owens

➤ from original New Romantic oldies like Steve Strange and Adam Ant to 18-year-old kids dressed in charity shop bargains from this era. In New York City, switching on VH1 cable, I discover that the theme is 'The Big 80s'. Back in Britain, the BBC's big documentary series is 'Peter York's '80s'. This, in 1996.

Will the imminent '90s Revival' ('The Big 90s') have the patience to await the first day of the year 2000? I suspect not. And is the idea of a revival of revivals (essentially, of course, precisely what an '80s Revival' amounts to) really a viable proposition? As 'The Past' becomes an ever more precious commodity, what happens if (like fossil fuels) the supply simply runs dry?

We have become a culture of nostalgia junkies – waiting on Neo-Georgian, gas-lit street corners for an angry fix. We know that fake old is not the real thing, but it is presumably better than any future that we can envision. Let us remember that nothing in *Blade Runner* (save the technology) is post-Post-Punk. Not Deckard's 50s sports jacket. Not his sidekick's 40s Hispanic Pimp Look. Not Rachel's *film noir* glamour. Not Pris's Punkish Space Hooker. And certainly not the architecture – 1920s Shanghai meets decaying Gothic meets traditional Third World bazaar. This is *Blade Runner*'s central point. The future isn't futuristic. Its Retro.

Nostalgia ain't what it used to be. Once simply a personal reminiscence – a subjective stroll down memory lane – now it's a shared, objective past-perfect vision which eclipses both the present and the future.

Or does it? Isn't it possible to use a load of old bricks to construct a brave new, Post-Modern world? In order to answer this and a host of other crucial questions, it's time we got dressed up and went out for some serious Clubbing. ✦

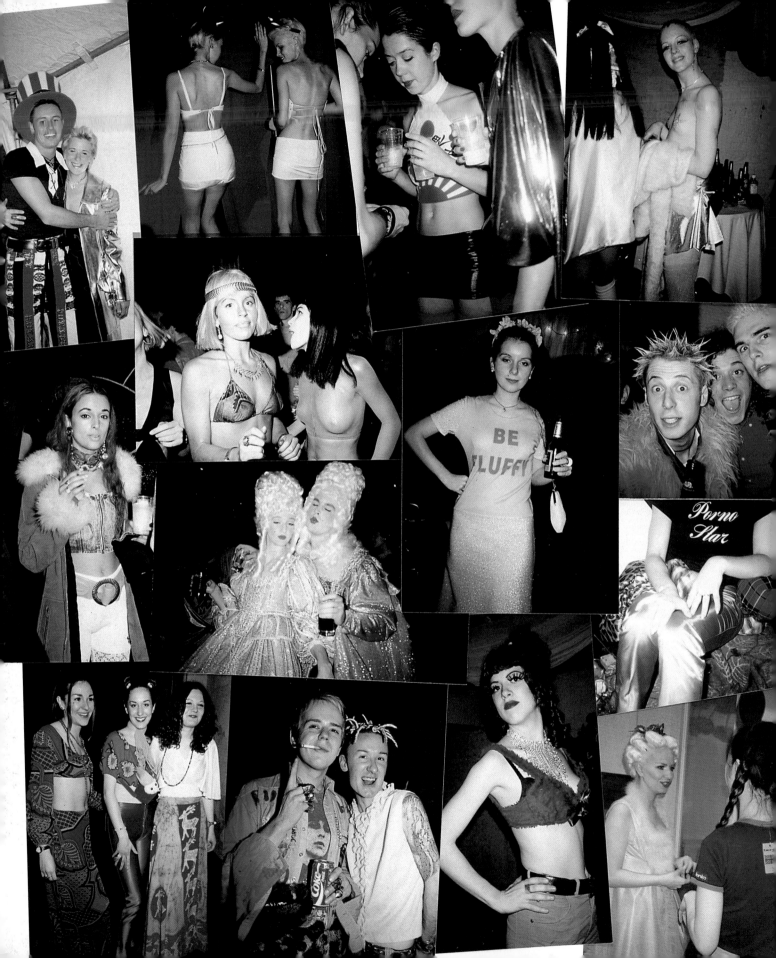

in clubland ➤

On Friday 4 December 1992 the place to be in London (some might argue, anywhere on the planet) was the Sign of the Times *Top of the Pops* party. Fiona Cartledge's clothing shop Sign of the Times has always specialized in exotic 'clubwear' – that is, clothing primarily geared to be worn in the half-private, half-public netherworld of Clubland; so it was logical to create events specifically geared to the styles that the shop featured.

Sign of the Times parties had been going since 1990 – each organized around a theme, ranging from 'Barbi' to 'Calamity Jane', 'Gothic Horror' to 'Treasure Island', 'Fun in Acapulco' to 'West Side Story'. This particular event, named after the BBC TV chart programme *Top of the Pops*, was focused on that programme's golden age, the 70s.

As the flyer put it: *Yes indeed Pop Pickers! We have very definitely caught 70s fever here at Sign of the Times. And so we thought what better way to kick off this Christmas's festivities than with a party in tribute to that golden, glittering decade of wide lapels and platform soles.*

The event was packed out, with some young people dressed in a variety of styles from the 70s: Glam, Left-Over Hippy, The Osmonds, Starsky & Hutch, Funk, The Bay City Rollers, Psychedelics, Punks, etc. The oldest person there by a long shot, I wore the same garments I'd worn when I first came to Britain from the USA in 1970 – patched denim flares, a psychedelic shirt with wide sleeves, an ethnic style headband I'd once knitted myself – together with a pair of canary yellow platforms which I'd bought at Biba in 1973. This is not to say that I was the only person in an 'authentic' outfit – charity shops and parents' attics had clearly been scoured for genuine articles. But, except for a couple of people wearing their own original, late 1970s, Punk gear, I was the only person old enough to have been there the first time around. ➤

above: Fiona Cartledge and friend in the original Kensington Market Sign of the Times shop at the time of the *Top of the Pops* party.
Photograph **Ted Polhemus**

page 84: Revellers at various Sign of the Times parties.
Photographs **Jeremy Deller**

page 85 and above: A selection of Sign of the Times party flyers, including (the round yellow one in the centre, page 85) the invitation to *Top of the Pops*.
Photographs **Ted Polhemus**

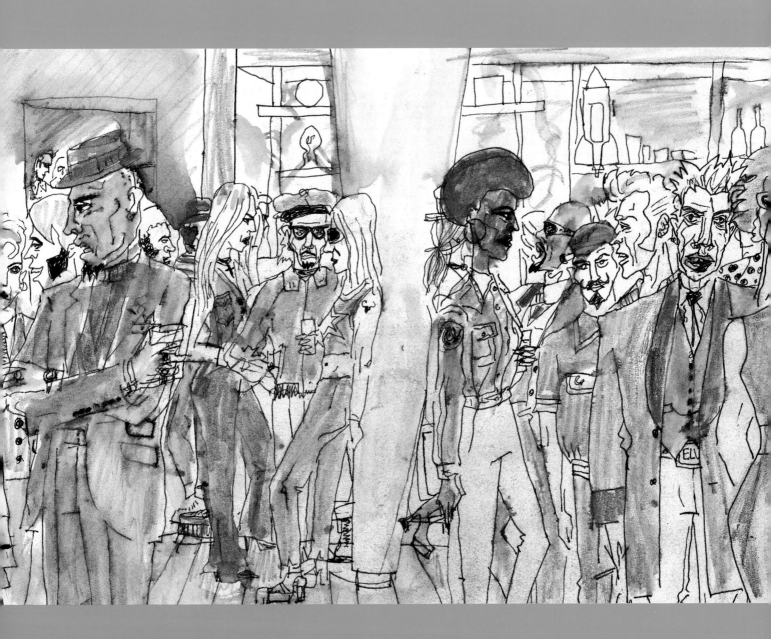

'And I don't care how good his
tailor is supposed to be – the cut
of that jacket wasn't even sad....'
Drawing **Chris Sullivan**

Dress for the Event

above: A selection of invitations for parties organized by Philip Sallon. Photograph **Ted Polhemus**

opposite, above right: A recycled psycho Philip Sallon, circa 1988.
opposite, below left: Philip Sallon with Napoleonic delusions, circa 1994 (outfit designed and hand-painted by Vivienne Westwood). below centre: Viking Vile-King Philip Sallon, circa 1991. below right: Philip Sallon as disturbed housewife, circa 1984.

Clubland – that state of mind where nothing is quite what it seems, where everything exists within quotation marks – has especially evident roots in Britain in the post-Punk explosions of the late 1970s. The list of those who would claim to be the Walt Disney of London's Clubland phenomenon is endless, but one name, that of Philip Sallon, cannot be ignored.

Philip Sallon's clubbing roots go back beyond Punk to the beginning of the 1970s – originally freaking out at Hippy happenings. He passed on to the early 70s Glitter era, then to Gay clubs (like Louise's and Chagueramus), through to the primeval beginnings of Punk, emerging in the full glare of hyperreal illumination as the New Romantics surged in the latter years of the decade. All the while, he defied the glossing stereotypes that the media struggled to impose on each subcultural era.

The shift from club-goer to club-organizer came with a string of bizarre spectaculars. Sallon launched the gigantic Mud Club in London's Soho in 1983. He has 'site surfed' ever since – for instance, running 'The Opera House' at a voluptuous belle époque London theatre, or using an immense film studio that allowed his imagination to run riot in creating sets for his parties.

What makes Sallon such an important figure in the history of Clubland? Firstly, the fact that neither he nor his club nights could ever be blithely categorized. While so many key photographs of the early Punks and New Romantics feature his OTT visage, Sallon never quite fitted within these or other subcultural labels. Secondly, there is his perpetual dalliance with 'straight' popular culture in the themes of his events – always, in Sallon's hands, given that perverse, knowing twist which places it within the overlapping territory of the camp and the Post-Modern. From TV's popular soap opera Coronation

PHILIP SALLON

Street to the Royal family, package holidays to beauty pageants, Blackpool to barmitzvah (Sadam Hussein's, actually), traditional Welsh folk costume to *The Sound of Music*… everything which served as the inspiration for one of Philip Sallon's 'Dress for the Event' parties emerged from the Clubland processor a bit 'off' – a surreal vestige of its former self. Warhol's use of popular art and Dali's dreamlike quality have been combined into something which was both yet neither – a capture of their essence, not their concepts.

Arguably the first true Style Surfer, Philip Sallon has never stayed in one styleworld long enough to let the dust settle on any of his extraordinary finery. Restlessly, impatiently, he is always passing through – cruising.

Drawings **Joe Brocklehurst**

'Philip has always defied classification. Like a lot of other people, I was really just following his lead. (He's the Dr Frankenstein, I'm the monster.) When he would walk into a club dressed in plastic pants and Malteser wrappers, or the wedding dress that he would wear (now here's real sampling & mixing for you) with a policewoman's helmet, everyone would ask, "What did you come as?" And that was the point. You couldn't put a label on it. Now no one wants to be classified – to be a Punk, a New Romantic, a Raver, a Techno. Philip started all this. He's always been a chameleon.' George O'Dowd

➤ At the time I was researching the 'Streetstyle' exhibition. My mission, as I saw it then, was to identify 'subcultures' – to slot everyone into a styletribe – but the evening proved to be a crucial turning point in my quest. What styletribe did those attending this *Top of the Pops* event belong to?

Like Fiona Cartledge herself, many of these people, only a few years before, had been thoroughly immersed in the world of 'Rave'. Its origins lying in the hedonistic clubs of Ibiza and in the 'Balearic Sound' which rapidly spread across Europe, the 'Rave Scene' had taken root in the colder climate of London and Manchester in the second half of the 1980s. 'Smiley' T-shirts, tie-dyed garments and 'Aceeeed!' (as in 'Acid House') had symbolized a nostalgic glancing back to the Hippies and the Psychedelics – unisex clothing styles and free-form dancing also, of course, ultimately indebted to the 1960s. A police clamp-down on illegal 'Raves', coupled with moral panic and misrepresentation in the tabloid newspapers, had generated a political dimension which eventually took the form of 'The Right To Party' movement. Few, if any, had actually called themselves 'Ravers' (a name sullied by negative media usage), but a sense of group commitment persisted for many years and by the late 1980s 'Rave' seemed to embrace most of British youth culture throughout the country.

At the *Top of the Pops* party in 1992, however, I could find no one who now actively identified with the 'Rave Scene'. When I strove to push those I questioned into some sort of classification, the response was inevitably, 'I'm a Clubber'. This was a new label for me – one which would only take on a fuller meaning (going beyond the obvious definition of someone who goes to a lot of night clubs) when I attended subsequent Sign of the Times events such as 'Superheroes' or 'Treasure Island'. (A process, Clubbing cannot be understood simply by ➤

A structural engineer, Brian Marshall has worked on a huge dam project in New Zealand and is now helping to build the new underground extension that will run some 100 feet below London's Parliament Square.

'Toiling away within subterranean confines isn't the easiest way to make a living. Working nights tends to cut you off from the real world. It limits your impression of current styles. You just don't know much about what's going on up there and this limits your own self-expression – something that's important to me. Occasionally, when I have the odd free night or day to myself, I'm out quick as a shot doing my best to catch up with the current trends in Clubland or in the more popular bars. Let's face it. A boiler suit, hard hat and life-saving equipment aren't exactly my idea of fun. Show me a pair of snakeskin pants and a paisley shirt from the 70s and I'm in heaven – albeit for a few hours less than the average guy.'

Motto: 'Don't judge a book by its cover.'

Photographs **Klive-D**

underground > subterranean

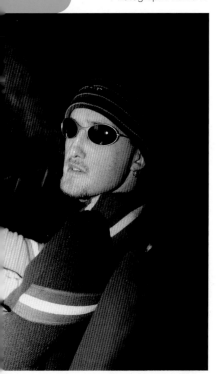

Favourite clubs: Whirly Gig, The Final Frontier, Club UK. Clothing shops: Nigel Hall, Sign of the Times, R.A.P., Duffer of St George. Music: Incognito, Dreamtime, Ultramarine.

➤ observing one point on its trajectory.)

What I eventually realized was that, unlike those who feel and express a consistent commitment to a particular subculture, 'Clubbers' delight in promiscuously 'cruising' through all manner of clothing and musical styleworlds – one month (or, indeed, one evening) plunging headfirst into the 70s (as at *Top of the Pops*), the next going Gothic or Techno or Fetish or New Romantic or Punk or Cowboy/girl or Hawaiian. It is this 'surfing' (as in 'Channel Surfing' or 'Surfing the Internet') that most tellingly identifies 'clubbing' as a post-subcultural phenomenon. And which, in so doing, defines this world and those within it as Post-Modern. Indeed, anyone seeking an index of the Post-Modern condition need look no further than the ever growing, ever more influential world of clubbing.

Clubland knows no time or place. At a Sign of the Times party, we can be in Hong Kong (*Suzy Wong*), the Wild West (*Calamity Jane*) or under the sea (*The Poseidon Adventure*). We can be in the 1950s (*West Side Story*), the 1960s (*Fun in Acapulco*), the 1970s (*Top of the Pops*) – or, in the case of 'Treasure Island', we can time-warp back and forth between the seventeenth-century world of swashbuckling buccaneers and that of 1980s New Romantic 'Pirates'.

This is what Post-Modern theorists term 'synchronicity' – parallel universes all out of 'real time' sync, all existing side by side in a past-present-future which stretches horizontally into infinity. Linear history trashed and irrelevant, everything is simultaneously available and possible – on line. On a given night in the Clubland International Departures Lounge you can take a trip to anyplace or anytime you wish. Pre-Revolutionary Paris? Gate 26. LA in 2016? Gate 18. Swinging London 1965? Gate 22. Haight-Ashbury 1967? Gate 7. The Primordial Rain Forest? Gate 14. The choice is yours. ➤

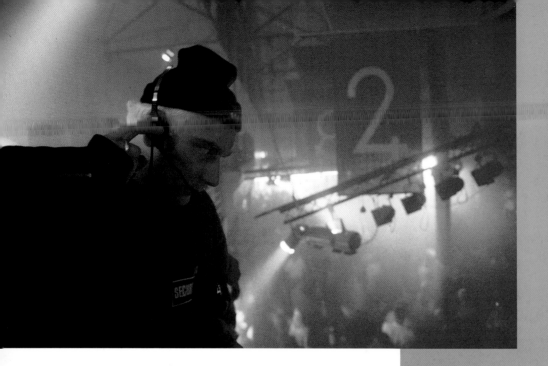

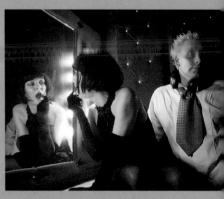

THE HAÇIENDA

A.k.a. 'Lady Bump' and 'Billy Idle', Ang and Billy describe themselves as 'clubbing style gurus'. They work at the Haçienda in Manchester – Ang as manager, promoter and DJ, Billy as DJ, designer and door person. Since 1982 the club has been in the forefront of the vigorous and influential 'Northern' dance scene. As if this were not enough, they also DJ at clubs throughout Britain – for example, at the Aquarium in London and the Warehouse in Leeds. On their nights off, they go out clubbing or relax at home cooking and watching TV in their pyjamas.

'We have been through lots of style changes. Ang might once have considered herself to be a Punk. Now we're just slightly odd.'

Hobbies: Going to the opera in Prague, being devoted wife and husband, respectively.

Heroes: Vivienne Westwood, Quentin Tarantino, John Lydon, Betty Boop, Patsy Stone (of *Absolutely Fabulous*).

Pet Hates: Grunge, Crusties, heavy metal, Country & Western, Beatles, leggings (diabolical garment which should never have been invented).

Fav Music: Tamla Motown and old Soul, house, classical, opera, Punk.

'We're not trying to make a statement with our style, but we'd hate to be ignored! We dress up for each other because no drug can beat seeing desire reflected in each other's eyes.'

Photographs **Simon King**

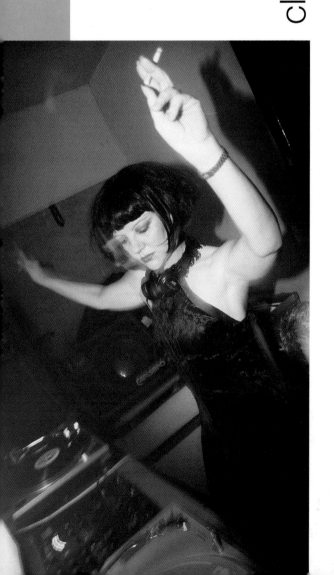

➤ Clubland is a Supermarket of Style where every world and every era you ever dreamed of (and these are, of course, all mythologized places and times) is on offer like tins of soup on a supermarket shelf. You can try 'Cream of the 70s' one night, then switch to 'Chunky Heavy Metal' the next night. Or, alternatively, you can 'sample & mix' your own brand of Gazpacho – throwing, say, a Hippy tie-dyed bandanna, a pair of Skinhead DMs, a 50s leopard-print cocktail dress, a Punk mohican and Swinging London mascara into the pot. Give it a good stir and, presto, you've got your own, synchronic take on fifty years of popular culture.

Clubland thrives on 'plundering' (to use Fiona Cartledge's own, pleasantly honest term) and pastiche. Nothing is what it seems. Everything is effect: Punk Effect, 60s Effect, Gothic Effect, Modern Jazz Effect, Psychedelic Effect, Back To Nature Effect, Smells Like Teen Spirit Effect, Slut Effect, Psycho Killer Effect, Sweet Innocent Effect, Sporty Effect, Caribbean Effect, Tacky Effect, Get Real Effect, Kinky Effect, Primitive Effect, Macho Effect, Babe Effect, Street Fighter Effect, Nerd Effect, Beat Effect and, of course, Ecstasy Effect. But rather than being swept under the semiological carpet, this simulation and artifice is celebrated. (Because in a Post-Modern age only the patently incredible is credible.)

Clubland is a place where the Replicants, rather than living in fear of the (now unemployable) Blade Runners, have come out of the closet to exalt in their artifice. Clubbers may survive on a constant diet of nostalgia, but it is always consumed with the tongue planted firmly in the cheek. This is not, in other words, RetroLand, where people in the 1990s live out their lives as if it was actually 1955, 1965 or 1985. In Clubland, revivals are often just one-night-stands – the kitsch dial turned all the way up to produce a reproduction that is deliberately, ➤

➤ unmistakably identifiable as reproduction.

Everything has a spin on it. A theatrical, ironic twist. A knowing wink. As at any traditional 'Fancy Dress Party', the explicit subtext of appearance is, 'I am not what I appear to be': not really a tart, not really a vicar, not really Count Dracula, not really a 50s Hollywood starlet, not really a Hippy. Clubbing, in other words, is a playful activity – a game where deliberate inauthenticity signals a very 1990s kind of authenticity, a Post-Modern credibility built upon the flaunted insincerity of pastiche.

Clubland is a place inhabited only by semiologists – a place where everyone knows (and makes use of) the precise meaning of Smiley badges, target T-shirts, Punk bondage trousers, a line from a Shangri-Las song, a kinky rubber mask, a pair of false eyelashes, a James Brown dance step. And yet, at the same time, Clubland is a place where all such symbols have been wrenched free of their original meanings – a place where 'meaning has already given way to fascination; a fascination demanded by a discourse of empty surfaces' (Wakefield, p.55).

Clubland is not, however, a meaningless place. Far from it. This discourse of empty surfaces somehow reverberates with signification – a never-ending, always articulate commentary on the meaning of meaning in a Post-Modern, post-subcultural, post-fashion, post-liberated and post-innocent world. The vocabulary of the discourse is composed of all the old, clichéd symbols of the Old World – but after they have been subverted by their positioning in a New World context, with its funky, implausible juxtapositions (pseudo-'Mods' dancing with pseudo-'Rockers', male 'Barbis' with beards) and time-warping, Einsteinian tendencies ('Swinging London' recreated in 1990s Tokyo). When today's Clubbers wear T-shirts decorated with the Smiley Face, a bullseye or the Queen with safety-pin, they are firstly demonstrating their knowingness; but ➤

Drawing **Mark Wigan**

➤ they are also indulging in a commentary not only on the Hippies, the Mods and the Punks, but upon youth/pop/subcultures in general. Their message is clear: we're beyond all that, we're playing with this stuff, we're chameleons... we're Post-Modern.

Clubland is a world of infinite fragmentation and heterogeneity. On a given night in London I can choose between Techno, Ragga, Jungle, Industrial, Hardcore, Handbag, Acid Jazz, Funk, Salsa, Country & Western, Garage, Rap, Post-Mod, New Wave, Brit Pop, Rock 'n' Roll, Disco, Trance, Boogie-Woogie, Swing, Mambo, BeBop and (the latest craze) Easy Listening. On one level these are musical categories but, on another, each carries its own stylistic and even ideological identity. Each is a statement; a personal trajectory surfing through them, a signature.

Increasingly, as such labels themselves fragment into too many sub-divisions to keep track of, Clubbers take their cue from the names of the DJs on offer, from the (increasingly surreal and, to the outsider, inscrutable) names of the clubs or from the visual clues of the flyers which advertise the more underground clubs and which can be picked up at clothing and music shops. Once upon a time a 'listings' magazine like London's *Time Out* (or the equivalent in your city) could realistically attempt to identify and signpost each world, but now such coherent indexing is clearly impossible. Impossible because of the very fluidity that is the essence of Clubland. Parallel worlds cross over, momentarily fuse, then splinter, finally spinning off like some intergalactic probe into oblivion. New scenes spring up and are most vibrant long before the media can pin a label on them.

It's the same in New York, LA, Paris, Tokyo, Berlin, Milan, Barcelona and everywhere else located within the ahistory and ageography of Clubland. As with TV: first there were just a couple of 'terrestrial' channels to choose from. Then cable and satellite brought a ➤

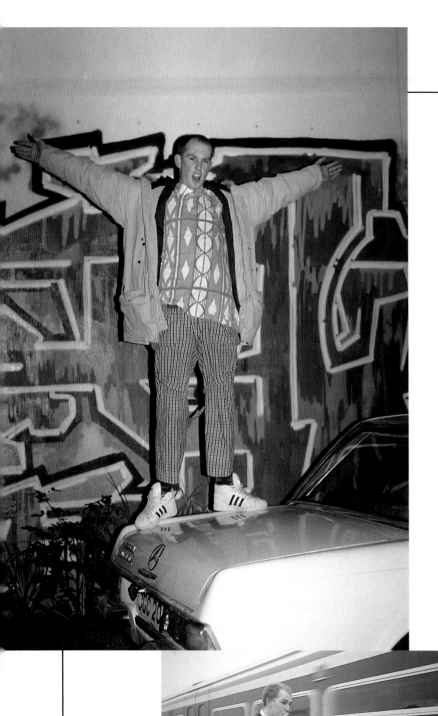

Bank teller,
graffiti artist,
Clubber
extraordinaire,

Ben leads an

interestingly complex life…

'My clothes come from literally anywhere and everywhere. I once found one of my favourite wigs in a bin down Charing Cross Road. The only designer I regularly buy clothes from is Vivienne Westwood. My style receptors are almost sponge-like – absorbing cheeky influences from all angles.'

'My style has no name. It's fun and should always make me laugh. Yes, I've always looked like this. Ahead of fashion, fashionable and, now, out of fashion.'

'My hobby is applying my medium to the rolling still canvas of London's transport systems and perfecting the ancient Eastern Martial Art known as the "Drunken" style. Oh yes, and backgammon.'

'I STRONGLY dislike:Fluffy-doll 15-year-olds with shit hanging out everywhere while on their quest for fake tan, club remixes, pill helldom, "House Anthems" and bad rock 'n' roll.'

'In the year 2000 I hope my bollocks will have dropped so I resemble a South African elephant. So I guess I'll be wearing my Taxi outfit... Taxi outfit? (Yet another of many ruses as I pass through life duckin' an' divin'.)'

'Yes, I'd say my style is slightly anarchistic.'

Photographs **Jeremy Deller**

cornucopia of 'narrowcasting'. But beyond even this is channel surfing – making my own programme by sampling and mixing, passing through, cruising, making a cocktail of *Happy Days*, the news on CNN from Bosnia, a bit of *Absolutely Fabulous*, some old Hammer horror movie, with a twist of 'EuroTrash' and *Prisoner in Cell Block H* thrown in for good measure.

Clubland is where my subjectivity and yours can eye each other up across a crowded room. Where we can grope each other metaphorically all night, yet always practise safe semiotics. Where none of our personal mind and style trips quite connect. (But then who wants that?)

Clubland, despite its best Post-Modern intentions, has a history. Punk clubs where eclecticism and bricolage ruled. New Romantics clubs where pastiche was perfected to a fine art. Raves where the past (e.g., 'The Summer of Love', Smiley badges, Hippies, Psychedelics, Acid, the last holiday in Ibiza) became synchronically merged into an endless ecstatic present. Events like those put on by Sign of the Times, where life became a theme park and where narrowcasting became an ever more microscopically differentiated Mandelbrot Set of worlds within worlds within worlds. The result was that never-gelling fluidity of time, place, style and meaning which is Clubland. (As we will see in the next chapter, a separate but often overlapping history of Clubland can be traced from Gays, Lesbians, transvestites and all those surfing new gender identities.)

Clubland is a state of mind – its eclecticism, fragmentation, surreal juxtapositions and synchronicity simply a particularly explicit, up-front realization of the Post-Modern condition. Many contemporary cultural theorists have seen the theme park, with its hyperreality, inauthenticity and historical dislocation as the perfect model of ➤

➤ Post-Modernity. It is a tempting, delightful and useful metaphor, but it seems to me that Clubland is even more apt. For the latter (aside from the fact that it's actually now a statistically more significant phenomenon) isn't even restrained by the reality of geography. A sweaty, stylish, embodied internet, Clubland takes the Post-Modern characteristics of the theme park and projects them onto a 'place' which isn't actually a place at all – a moving feast which is everywhere and yet nowhere; a 'Where It's At' which can never be located on a map.

For Jean Baudrillard, this world of 'a spinning of strobe lights and gyroscopes streaking the space whose moving pedestal is created by the crowd' signifies the 'complete disappearance of a culture of meaning and aesthetic sensibility' (quoted in Sarah Thornton, *Club Cultures*, p.1). But then J.B. is an Old Testament prophet railing against the semiological Sodom which has enveloped us. Like him, I am a boring old fart yearning for the days when things seemed to be moving in a coherent direction, when things seemed to make sense, when the messages on T-shirts could be decoded in a straightforward way, when you could 'really' dance to a James Brown record. But when I do bring myself to venture into the Post-Modern confusion of something like a Sign of the Times party, I inevitably come to the conclusion that it is these Clubbers, rather than Post-Modern party poopers like Baudrillard, who have got it right. Or, at least, who are being realistic. The world is what it is and there's sweet F.A. we – even Baudrillard – can do about it. If we've all fallen off a cliff, we might as well enjoy the view and the thrill of plunging into the abyss.

Or is it an abyss? Perhaps things are simply different. Perhaps this 'complete disappearance of a culture of meaning and aesthetic sensibility' is just a disappearance of *one's own* era's, *one's own* millennium's fix on semantics and style? I mean, I ➤

Arianna Chieli

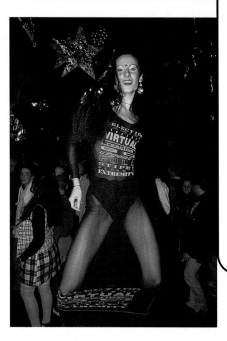

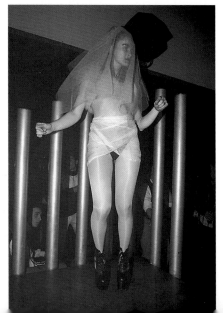

Throughout Italy it is now common practice for night clubs to hire exotically dressed young women (and, less frequently, young men) to provide a visual and erotic focus. These come in two, distinct forms: the 'Ragazze-Immagine', who circulate amongst the clientele, and, on the other hand, the 'Ragazze-Cubo' – the dancing girls who gyrate all evening on special cubes or platforms raised above the audience. The outfits are usually created by the performers themselves. Thus, while the dictates of the conventional fashion industry continue to hold substantial sway over most Italians' appearance – even in the night clubs – these professional exotics inject a much-needed note of stylistic innovation, flair and daring. It is interesting to compare this situation with that in, for example, Great Britain, where Clubbers themselves typically provide all the necessary visual excitement – where a 'door policy' is, in effect, no entry if your appearance isn't sufficiently unconventional. Another interesting contrast is with the 'Body Con' clubs of Tokyo – see pages 26 and 27 – where provocatively dressed girls also dance the night away on raised platforms. Typically, however, while such girls may well be admitted free to the clubs, they are not paid and do what they do for their own exhibitionistic pleasure.

Rimini, a resort city on the Adriatic coast renowned for its countless glitzy night clubs, has a virtual army of 'Ragazze Immagine' and 'Ragazze-Cubo' – a selection of which appear on these pages. One of these women, **Arianna Chieli** (pictured opposite), has worked as a professional club dancer for the last five years. Trained in both classical and jazz dance, Arianna has used her income from club dancing to support herself while studying communication theory at university. (Her thesis, naturally, explores the history of Club Culture in Italy.) She sees the roots of this phenomenon in the kind of dancing developed in Paris at the Folies Bergère and the Moulin Rouge – but with more contemporary stylistic influences coming from films like *Flashdance*, *Fame*, *A Chorus Line* and *Showgirls*.

'In my everyday life I'm a normal girl who dresses in jeans and boots. I adore the burlesque aspect that goes with my work as a club dancer. Transforming myself into a VAMP a couple of times a week is very liberating. **I see myself and all the others in this profession as a sort of holographic projection of how all the regular Clubbers would like to look and feel. Constantly looked at but never touched, we are like phantoms to be dreamt about.**

I'm absolutely free to dress exactly as I choose. I usually make my own costumes. If it's to be a "theme" evening I try to incorporate this in my look. Only a few years ago, few girls were willing to dance for payment, since it was considered a rather sordid activity. Now everyone wants to do it. It's true that being a 'Ragazza-Cubo' isn't exactly what I had in mind when I was studying classical dance, but I do feel that – both in the dance movements and in the outfits I make – my profession is a creative one. By 6 o'clock in the morning I'm destroyed, but happy to have brought to life another night in these unpredictable and decadent 90s.'

Photographs **Stefano Dati**

the RAGAZZE-IMMAGINE and RAGAZZE-CUBO of RIMINI

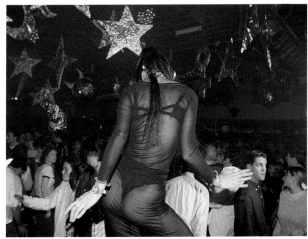
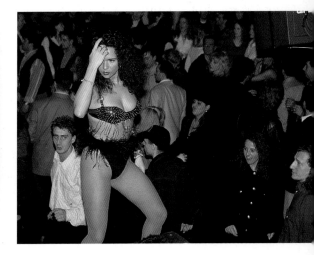

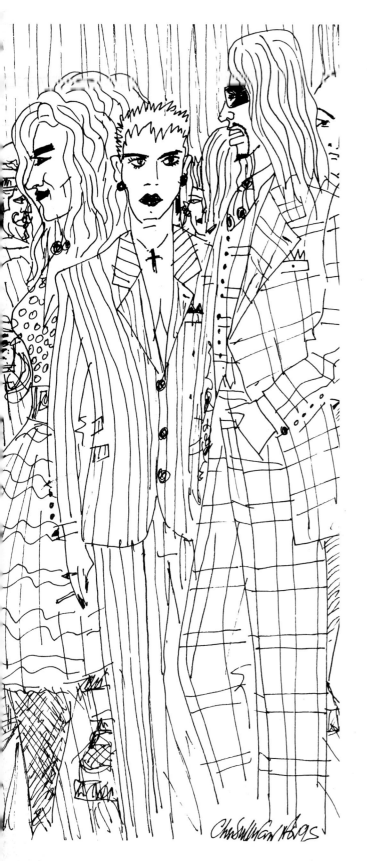

➤ can't dance to Techno for the life of me, but millions can and do. Strangely, they even appear to be enjoying themselves. To me it's a complete mystery. To a younger generation it's patently obvious – 'natural' even.

Clubland is today inhabited by an incalculable number of Clubbers – all doing their Post-Modern thing in London, Rimini, New York, LA, Berlin, Frankfurt, Stockholm, Paris, Tokyo, Manchester, Goa and points in-between. But you don't actually have to go out to night clubs to be a Clubber. As I said, it's a state of mind – a promiscuous capriciousness of touching down and taking off, of dropping in and dropping out, of sampling & mixing, of taking bits and pieces of history and dollops of geography and sticking them in the semiological blender, of making sense of nonsense and nonsense of sense.

There's too much stuff – too much history, too many fat newspapers and magazines, too many channels on the TV, too many restaurants and kinds of food to choose from, too many people to keep in touch with, too many books to read, too many films to see, too many messages on the answering machine, too many computer games to play, too many contacts on the internet… too many possibilities. We can't possibly take it all in, so we sample bits of it as if life was an 'All You Can Eat' smorgasbord. (And you know what? It is.)

Clubland is just a particularly vivid expression of this state of affairs. A potent (and popular) distillation of the Post-Modern condition, with all its dilemmas and all its possibilities – its agony and its ecstasy.

Clubland is the elephants' graveyard of the twentieth century. (And of Western civilization as we know it.) Clubland is the playful prototype of the 3rd Millennium. ✦

left: 'I heard that by any measure it was a top night….'
right: 'But is that bald geezer who I think he is?….' Drawings **Chris Sullivan**

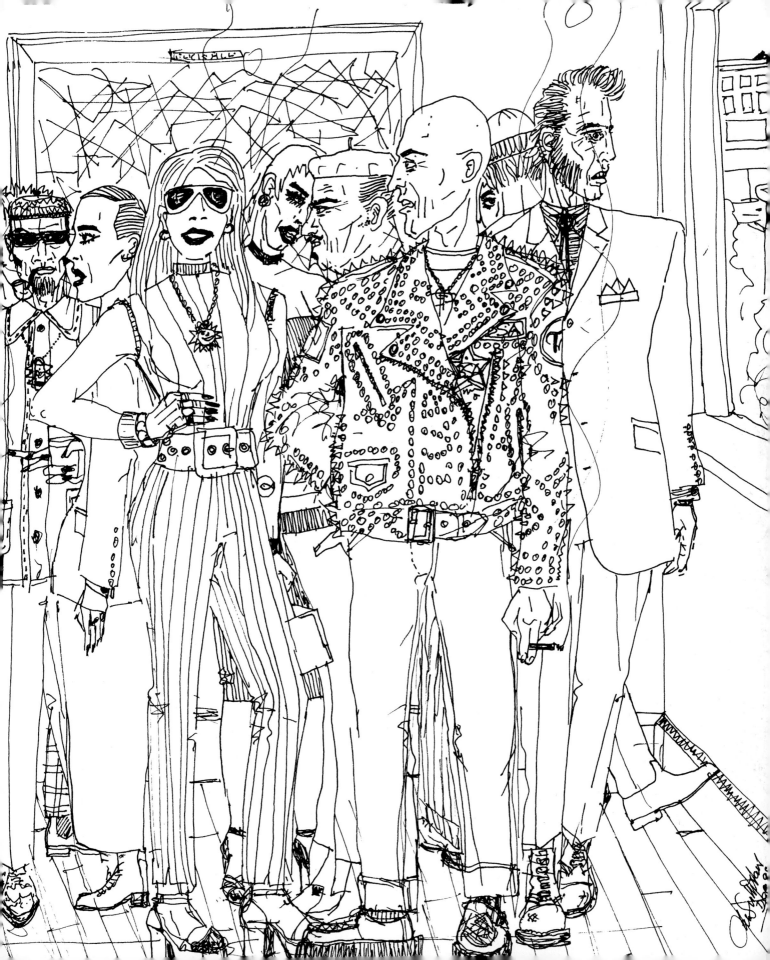

'Pervs' & 'Trannies'

(chapter seven)

opposite: 'Typical Soho Street Scene', London.
Drawing **Joe Brocklehurst**

below: At the Rubber Ball, London, 1995.
Photograph **James & James**

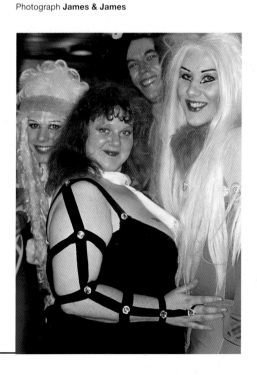

'I'm a clubber into rubber'.

This is the message printed on a necklace worn by Ron Elliston, an organizer of 'Submission', a hugely popular London club catering to, well, all those Clubbers who are into rubber. It's a telling message – underlining the way in which even 'The Fetish Scene' has become part of Clubland ('Fetish World') and providing a particularly fascinating example of what might be called 'clubification'.

The transition of fetishism from the private sphere to the public domain was first seen (by my generation) in the 1960s when 'kinky' materials like PVC and leather were drawn into the mainstream by fashion (with a little help from *The Avengers* TV series). Another important step came with Punk: the rubber masks and other previously clandestine, mail-order garments sold proudly in McClaren and Westwood's shop SEX, the breast-exposing PVC bra worn by Siouxsie Sioux at her first performance at the '!00 Club' and, most importantly, the multitude of actual street Punks who sported handcuffs and dog collars as part of their everyday attire.

Punk, as we have seen, made use of an extraordinarily eclectic range of symbols and garments – sampling and mixing them in a potent bricolage and, in the process, achieving a new kind of visual confrontation. The symbols of fetishistic 'perversion' were only a small part of Punks' vocabulary, but once brought out of the closet they refused to return to it – crossing over from subcultural emblem to a more generalized marker of the risqué and provocative (for example, in the costumes of dance groups like 'Hot Gossip', in the incessant rise of 'Fetish Fashion' and in a renewed interest in the artist Allen Jones, who had pioneered the use of fetishistic imagery in the 1960s).

In early 1980s London, the post-Punk explosion of styleworlds saw all manner of esoteric, cult phenomena propelled into the niche status of 'one-➤

➤ nighter' clubs. Most of these explorations in the obscure (a gathering of fans of the cult children's TV series *Thunderbirds*, a collective of experimental Japanese music enthusiasts) came and went with great speed; but one of them, Skin Two – a Monday night club in London's Soho which specialized in fetishism – became internationally influential, with a host of associated glossy magazines, designers, photographers and clubs springing up to fuel an ever-growing demand. While the original Skin Two club held a maximum of two hundred people and was greeted with sniggering disapproval even amongst the flotsam and jetsam of the now not so new New Romantics, today an event like 'The Rubber Ball' attracts some three and a half thousand and exists within an arena of 'Fetish Fashion' that both fascinates the avant-garde and mesmerizes the mainstream.

Like Punk, the original Skin Two club crossed an essential divide between 'real fetishism' and its transubstantiation within the sphere of popular culture. Present on the opening night were a mix of, for example, members of the Mackintosh Society (a group focused on the erotic potential of the rubber mac), shoe fetishists, professional Dominatrixes and their submissive clients, corset fetishists and, on the other hand, such trendy pop musicians as Marc Almond of Soft Cell and young, alternative fashion designers.

By and large, however, the original Skin Two club existed within that 'narrowcasting' of taste that characterized the initial post-Punk era – with those who regularly attended secure in their own particular fetishistic groove. Unlikely to cross-over into the other, myriad worlds that existed cheek by jowl around it, such original Skin Two regulars saw themselves not as 'Clubbers', but as fetishists enjoying the company of other fetishists in a club environment. ➤

Fetish fashion show at a London club, early 1980s.
Photographs **Ted Polhemus**

One face, 1000 costumes, 'A day in the life of a **Barbaric Doll'**

Being naked doesn't feel comfortable.

Dress me up! (Demands the bitch blonde out of a cardboard box.)

Another long day down the charity shops, DIY superstores and 'Pound Stretcher' just to find what's right for HER.

Bought a few chains, some leather straps, a plastic poodle, a miniature toilet, gloss enamel paint and a bit of fake hair – all mixed up with the rest of my shopping.

Here, I've got something for you!

You are going to be a Country & Western Bimbo!

Fuck off!

I am a policeman with a black helmet and a dildo as a weapon...

Ah! And I want my nipples pierced and a love heart tattoo on my buttock.

Understand?

They've got a life of their own these Barbaric Dolls! Life's a drag.

Dolls, Photographs & Caption
Diana Lorenzo Saxby

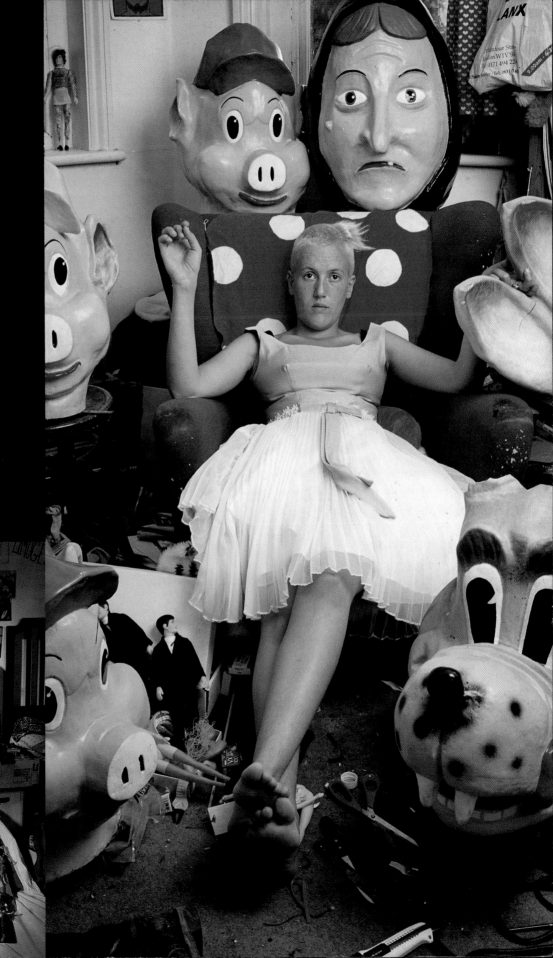

DIANA LORENZO SAXBY
'Artista', born in Ibiza, 1967.
Moved to Barcelona, 1987.
Moved to London, 1989.
Moving to Europe, 1996.

'I'm always moving –
travelling through characters
becomes a lifestyle. Since the
age of two I was dressed up
in costumes, now it gives me
a way to live life without
labels. Adolescent rebellion,
carnivals, being different from
the establishment – but with a
sense of humour – has taught
me again and again how
impersonating different
characters can be the best
way of weaving though life.
Disguised as a nurse, a
flamenco dancer, an efficient
secretary, a heavy-metal
victim, a taxi driver, a cocktail
party star…. Who am I?'

Photographs **David Turner**

➤ Today, on the other hand, a great many of those who on one night of the week attend a 'Fetish' event like The Rubber Ball, Submission, The Rubber Nipple Club, Fantastic or The Torture Garden (to name only the principal examples in London) will, on another night of the week, happily surf through other worlds within Clubland's eclectic repertoire. Many, like Ron the organizer of Submission, may be 'Clubbers Into Rubber', but first and foremost they are Clubbers and as such they may be 'into' a whole range of things – fetishism constituting but one stopping point on their itinerary.

Even for those who only attend 'Fetish' clubs (and there are so many now that this in itself can be a full-time occupation), the overall tone of such events has been fundamentally changed. This is because the context of 'fetishism' and 'S&M' has itself been transformed. What once had to be concealed can now be proudly flaunted. What once brought only sniggers of disdain (rubber, for example) is now seen as hip with the in crowd. What was once suspect and déclassé – 'sexual perversion' – has now become a part (a significant part) of Clubland's appropriation of all that is weird and wonderful (and recyclable) in Western culture at the close of the twentieth century.

As we saw in the previous chapter, Clubland is a welcoming place where practically anything can be accommodated and what is true of, say, the 1970s (once described by *The Face* as 'The Decade Taste Forgot') is just as true of fetishism. In the process, however, as 'The Fetish Scene' has become a part of Clubland, a subtle, but important, transformation has taken place. Once a comparatively straightforward, personal affair, fetishism has itself been fetishized – even institutionalized – within the context of the (anything but straightforward) polymorphous perversity of the Post-Modern condition. Essentially, the meaning of fetish objects has become more ➤

Kim welcomes you to the rubber nipple club

'When Daniel Holloway and I founded The Rubber Nipple Club in 1995 our aim was to create a club where fantasy and fun would predominate – more fancy-dress theatre than "serious" S&M. That's why we got Vince Ray to draw the flyers, to make it more like comic-book capers.' – Kim

'Kim and I felt from the start that the invites should be a bit unusual. We wanted to inject a note of humour and playfulness. Sometimes this comes out as a fantasy world of fairies and pixies, at other times, as Mistress Atomica – a pastiche of the styles of 1950s American comics and the work of the early S&M and fetish artists.' – Vince Ray

Photograph **Trevor Watson**
Flyers **Vince Ray**

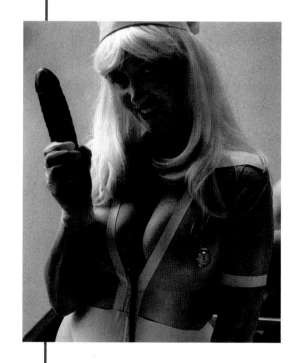

the **Rubber Ball**

From its origins in a tiny club – 'Skin Two' – in London's Soho, the 'Fetish Scene' has grown into a huge international network of designers, magazines and clubs. The 'Rubber Ball', which *Skin Two* (now a glossy magazine and stylish shop) hosts as an annual charity event, vividly demonstrates this dramatic change of scale – the 1995 ball pictured here was attended by some 3,500 people, its glitzy fetish fashion show spotlighting the work of eighteen different designers.

Bringing together both straight and Gay 'Pervs', the first Rubber Ball – held in 1992 – proved to be 'The Ultimate Fetish Party'. The idea for the event was conceived and promoted by *Skin Two* Magazine features editor Michelle Olley who, as lead singer with the 'full-on glamour experience' band 'Salon Kitty', also dazzled the crowds in her spectacular rubber dress. Michelle sees the Rubber Ball as 'The best advert for S&M and fetish you could wish for. It sets out to include and welcome all those who want to use clothes to make them feel good about themselves. It's not about being young, thin, gorgeous and rich – it's about feeling glamorous by dressing up as whoever/whatever you want to be.'

Photographs **James & James**

➤ complicated – more referential, more subtle, more thought-provoking, more embedded with double, even triple connotation, more a personal statement than a fetish *per se*, more a commentary on life at the end of the millennium than a public display of private fantasies, more a celebration of perversity as a sign of the times than a simple erotic trigger.

As an example, consider the attire of Kaisu, whose photographs appear on pages 114 and 115. Born in Lapland, Kaisu has long been one of the most stylish, beautiful and provocative figures within London Clubland's 'Fetish Scene'. On page 114 we see her wearing one of her favourite outfits – a rubber 'nurse's' uniform – in one of her favourite haunts, the Imperial War Museum.

In this dramatic context especially, the interplay of the 'real' nurse and the erotic 'nurse' is obvious. But the same cross-referencing is characteristic of all those 'nurse' outfits once available by mail-order from 'glamourwear' catalogues and delivered to your door in discreet brown paper parcels. Where Kaisu's outfit differs is in the way it embraces and reflects upon *both* the 'real' nurse *and* the mail-order glamourwear 'nurse'. (Note how a private garment intended for use only in a bedroom with the curtains tightly pulled has been recontextualized within a public environment. Note also how an outfit which might once have been seen as tacky has been elegantly restyled to render it chic – the shoes, for example, while white, are hardly the traditional white stilettos associated with classic 'glamourwear'.) Like practically everything in Clubland, this is a triple take.

Kaisu's chic Clubland 'nurse' returns to the Imperial War Museum to admire the original, genuine article from the perspective of – but slightly, significantly distanced from – the world of the glamourwear 'nurse'. And in the process provides a knowing, 1990s commentary upon both sources of inspiration. Kaisu isn't a 'real' nurse. Neither is she ➤

➤ the stereotyped *Carry On* erotic parody 'nurse'. She's a pastiche of a pastiche and, as such, she sucks even the old-world 'straightness' of the Imperial War Museum into the 'bent' world of Clubland.

While attempting to describe these subtle differences of meaning I was reminded of a fascinating essay by Susan Sontag called 'Notes On Camp', reprinted in *A Susan Sontag Reader*. Writing (amazingly) in 1964, Sontag suggests that the camp sensibility exhibits the following characteristics:

'It is the love of the exaggerated, the "off", of things-being-what-they-are-not.' (p.108)

'Camp sees everything in quotation marks. It's not a lamp, but a "lamp", not a woman, but a "woman". To perceive Camp in objects and persons is to understand Being-as-Playing-a-Role. It is the farthest extension, in sensibility, of the metaphor of life as theatre.' (p.109)

'Camp is playful, anti-serious. More precisely, Camp involves a new, more complex relation to "the serious". One can be serious about the frivolous, frivolous about the serious.' (p.116)

'Camp is the answer to the problem: how to be a dandy in the age of mass culture.' (p.116)

'The experiences of Camp are based on the great discovery that the sensibility of high culture has no monopoly upon refinement. Camp asserts that good taste is not simply good taste; that there exists, indeed, a good taste of bad taste.' (p.118)

'Camp taste is, above all, a mode of enjoyment, of appreciation – not judgement.' (p.119)

I'm not suggesting that Kaisu's outfit is camp. Rather, that her outfit and the Clubland take on 'perversity' (of which it is an admirable example, as it is of the entire Post-Modern play with meaning that I have summarized within the metaphor of Clubland) share certain characteristics with those of camp which Sontag adroitly identifies. In particular: the ➤

Polly: a personal presence

Born in Ireland, Polly has been living in London since 1988 and has become a key figure on the club scene. Her distinctive and highly personal style has had extraordinary influence, with countless women imitating her look – some copying her down to the last facial piercing and enormous false eyelash. She earns her living as a model, but not in the usual sense of the word – instead of modifying her look to suit the whims of photographers and designers, Polly always remains true to her own vision of herself.

'For me style has always been a matter of presence – of having the confidence and skill to present yourself in a way that truly reflects your inner personality. When I was 13 or 14, I discovered the joys of make-up and hair-dyes. So while my school friends were busy adoring pop singers from afar, I was happily experimenting with many, many different hairstyles, make-up styles and ways of altering my natural appearance.'

'Over the years I have never looked to anyone for any type of influence over either my lifestyle or my style of appearance. While it is very gratifying to be getting paid for the way I look, my career does not influence my appearance. On the contrary, this career of mine has developed out of something I had been doing for purely personal reasons for years previously. Piercing and tattoos are a perfect example. I first got my body pierced in 1991 because I love any type of body adornment and thought it would be fabulous to wake up every morning wearing my jewelry! I had no idea that being pierced would become so trendy and popular five years later.'

'True style is, to me, something that cannot be changed by fashions or trends, but which remains true to the individual.'

Photographs **James & James**
Make-up **Sean Chapman**

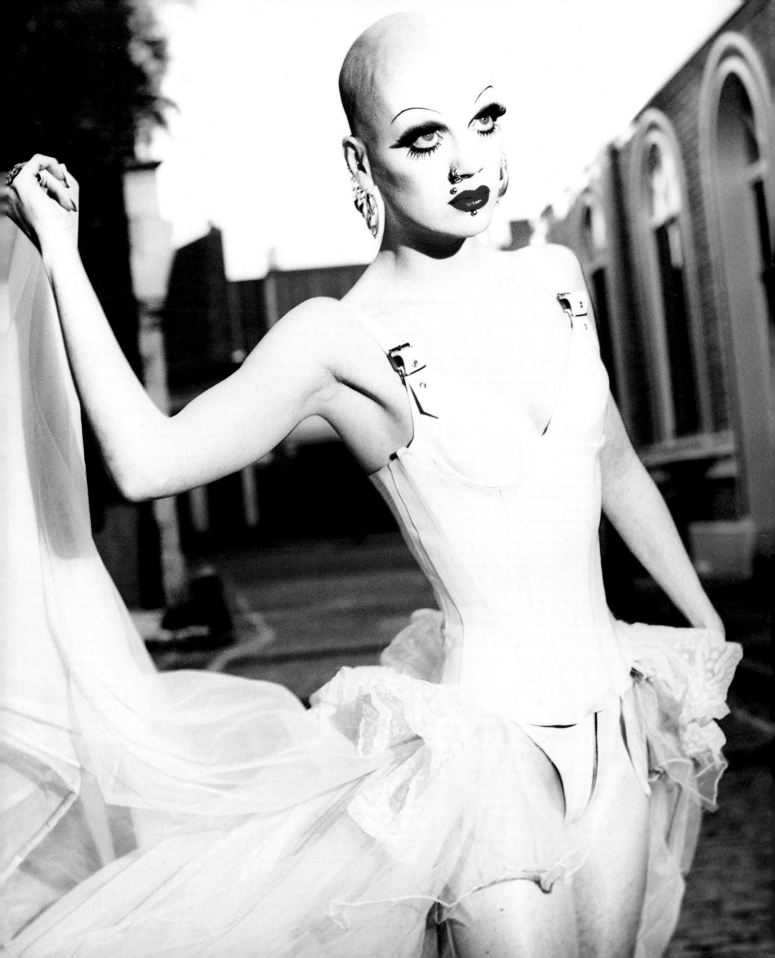

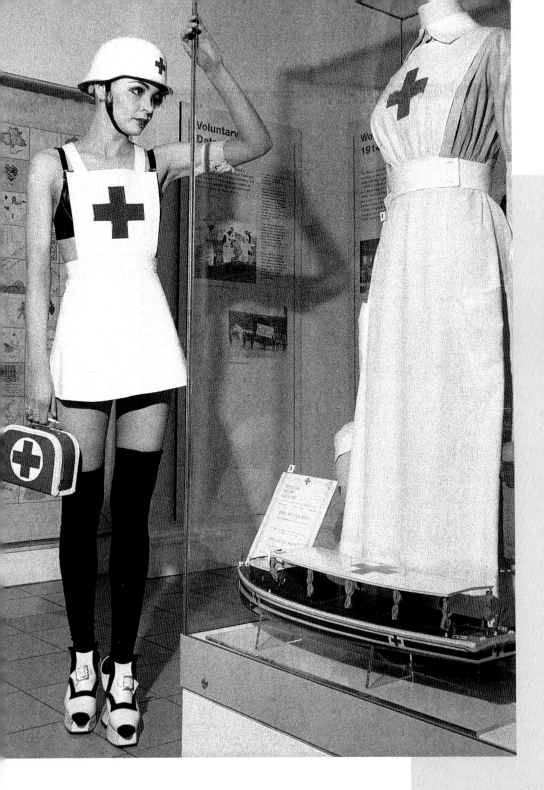

KAISU

Born in Lapland, Finland, Kaisu moved to London in 1984 and soon became a prominent figure on the 'Fetish' Clubland scene. She works as the fetish fashion production manager for Skin Two manufacturing. Her favourite clubs are 'The Torture Garden', 'Blue Martini' and 'The Mint Tea Rooms'. Her musical interests include 60s girl groups like the Paris Sisters, Dick Dale's surf guitar sounds, Techno (for dancing) and traditional Eastern music. Her style history goes back to Lapland, where she began giving classic American 50s looks her own distinctive twist. In London she found the transition from 50s to Clubland fetish to be 'natural and obvious as 50s style was always very dressed up, sexy and – at least to my eyes – very fetishstic'.

'I became involved in the fetish club scene from 1989 when it was evolving from the old style 'straight' fetish/S&M scene to the more contemporary multi-dimensional mix. My style in recent years has been moving away from the classic fetish look, which has now become normal and rather boring.'

'I design and make most of my outfits, or assemble a mix of some bought new, some found second-hand and some made to create my own look. I like to have a lot of different looks for different occasions and moods: Classic Sophisticated, Military, 50s, Fetish, Fantasy, Futuristic, etc.'

'As in these photographs in the Imperial War Museum, I find it interesting and get a fetishistic kick from wearing "real" objects with a

nursing the erotically wounded

"real" history – for example, the military red cross helmet and armband – which were used before in a "real" situation. When worn out of their original context such garments or accessories are subverted to twist the original meaning and thereby generate an extra erotic dimension. There is also a certain nostalgic/romantic element when wearing items from another age, time and place. Wearing the "real" Red Cross items in, for example, a club, takes their meaning into another dimension. To wear such things in a "real" environment (as here in the Imperial War Museum) provides a third twist to the game.'

Photographs **Jola**
(Our thanks to the Imperial War Museum)

Kaisu at 'The Torture Garden'

➤ celebration of artifice and exaggerated stylization, the delight in being 'off', the appeal of 'things-being-what-they-are-not' and of playfulness, the uninhibited embrace of the popular (even the magnificently vulgar) and the enjoyment of this process.…

But most of all, the tendency to place the world within quotation marks. We cannot describe Kaisu's outfit without quotation marks – indeed, her 'nurse' requires two sets of them, since it is a quotation (of the erotic 'nurse') of a quotation (of the 'real' nurse). And this, it seems to me, is the hallmark of Clubland – a place where Glam becomes 'Glam', Hippies become 'Hippies', cowboys become 'cowboys' and fetishists become 'fetishists'. Like camp, Clubland accomplishes this by stepping back, putting everything within a broader contextual frame. Everything. Even 'perversity'. Even 'sex'. For in Clubland – which is to say, in the Post-Modern age – everything has a meaning beyond itself; everything looks back upon itself reflexively and nothing is simply what it is.

Correctly (in 1964) Sontag saw camp as exclusively Modern. In retrospect, however, we can see it as the starting point of a *Post*-Modern sensibility – its artifice, its exaggeration, its delight in vulgarity, nostalgia and quotation all pointing resolutely in that direction. Camp, in other words, is to the Clubland *Zeitgeist* what Coney Island is to the theme park – it is the godfather (but, of course, one in drag, wearing an obviously false moustache and mimicking Brando's parody of the genuine article).

Sontag also notes camp's obvious debt to the gay world. This too is clearly true of Clubland – a place which (in spirit if not in fact) was always more 'bent' than 'straight'. In London (and I'm sure the same is true elsewhere, but I only know the situation in London from personal experience), the gay contribution to 'Club Culture' has always been ➤

➤ enormously important. Louise's, which saw the first flowering of Punk, was a lesbian club with gay men such as Philip Sallon and his protégé George O'Dowd highlighting most evenings with their presence and extraordinary costumes – one especially memorable night arriving wrapped from head to toe in white bandages in the style of an Egyptian mummy (or, possibly, victims of some terrible accident). The New Romantic Clubs always resounded loudly with gay sensibilities – the quality of pastiche that I have previous described is perhaps more accurately identified simply as camp. And at any of the Sign of the Times parties on which I focused in the previous chapter, such gay designers as Jimmy Jumble, gay performers as Anthea Blowjob or gay DJs as Miss Barbi always managed to go just that little bit further in the boldness of their quotation marks.

This isn't, of course, pure coincidence. To be gay or lesbian is to forgo the lazy luxury of presuming that identity is 'natural'. And, in so doing, to question nature itself – that is, to confront head on the constructedness of identity. The placing of sexual orientation, 'masculinity' and 'femininity' within quotation marks is the first step in the process of placing 'reality' itself within quotation marks – this process tracing out the history of camp, of ➤

In the mid-1980s glamorous and talented New York TVs hung out and performed at The Pyramid Club. One night, clowning around on the bandstand at nearby Tompkin Square Park, some of the regulars at the Pyramid hit on the idea of holding a drag festival come party in the park. One of these, Lady Bunny, had the gumption to turn 'Wigstock' (as it came to be known, in parody of 'Woodstock') into a reality.

Reflecting and in turn augmenting the rise of the TV as cultural icon, what started in a small, ramshackle way soon became a major event in its own right. Too popular to be accommodated in Tompkin Square Park, Wigstock spilled onto the streets of the Village and refocused on a huge, unused riverside site.

In 1995 I was fortunate enough to be in New York on Labor Day when Wigstock is held. The outfits were unbelievably inventive and dazzling. The people were unbelievably friendly and welcoming. The crowds were unbelievably huge – with every sidestreet, every bar bursting with gorgeous 'babes'. The best bit was watching the burly New York cops trying – yet, inevitably, failing – to act as if they were erotically uninterested in the midst of so many beautiful 'women'.

A good time was had by one and all. My thanks to Lady Bunny and her organizers for a great day – and to all those participants who generously allowed me to photograph them. Like the TV herself, Wigstock demonstrates the positive, creative possibilities of life in the Post-Modern age: the triumph of artifice over the tyranny of the natural.

Photographs **Ted Polhemus**
Special thanks **Emi Yoshida**

George O'Dowd and Philip Sallon on the King's Road, London, 1981.
Photograph **Ted Polhemus**

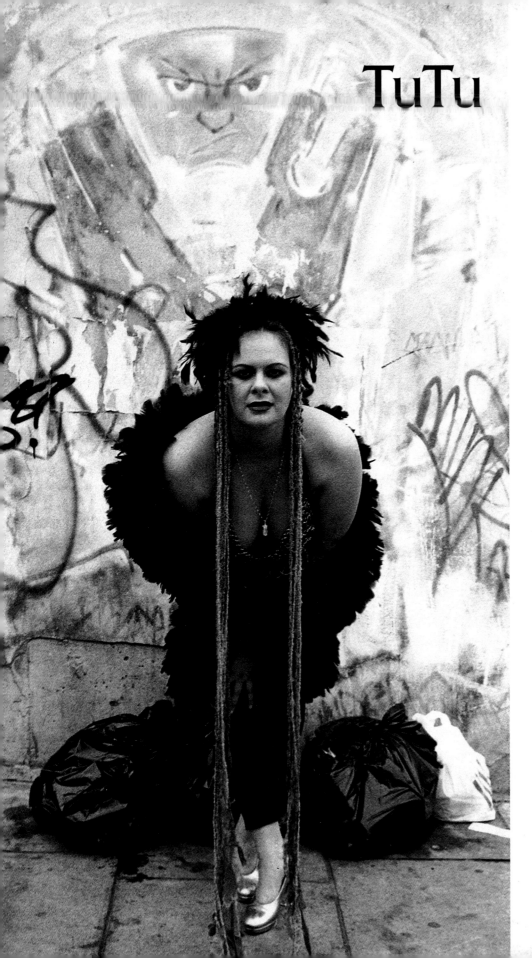

TuTu

'I'm a club promoter – at Heaven, Dance Bastard at underground parties, Platform at Bar Fridge – a performance artist, a stripper and an artist's model. As well as a stepmother to my girlfriend Janet's 8-year-old girl, Louise.'

'As a lesbian I get a lot of jibes for my femininity. These days everyone is supposed to be butch. I'm sure that a hell of a lot of the dykes I know, who wouldn't be caught dead in make-up or a dress, would secretly love to try them. I went through a stage of trying to look like a dyke – jeans, boots, T-shirts, shaving the sides of my head – but somehow I still ended up looking fem.'

'I find I rarely, if ever, get chatted up by other lesbians – except occasionally a few of the S&M girls who enjoy role playing. The right-on brigade can't deal with me at all. But the Gay boys don't think twice about burying their faces in my cleavage. Straight boys are usually just gobsmacked by the sight of me – calling me a "fat cow" or something (while trying to stifle their erections).'

'It's impossible for me to buy any sexy clothes in my size (18-20). Everything shown here is a "costume" made for specific events or performances. Hostessing a private party called "A Night of Decadence" conjured up the sequin dress. The leather catsuit outfit was put together to hostess the VIP lounge at this year's Alternative Miss World. The record and mirror outfit I call "Ode to a DJ" - I made it for a night out at Queer Nation and I've also used it for my stage work. I refer to most of my clothes as "costumes" because I like to feel the world is a stage and I'm on it.'

Photographs **Ashley**

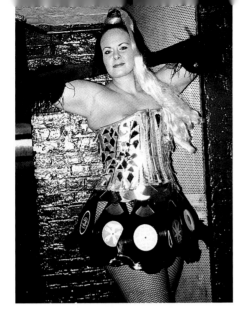

'I've been a Style Surfer for as long as I can remember. I call it "Fantasy Dressing". I only have to open my closet and I start surfing the fantasies in my head. I can be whatever, whoever I want to be. Isn't this what "drag" is all about? Whatever you call it, it's my great escape.'

Mottoes: 'Let me be Drag!' and 'Work That Look!'

➤ Clubland and of the 'Twilight of the Real', which lies at the heart of our Post-Modern condition.

Whether gay or 'straight', the transvestite pinpoints even more vividly this Post-Modern estrangement/liberation from 'The Real World'. While the transsexual seeks a physical solution to correct a 'mistake of nature', the 'drag artist' scoffs at the very idea of 'The Natural' – delighting in artifice, exaggeration, the 'off', always proudly proclaiming, 'I am not what I seem.' More 'woman' than a real woman, more 'man' than a real man, the male-to-female or female-to-male cross-dresser exhibits precisely those qualities (hyperreality, the dislocation of image and meaning, quotation, playful semantic cruising) that define camp, Clubland and Post-Modernity. The ultimate Style Surfer, the transvestite cruises gender identity as well as all the other universes of style as meaning.

It's hardly surprising, therefore, that the transvestite has become the key reference point of our age – the most quoted source in our age of quotation. From John Waters to Almodovar, from 'Priscilla Queen of the Desert' to 'Ed Wood', from 'Kiss of the Spider Woman' to 'Madame Butterfly', from the wonderful Levi's ad that used a gorgeous 'tranny' to sell jeans for men to the high fashion catwalks to Madonna's 'Vogue', from clubs like 'Kinky Gerlinky' to events like New York City's huge 'Wigstock' festival (see pages 116 to 117), the transvestite commands an incomparable iconic presence. As Greta Garbo or Marilyn Monroe once were, RuPaul (or whoever else is top of the totem pole by the time this book comes out) is *divine*. The goddess now possesses a penis.

This is because the transvestite so perfectly embodies and personifies our Post-Modern age. Adorned in quotation marks, 'she' (or 'he') proudly exudes the aroma of simulation that befits an age in which 'The real is no longer real', a world in which ➤

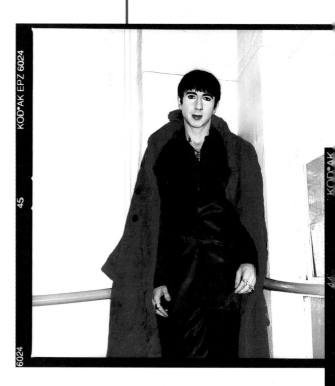

Photographs **James & James**
Make-up **Shelley Manser**
Stylist **Fernan d'Abreu**

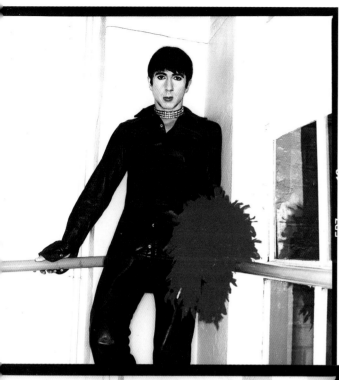

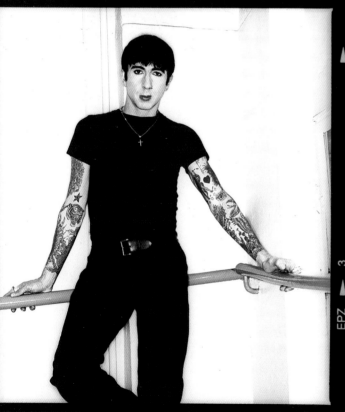

Torch singer, lounge lizard, beatnik, rebel, hustler, vampire, vamp, Spanish dancer... Marc Almond

FILM INFLUENCES: Liza Minelli in *Cabaret*, *Scorpio Rising* by Kenneth Anger, Andy Warhol's *Dracula*, *Pink Narcissus*, Marlene Dietrich in Von Sternberg films, the existentialism in the Tony Hancock film *The Rebel*

EYELINER: Juliette Greco in the 50s, early Bryan Ferry

LEATHER: Elvis '68 comeback special, motorbikes, New York S&M clubs, Jim Morrison, Marianne Faithful in *Girl on a Motorcycle*

TATTOOS: Rock 'n' Roll, Rent Boys, Criminals, Sailors, Carnival Side-shows

SEQUINS: Judy Garland's sequinned jacket, burlesque, striptease, Folies Bergère, Cheap Glamour, Glam Rock

GLITTER: Marc Bolan, early Roxy Music, Pierre et Gilles, Folies Bergère, Disco

FAVOURITE COMBINATION: black leather + fake diamonds

'I usually wear black for its simplicity, sexiness, purity and drama. The equivalent of Piaf's little black dress, sometimes with red for a dash of passion. The darker my lyrics, the blacker my clothes.'

'In the millennium I'll look pretty much the way I do now except ten years younger.'

Fetish club, London, early 1980s.
Photograph **Ted Polhemus**

➤ 'artifice is at the very heart of reality'. For Baudrillard, from whom those quotes are taken, this 'threat of vanishing in the play of signs' represents imminent catastrophe. For the replicants of Clubland, however, the 'tranny' represents the ultimate positive role model – the hero/ine come to rescue us from the tyranny of the real.

Indeed, so popular is the transvestite that 'she'/'he' is even copied by those who are not transvestites. Currently, one of the most popular designers amongst the inhabitants of 'Fetish World' is 'Dane', whose provocative, see-through tops and catsuits are boldly stamped with the word 'TRANSVESTITE'. Interestingly, more often than not, these garments are worn by women. (And let us, in awe and admiration, note the complex semiological layering here: 'real' women parodying unreal women parodying 'real' women. As with Kaisu, Clubland 'nurse', allusion has been taken to the third degree.)

More pervasively, any woman today who hopes to make her erotic presence felt must either contrive to appear 'boyish' (Kate Moss), or must slap on the make-up, pluck her eyebrows and wiggle her hips in a parody of 'femininity' defined not by other women but by other 'women'. 'Natural femininity' no longer cuts the mustard. The replica(nt) triumphs over the original.

In the end, even the body itself enters the arena of constructedness and simulation. While, for the transsexual, hormones for breast and buttock enhancement were previously but a preamble to 'the chop', the tendency today is to halt the process at precisely the moment at which nature is most subverted: the big-busted, wide-hipped 'tranny' with a cock, the macho, bearded 'Daddy' with a pussy. Constructedness – now literal as well as symbolic – is the turn-on. Whereas previously the goal of all cosmetic surgery was to be invisible (to hide within the domain of 'the natural'), the deliberately half-way transsexual flaunts and derives erotic power from ➤

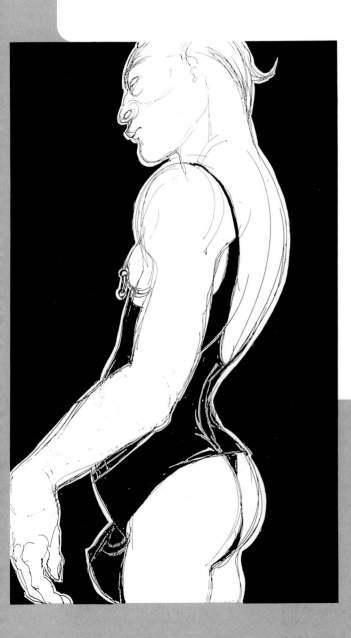

▶ the advertising of artifice.

To my knowledge, this literal, physiological pursuit of simulation has only been bettered by one person, the French performance artist Orlan. In a series of plastic surgery operations – 'The Reincarnation of Saint Orlan' – she has had her facial features remodelled in a recreation of various icons of feminine beauty (for example, the forehead of the Mona Lisa, the chin of Botticelli's *Venus* and the eyes of Gérôme's *Psyche*). Taking things a stage further (significantly, deliberately deviating from our standard ideals of beauty), in an operation/performance entitled 'Omnipresence', Orlan had silicone inserted in her temples in order to create artificial 'horns'. In an operation to be performed in Tokyo in the future, it is Orlan's intention to have her existing 'cute' nose transformed into a much more prominent one of 'caricature proportions'. Like the transvestite – only more so – Orlan oozes the erotic juice that, in its artifice, seduces.

The eventual result, Orlan as self-made, constructed woman. Orlan (literally) as replicant. Orlan as virtual body – a simulation befitting an age of simulation, a Style Surfer of metaphysical possibility. Orlan as supreme being in the twenty-first century: the virtual goddess, the goddess of the virtual. ◆

perve author shock!

Ted Polhemus is a writer, anthropologist, photographer. He normally wears suits – finding casual dress 'the catastrophe of our age'. Here he is dressed for a night at The Torture Garden.

Drawing **Joe Brocklehurst**

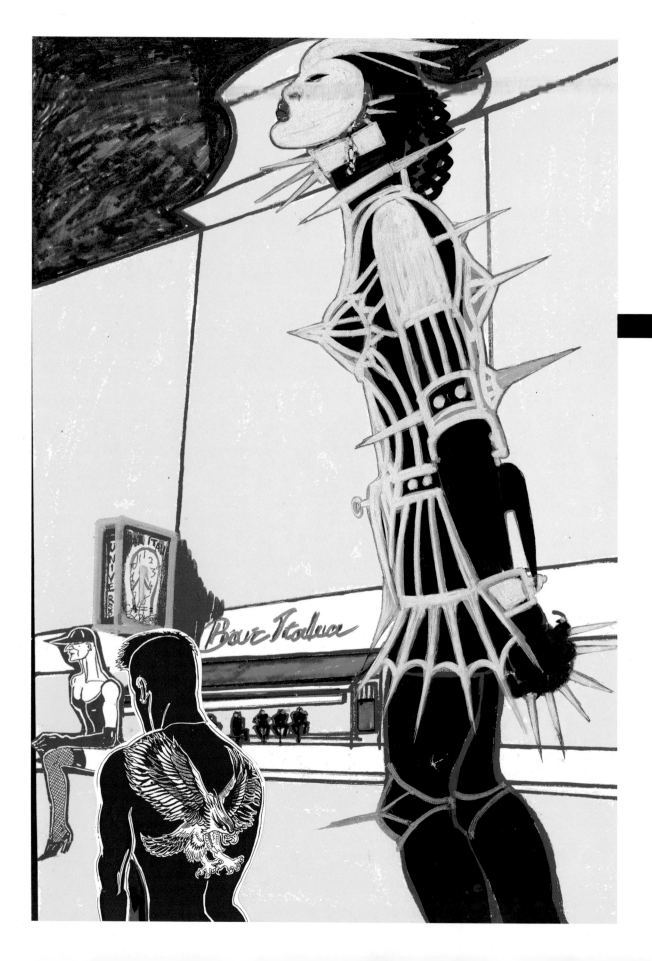

12:01 am January 1
AD 2000

above: Tomorrow's Trannies Today – all dressed up for the next millennium at the 1995 Wigstock festival, NYC. Photograph **Ted Polhemus**

opposite: 'Birds of Prey', Soho, London – woman's outfit inspired by the work of Izzy Lane and Anthony Gregory. Drawing **Joe Brocklehurst**

Towards the end of the year AD 999 much of Europe, young and old, rich and poor, thronged the churches, monasteries and cathedrals to await the Day of Judgement – the end of the world, the prophesied doomsday. Anyone glancing around such a gathering would have found differences of class, wealth, profession and gender immediately evident from the different clothing and adornment styles – appearance a symbolic reflection of the social order. Precisely the social order which was about to end. But which, to everyone's surprise, didn't. (And, in thanks, the year AD 1000 saw work begun on building a large number of new churches throughout Europe.)

At the end of the year AD 1999 the urbanized, Westernized inhabitants of planet Earth will throng the great cathedrals of Clubland to await a new beginning. They, too, will probably exhibit extraordinary stylistic diversity. Rather than a reflection of a complex social order, however, this diversity will reflect a *lack* of social order – each personalized, surfed identity a different vision of how the new order might be. If there is fear here, it is simply a nagging anxiety that somehow, magically, at the stroke of midnight on 31 January 1999 everything will *not* change.

Back forty years ago, when fashion ruled, the farsighted could hope to predict 'The Next Big Thing'. Also, as we have seen, tribal styles – in the days before Punk exploded in myriad different directions – tended towards a singular, cohesive subcultural consensus of style and worldview, an 'alternative' linear history. Our current Post-Fashion, Post-Punk, Post-Modern Age, however, is defined in large part by its fragmented simultaneity, with all sorts of startlingly different possibilities shooting off in different directions.

This is where we are coming from as we prepare for the next millennium and this also – presumably – defines much of what will happen when the ➤

➤ cosmic clock reaches midnight on the fateful day. Instead of *The* New Age, countless different (often completely contradictory) New Ages – each with its own, idiosyncratic vision embodied in cloth and flesh. While the Christians of Europe in AD 999 may not have been able to agree on just how many angels could dance on the head of a pin, they did have a reasonably cohesive vision of how things would be after the Day of Judgement. In our case, on the other hand, our visions of the new millennium are fractured and bent according to each and every subjective prism. And our heterogeneity of appearances – our supermarket of styles – precisely reflects this diversity of vision.

The problem of what to wear to the 1999 New Year's Eve Party is anything but an inconsequential side-issue. Our separate, distinct visions of the New Age all need to be articulated – our one and only common ground, the fact that our appearances, rather than our words, will be called upon to serve as the primary medium of expression. We will each go to the party dressed in our own vision of how it should be in the next millennium. Our visual cacophony will be unresolvable, but this won't matter – indeed, this clash of stylistic visions will constitute *the* defining feature of the Post-Modern millennium.

Against this view, we must consider another possibility: that the historical magnitude of witnessing the birth of a brand new millennium will in and of itself generate a cohesive spirit which will sweep us all into the shared experience of a New Age – a going beyond Post-Modernism, a *something* which exists in its own right without reference to that which it is not. A new kick-starting of history. A point when all the looking back nostalgically, with its endless cycles of revivals of revivals, gives way to something new and fresh – 'The Next Big Thing' – something which is not a tongue-in-cheek pastiche of something else that has already happened. A point at which our ➤

Denmark is not a country noted for outlandish clothing design. Indeed, quite the opposite. (When I lived in Copenhagen some years ago, I found it extremely difficult even to tell one Dane from another, their dress being so similar.) Conflicto is a Danish design group that proves just how wrong such stereotypes can be. It's hard to think of any designers in any country today who have set themselves as far apart from the convention of 'normal attire' as **Dorrit & Otilio Shoshan of Conflicto.**

'Denmark is such a boring country. No one should underestimate the depth of our hatred for what we see around us. There's loss of ideals, a total lack of aesthetics, no elegance,

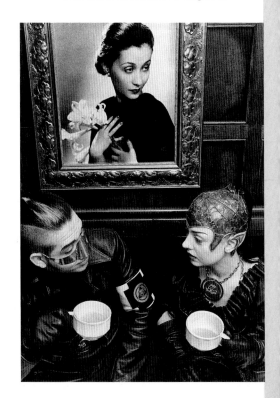

no manners. People's "individual freedom" has turned into vulgarity.'

Conflicto was born when Dorrit and Otilio got married in 1989. They then perfected their skills until they felt ready to open a shop/studio – their atelier – in Copenhagen in 1993. Since then they have been selling their designs and establishing their contacts abroad – in 1995 putting on a show in London at 'The Torture Garden' club. Their work is (deliberately) impossible to classify, their inspiration coming from such diverse and obscure sources as military history, the Middle Ages and various religions. Most garments are custom-made and in the future they would like to concentrate more on creating designs for film and theatre.

'The clothes are made for the individual who likes to remain so. They are meant for humans who require clothing that stands out, functional features and hand-crafted. The clothes are not dedicated to any particular group of people or fashion movement. Conflicto offers its clients "The Anatomical Line": alternative clothing with the possibility of different looks within one outfit.'

Their atelier is decorated with reproductions of skeletons and parts of the human body: 'The beauty of our bones can only be understood by an anatomical doctor. Most people, mistakenly, believe that they carry the symbol of Death under their precious skin. But Conflicto finds its inspiration to create from bones. What can you do with your skin without a skeleton? Don't forget to donate your bones to us!!!'

'M20+M21 is Conflicto for the modern world in the late 20th and the 21st century. The 2nd millennium is almost dead. Conflicto looks towards the 3rd millennium. Most contemporary clothing is not appropriate for our times.'

Their motto: 'You will definitely die.'

Photographs **Peter Marchetti**

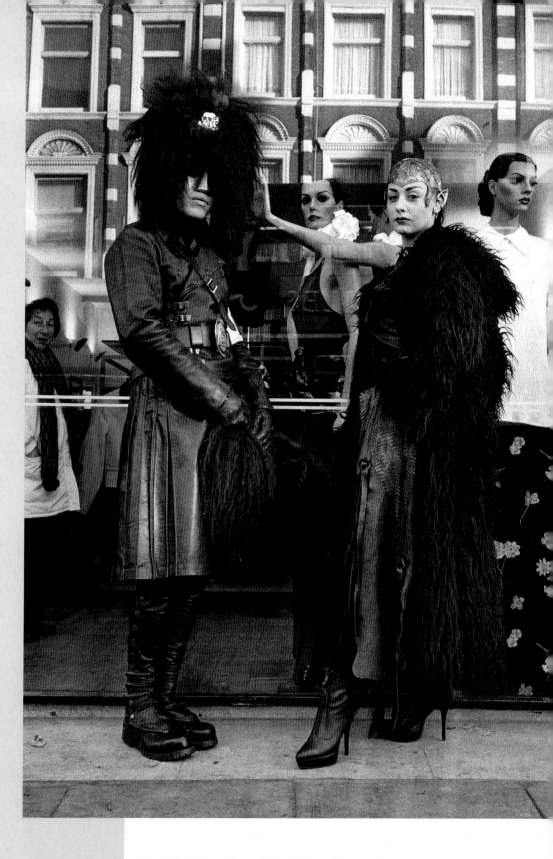

C O N F L I C T O

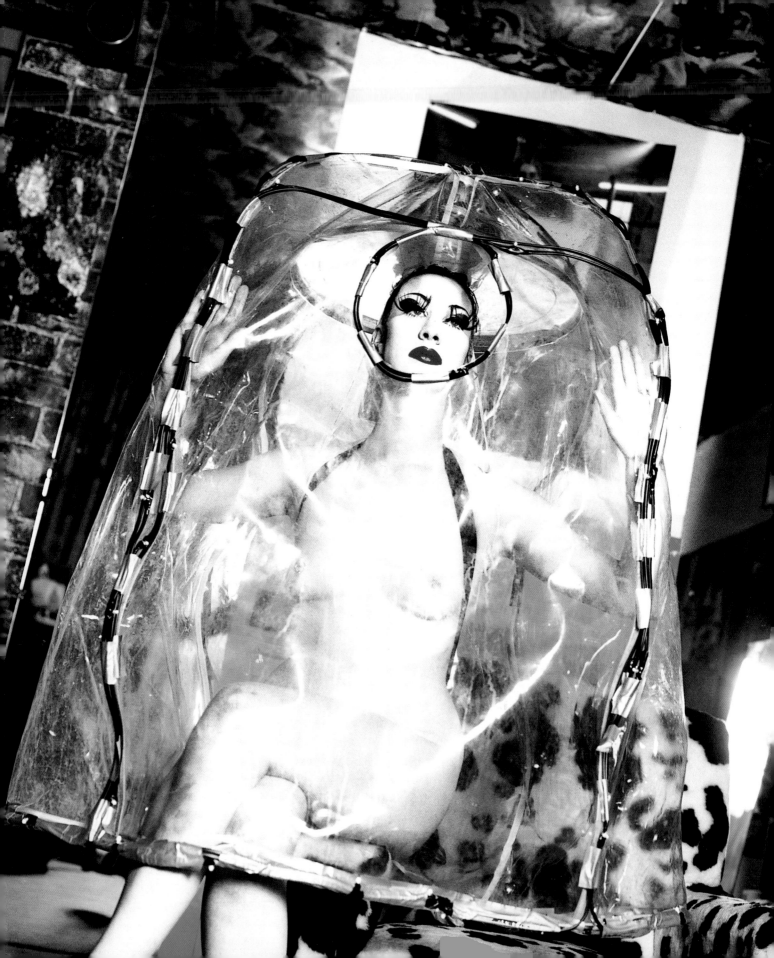

Nicola Bowery 'I AM MY OWN CANVAS'

Pattern cutter for Bella Freud, nude model for artist Lucian Freud, performer with group 'Minty'. Widow of Style Surfer extraordinaire, Leigh Bowery, and like him, a club personality, visionary and performer of considerable renown. Shown here wearing her own design, relaxing at home.

Style history: 'For ten years I've been dressing up in radically different styles – none of which are really definable.'

Whose style do you especially admire? 'Leigh Bowery, Ron Athey.'

Is your style intended as a 'statement'? 'It's a part of my art. I am my own canvas.'

What do you think you'll look like on the 1st of January, 2000? 'Older.'

Photograph **James & James**

➤ ever expanding, ever multiplying, ever more disconnected universes slow down, pause in cosmic anticipation and then – feeling the gentle but effective tug of some new consensual gravitational force – reverse and implode towards a centrality.

This point must, of course, be the year 2000. It's true that even for Christians the precise date that one millennium ends and another begins cannot be guaranteed historical accuracy. And, of course, for the non-Christian the year 2000 is actually a completely arbitrary chronological moment. Yet despite this, as the 1990s tick relentlessly away, each year engenders in us all a frisson of excitement at what is to come – an almost tangible feeling that something big and different and COSMIC is about to happen. Despite all the fragmentation and individualization of our age, this is clearly a shared anticipation. We are, all of us, waiting. (And surely, in a very real sense, it is this and this alone that defines the 1990s – 'The Decade That Awaited M3'.)

If the shift into a new millennium succeeds in triggering a sense of purpose, of direction, of a global community that is more than the sum of its parts, then – as has happened throughout human history – such consensus will be expressed stylistically. Instead of (as now) using our appearance to signal personal difference, we will use appearance as a 'uniform' to signal common purpose and vision. As in any traditional tribal society, this needn't suggest absolute, head-to-toe uniformity. More likely, there will be some logo, insignia, adornment, cut of dress or colour which will become a symbol of a shared belief in 'The New Age'.

At the start of the 1990s, as a marker of closure to the matt-blackism of the 1980s, a wide range of different clothing designers came to the same conclusion: 'The New Age' would be clad in white. The symbolism was clear: instead of 1980s materialism, a new spiritual dawn – a new ➤

MEDIEVAL MAGICK

GAILE McCONAGHIE – Raised in Northern Ireland, she moved to London to study fashion design in the mid-1980s. Her shops (in Hyper Hyper and Portobello Green in London) feature her Medieval Magick range, which also sells extensively outside the UK. Mixing 'tribal' and 'fetish' motifs, her designs are frequently seen in London clubs such as Fantastic!, The Torture Garden, The Rubble Nipple Club and Submission – her brightly coloured, intricate embroidery always standing out from the black rubber and leather more typically seen in such clubs.

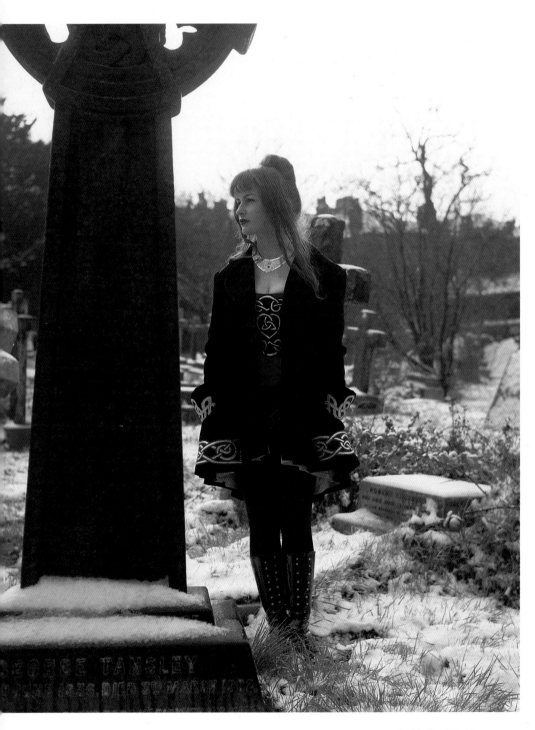

opposite: Medieval Magick fashion show at The Torture Garden, London, 1995.

Photographs **Jeremy Deller**

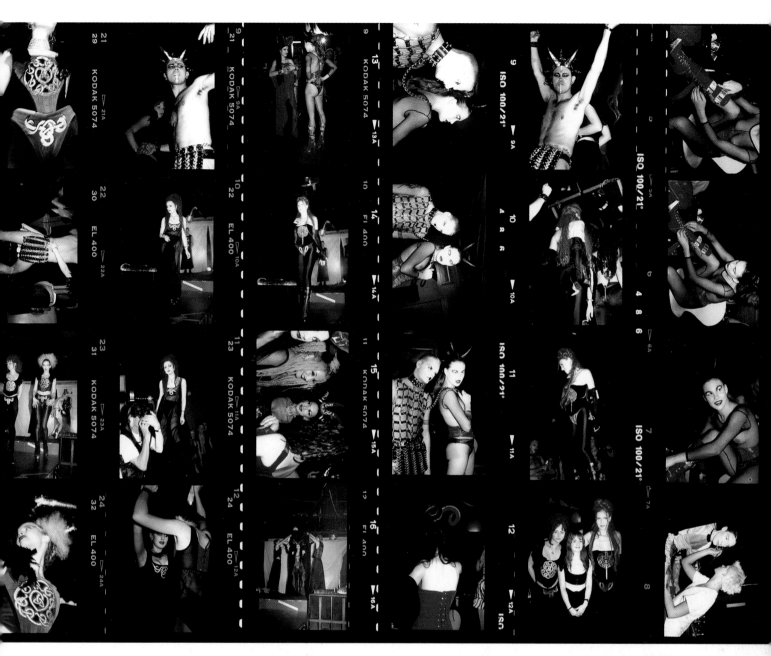

'I've been making clothes since I was 11 and all the while I've been inspired by those cultures like the Celts, the North American Indians and the Ancient Egyptians that incorporate powerful spiritual, mystic imagery into their appearance style. I try to create looks which reverberate with ancient symbolic meanings. At the same time I look to the future – dancing between the old and the new.'

'I'm not interested in fashion – the idea that you've got to come up with something completely different each season just for the sake of it. I'm perfecting a style which is both ancient and futuristic – a classic, which will look as good in the next millennium as it does today.'

opposite: Professional body
piercer and performance
artist, Dave Deacon.
Photograph **Eva N.**

➤ innocence, purity, a clean piece of paper waiting
to be written upon. As it happened, New Age White
came and went. But the transition from one decade
to another is a far cry from the birth of a whole new
millennium. Could 1990 New Age White have simply
been a dress rehearsal for the big event? Only a few
decades ago the fashion industry could snap its
fingers and most of us would jump into line, hiking up
skirts or switching to single-breasted suits according
to its dictates. Isn't it conceivable that our millennial
sense of history could bring about a similar stylistic
consensus? And wouldn't New Age White be just the
thing for such an occasion?

Except, of course, that it, too, would smack of
revivalism: 2000 kitted up as a flashback to a 1990
imagery which, in the end, proved to be a symbol
only of Post-Modernism's capacity to place even
'The New Age' within quotation marks.

So how about black? A flashback to the 1980s,
yes, but maybe a new spin could be put on it –
emphasizing, instead of designer chic, black's
ancient associations with reverence, solemnity,
dignity and ritual. While white is the colour
associated with post-Hippy New Age
Consciousness, black also has connotative links with
a wide range of contemporary explorations of
spiritual fulfilment. From Brazil to New York, LA to
London there is renewed interest in the positive
powers of Black Magic. And while much fetishistic
and S&M imagery has been converted into 'Fetish
Fashion' and Clubland play, a hardcore (but ever
growing band) of 'Radical Sex' practitioners –
'Leatherfolk', inevitably and religiously clad all in
black – have been exploring the consciousness –
raising possibilities of 'perverse' sexual practices.
Could it be that the ecstatic *rapture* that seems to lie
at the heart of all of our millennial expectations will,
come 2000, be robed in the dense black of midnight
rather than the white light of dawn? ➤

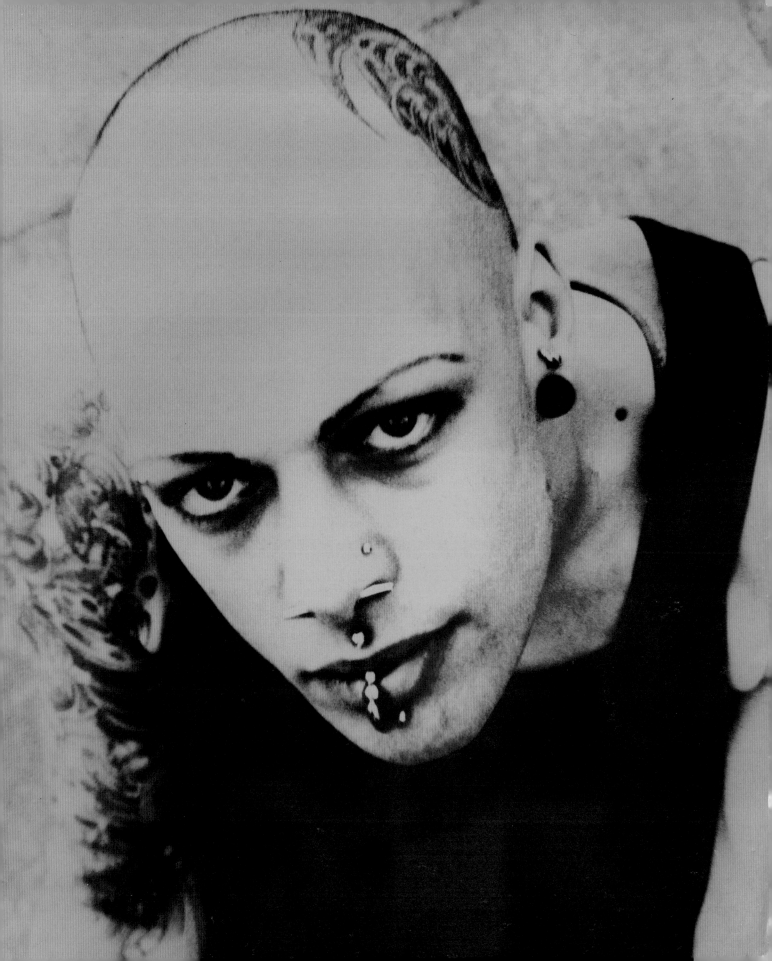

FIN DE SIECLE

A band which sounds 'like they're on the edge of a new world where the laws of physics no longer have quite the same hold' (J. Selzer, *Melody Maker*), Fin de Siècle consists of Isa Suarez (vocals, keyboards, sampler, sequencer), F. Noze (saxophone, flute, clarinet) and Cyroy a.k.a. Zedechia (congas, percussion).

'Fin de Siècle began with just me and another woman soon after I'd come to London (from the Basque Country in the South West of France). We played the Edinburgh Festival using found metal objects, drumming, chanting and slide projections. The present line-up of the band evolved in 1995. We're different from other Techno bands in part because of our emphasis on the visual – atmosphere is very important, visual style is an integral part of what we do – and also because of the extent to which we mix in a wide range of other musical styles – dub, jazz, African, industrial, psychedelic, rock, Funk, classical, blues, Afro-Brazilian rhythms. The way I look in Fin de Siècle is directly linked with the idea of change, of unpredictability, mystery, mutation.' (Isa Suarez)

'The clothes that I wear on stage with Fin de Siècle are intentionally "other worldly". We aim to transport anyone who comes to see our show to a different time and space – a fantastic place, a fantasy place. I make my costumes and headgear from found objects (from skips, junk shops, scrapyards, etc.), transforming everyday things into weird mutated constructions. Fun it is!' (F.Noze)

'I was born in London and have lived here ever since. My parents came from Jamaica to England in the late 50s and settled in south-

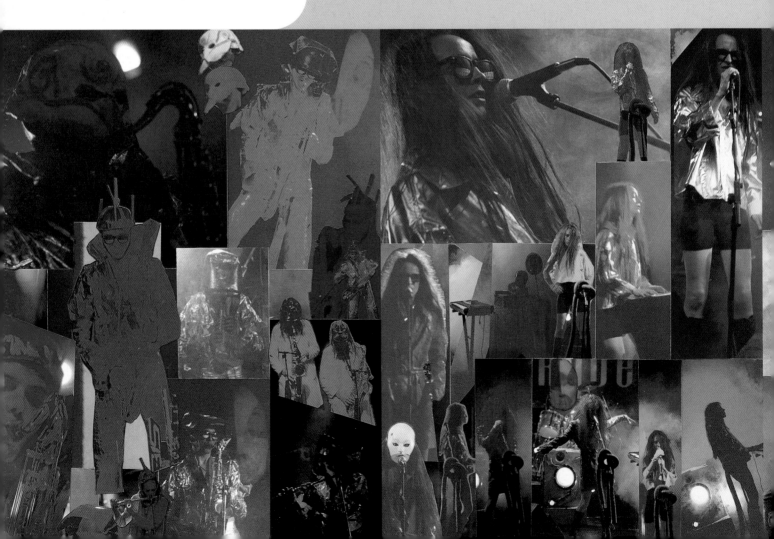

east London. Although I was born in England I feel drawn more and more towards Africa and its vibration. I like being myself as much as possible when performing, so I don't have a set dress code for stage. But I do like to vary what I wear – anything from waistcoats to traditional African garments. As the times change so will I/we.' (Cyroy)

Fin de Siècle's debut album 'End of the Century' was released in January 1996. 'Time is running out, and suddenly all kinds of ideas are coming out. We're using all these styles that come from different periods, but now, at the end of the century, they are all significant.' (Isa Suarez)

Photographs **James Barrington**
Collage **Fin de Siècle**

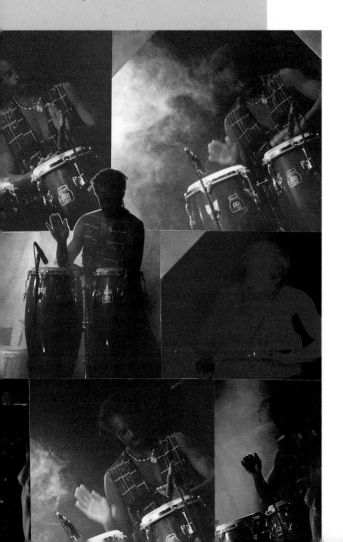

➤ Or, another possibility. Like the extensively tattooed and tribally adorned 'Coloured People' of William Gibson's futuristic classic *Virtual Light*, today's 'Primitives' and 'Savages' use their own bodies to project a 2000+ way of life that synthesizes the most ancient and the most modern. The 'Tattoo Renaissance' and phenomenal growth of interest in body piercing in the West in recent years, extrapolated forwards, might suggest a 3rd Millennium world inhabited predominately by the radically customized. (A revivalism of sorts, but one at least with a time-span of hundreds of thousands of years.)

Yet, in the end, I find it hard to believe that *any* such consensus – *the* vision, *the* look – could be regained. However great the sense of occasion wrought by a change of millennium (and one can hardly even now overestimate its electric frisson), I cannot imagine that even this will have the effect of generating an all-pervasive sense of commonality and of precipitating a stylistic singularity. Our delight in individuality, our respect for difference, our distrust of uniformity (and of 'The Real Thing', which – whatever it is – must occasion any such shared vision) is simply too great.

I can see groups of white-clad New Agers gathered together in holographic Stonehenges awaiting the dawn. I can see black-robed pagan witches and Leatherfolk each pensively engaged in their own separate rituals in the dark night. I can see huge numbers of 'Primitives' permanently marking the birth of the new millennium into their flesh. But I cannot see a single, all-unifying millennial movement which (even as the miniskirt did in 1964) will sweep us all into stylistic synchronization.

For such a thing to happen, we would have to get it together in a way that is no longer plausible. Our distaste for stylistic conformity derives from a more fundamental distrust of collectivism. And of taking ➤

➤ things seriously – straight, without an ironical twist. While there are New Agers, Pagans, Radical Sex experimenters, Modern Primitives and so forth, who hold to their respective beliefs with the conviction of European Christians in AD 999 , most of us prefer to take such convictions with a hefty pinch of Post-Modern salt. We won't be fooled again. We've seen too much dissolve in a chimera of hype. Primordial instincts of self-protection triggered, we group together – but not too together – in the safety of a Clubland mentality, insulated by a safety barrier of parody and playfulness.

This is how I suspect most people will see in the New Year of 2000. Keeping the serious – the straight – at arms length. Cosseting 'The Rapture' within the safety of quotation marks. Doing their own, idiosyncratic thing. Being millennial in a thoroughly Post-Modern way. Knowing that time and history are an illusion waiting to be replayed on the cosmic video. (And yet, in an age like ours, even this is too matter-of-fact, too neat and tidy. For, of course, there will be those who will cross the great divide to surf the vistas of Post-Modern possibility, but with an enlightened reverence that is entirely antithetical to the spirit of Post-Modernism. Those who will, as Susan Sontag commented about camp, discover the serious within the frivolous, just as – around them – others are busy converting the serious into the frivolous.)

All of which is a pity for those who (like myself) write about such things and find it convenient to identify neat chronological cut-off points where square pegs can be crammed into generalized holes. It would, for example, be great fun to do one of those 'In'/'Out' listings, of which journalists are so fond, for January 2000.

A pity, and yet at the same time, a relief. For surely 'The Next Big Thing', were it to happen, would (like all 'Next Big Things') be profoundly inhibiting. Just ➤

Drawing **Mark Wigan**

➤ as our planet needs its biodiversity, so also we need our stylistic and ideological differences. Our Post-Modern 'Twilight of the Real' offers a new dawn of infinite possibility – one in which, freed from the shackles of the 'natural', we can evolve new lifestyles. A time in which (we may hope) difference will be tolerated, respected and celebrated.

If nothing else it should be a great party. The Girls of Wigstock, in their dazzling frocks, dancing with the designer-clad Club Kids of Tokyo. Gaile McConaghie in futuristic Celtic attire cavorting with Steve Cato in his best 1960s gear. Eva and Dave jangling their body piercings to the rhythm of Conflicto's bones. Chris on his BMX bike and Mr Gravy on his skateboard running circles around each other. Nicola Bowery's plastic fantastic bubble bouncing off Philip Sallon's Elizabethan ruffles. Jean Baudrillard sporting a patently fake Old Testament beard and a Smiley T-shirt, raving with a couple of high-fashion 'Punks'. TuTu and Diana Saxby swapping gender identities like recipes. Gunilla Kjellnäs in bright neoprene, admiring Pandora Gorey's black Gothic lace. Ang & Billy in their best striped pyjamas twisting the night away with Lazer in her finest psychedelic plumage. Dale the 'real' nurse with pillar-box red hair – and Kaisu the Clubland 'nurse' administering to the stylistically wounded.

You and me resplendent in our own, contrasting, distinctive visions of life in the twenty-first century and beyond.

And perhaps, as the dawn breaks, an ecstatic rapture of sorts will be achieved as we all, together, wait patiently in line for the cloakroom. ✦

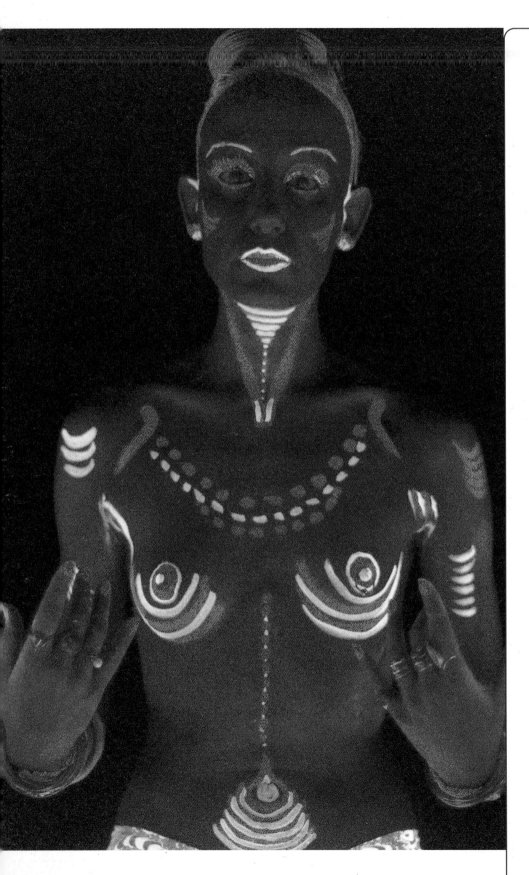

A.k.a. **Lazer,** performance artist born in Barcelona, where from 1991 she has worked with Albert Vidal, the Spanish artist renowned throughout Europe for his experimental work in body energy. Such telluric chanting and art seeks to tap into primordial, terrestrial forces in order to energize the human spirit.

Currently living in London, she is preparing performances (for clubs, as well as the more conventional cultural establishments) in which she will re-create herself as a 'living icon' – in this guise, surfing between the identities of **'Madam Durga', 'The Virgin of Perversity'** and **'Lady Lazer'** (an Intergalactic Gold-Digger).

Photographs **Kate Owens and Ted Polhemus**

LIVING ICON
VIRGIN OF PERVERSITY
MADAME DURGA
FETISH ENACTMENTS

MARIA DE MARIAS

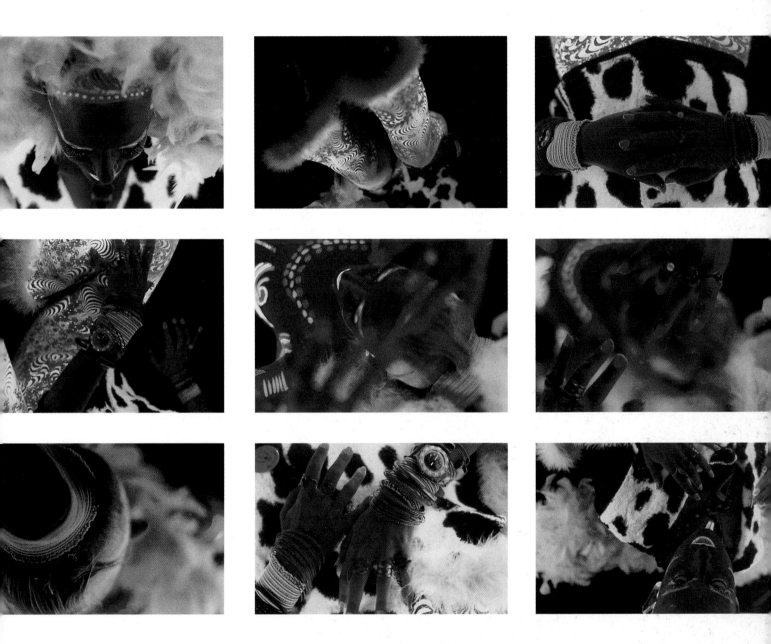

'My style comes from my experiences – in Spain, in India, in London, in other timeworlds and in the galaxies of love. I'm happiest when people assume that I am a transvestite – this reaffirms my femininity. Although I am neither a professional dress-maker nor a stylist, I consider that my appearance is part of my art. I try to incorporate as many sources and inspirations into my style as possible: 50s pearls from my mother, the Christian cross of Caravaca from my grandmother, a Tuareg animistic amulet, Indian bangles, psychedelic trousers from Kensington market, mink and zebra fake fur shawl, fluorescent make-up, nails and feathers. I am a bizarre bazaar.'

bibliography

Anscombe, Isabelle, *Not another Punk book*, Aurum Press, London, 1978

Appignanesi, Richard and Garrat, Chris, *Postmodernism for beginners*, Icon Books, Cambridge, UK, 1995

Armstrong, Rachel, 'Post-human Evolution', *Artifice,* Issue 2, 1995

Batterberry, Michael and Ariane, *Fashion: the Mirror of History*, Columbus Books, London, 1982

Baudrillard, Jean, *Revenge of the Crystal: selected writings on the modern object and its destiny, 1968-1983*, Pluto Press, London/Concord, Mass., USA, 1990

Baudrillard, Jean, *Simulations, Semiotext(e)*, New York, 1983

Baudrillard, Jean, *Seduction*, New World Perspectives, Montreal, 1990

Baudrillard, Jean, *The Transparency of Evil: essays on extreme phenomena*, Verso, London, 1993

Baudrillard, Jean, *Symbolic Exchange and Death*, Sage Publications, London, 1993

Baudrillard, Jean, *The Illusion of the End*, Polity Press, Cambridge, UK, 1994

Berger, Peter L. and Luckmann, Thomas, *The Social Construction of Reality: a treatise in the sociology of knowledge*, Penguin Books, London, 1971

BillyBoy, *Barbie: her life & times*, Columbus Books, London, 1987

Bradbury, Malcolm, 'Let's do the Popomo a-go-go', *The Guardian*, 9 December 1995

Bright, Susie, *Susie Bright's Sexual Reality: a virtual sex world reader*, Cleis Press, US, 1992

Chambers, Iain, *Border Dialogues: journeys in postmodernity*, Routledge, London, 1990

Chermayeff, Catherine, et al., *Drag Diaries*, Chronicle Books, San Francisco, 1995

Cohn, Nick, *Ball the wall: Nick Cohn in the Age of Rock*, Picador, London, 1989

Debord, Guy, *Society of the Spectacle*, Rebel Press, AIM, 1987

Eco, Umberto, *Travels in Hyper-Reality*, Picador, London, 1987

Feher, Michel *et. al*, *Fragments for a History of the Human Body (Parts 1-3)*, Zone, New York, 1989

Fleming, Jonathan, *What kind of House Party is this?: the history of a music revolution*, MIY, Slough, UK, 1995

Gane, Mike, *Baudrillard's bestiary: Baudrillard and culture*, Routledge, London, 1991

Garber, Marjorie, *Vested Interests: cross-dressing & cultural anxiety*, Penguin Books, London, 1993

Gibson, William, *Virtual Light*, Penguin Books, London, 1994

Gibson, William, *Mona Lisa Overdrive*, HarperCollins Publishers, London 1995

Godfrey, John, *A decade of I-Deas: the encyclopaedia of the '80s*, Penguin Books, London, 1990

Goffman, Erving, *The Presentation of Self in Everyday Life,* Penguin Books, London 1975

Greenfeld, Karl Taro, *Speed Tribes: children of the japanese bubble*, Boxtree, London, 1995

Hebdige, Dick, *Subculture: the meaning of style*, Methuen, London, 1971

Hebdige, Dick, *Hiding in the light: on images and things*, Routledge, London, 1988

Hebdige, Dick, *Cut 'n' Mix: culture, identity and caribbean music*, Routledge, London, 1993

Hofler, Robert and Zarco, Cyn., *Wild Style*, Fireside Books, New York, 1985

Hollander, Anne, *Seeing through clothes*, Avon Books, New York, 1980

Hollander, Anne, *Sex and Suits: the evolution of modern dress*, Knopf, New York, 1994

Jameson, Frederic, 'The Cultural Logic of Late Capitalism', *New Left Review*, No 146, July/Aug. 1984

Kaplan, E. Ann (editor), *Postmodernism and its Discontents: theories, practices*, Verso, London, 1993

Kirk, Kris and Heath, Ed, *Men in Frocks*, GMP, London, 1984

Kundera, Milan, *The Unbearable Lightness of Being*, Faber and Faber, London/Boston, 1985

Les Pirates Associés (editor), *25/34 Photographes: fin de siècle*, Paris, 1990

Lobenthal, Joel, *Radical Rags: fashions of the sixties*, Abbeville Press, New York, 1990

Lurie, Alison, *The Language of Clothes*, Hamlyn Paperbacks, Feltham, UK, 1983

Martin, Richard, *Fashion and Surrealism*, Thames and Hudson, London, 1988

McDowell, Colin, *McDowell's Directory of Twentieth-Century Fashion*, Muller, London, 1984

McLuhan,Marshall and Fiore, Quentin, *The Medium is the Message*, Penguin Books, London, 1971

Melly, George, *Revolt into Style: the pop arts in the 50s and 60s*, Oxford University Press, Oxford, UK, 1989

Musafar, Fakir (editor), *BodyPlay: the Book, Vol.I*, Insight Books, Menlo Park, USA, 1995

Papadakis, Andreas C.(editor), *The Post-Modern Object*, Art & Design, London, 1987

Papadakis, Andreas C.(editor), *Reconstruction Deconstruction*, Architectural Design, London, 1989

Pierre et Gilles, *Pierre et Gilles*, Taschen, Cologne, Germany, 1993

Polhemus, Ted, *Body Styles*, Lennard Publishing, Luton, UK, 1988

Polhemus, Ted, *Streetstyle: from sidewalk to catwalk*, Thames and Hudson, London and New York, 1994

Polhemus, Ted and Procter, Lynn, *Fashion and Antifashion: an anthropology of clothing and adornment*, Thames and Hudson, London, 1978

Polhemus, Ted and Procter, Lynn, *Popstyles*, Vermilion, London, 1984

Polhemus, Ted and Randall, Housk, *Rituals of Love: sexual experiments, erotic possibilities*, Picador, London, 1994

Poynor, Rick, *Nigel Coates: the city in motion*, Fourth Estate, London, 1989

Randall, Housk, *Revelations: chronicles and visions from the sexual underworld*, Tim Woodward Publishing, London,1993

Redhead, Steve, *The End-of-the-Century Party: youth and pop towards 2000*, Manchester University Press, Manchester, UK, 1990

Redhead, Steve, *Unpopular Cultures: the birth of law and popular culture*, Manchester University Press, Manchester, UK, 1995

Riemschneider, Buckhard (editor), *Wolfgang Tillmans*, Taschen, Cologne, Germany, 1995

Rose, Cynthia, *Design after Dark: the story of dancefloor style*, Thames and Hudson, London, 1991

RuPaul, *Lettin It All Hang Out: an autobiography*, Warner Books, London, 1995

Shelley, Jim, 'LA is burning. Happy New Year', *The Guardian*, 9 December 1995

Sherman, Cindy, *Cindy Sherman*, Schirmer/Mosel, Munich, Germany, 1987

Smart, Barry, *Postmodernity*, Routledge, London, 1993

Sontag, Susan, *A Susan Sontag Reader*, Penguin Books, London, 1983

Steele, Valerie, *Fashion and Eroticism: ideals of feminine beauty from the Victorian Era to the Jazz Age*, Oxford University Press, New York, 1985

Steele, Valerie, *Fetish: fashion, sex and power*, Oxford University Press, New York, 1996

StudioVoice, *Rebirth of Punk*, Infas, Tokyo, 1994

Sudjic, Deyan (editor), *From Matt Black to Memphis and Back Again: an anthology from Blueprint magazine*, Architecture Design and Technology Press, London, 1989

Thompson, Mark (editor), *Leatherfolk: radical sex, people, politics & practice*, Alyson Publications, Boston, 1991

Thorne, Tony, *Fads, Fashions & Cults: from acid house to zoot suit*, Bloomsbury, London, 1985

Thornton, Sarah, *Club Cultures: music, media and subcultural capital*, Polity Press, Cambridge, UK, 1995

Tickell, Paul, 'Teenage', *The Face*, June 1982, Vol.II, No. 26

Vale, V. and Juno, Andrea (editors), *Modern Primitives: an investigation of contemporary adornment and ritual*, Re/Search Publications, San Francisco, 1989

Wakefield, Neville, *Postmodernism: the twilight of the real*, Pluto Press, London, 1990

Ward, Peter, *Kitsch in Sync: a consumer's guide to bad taste*, Plexus, London, 1991

Wilson, Elizabeth, *Adorned in Dreams: fashion and modernity*, Virago, London, 1985

Wolfe, Tom, *The kandy-kolored tangerine-flake streamline baby*, Mayflower, London, 1971

Wolfe, Tom, *The pump house gang*, Bantam Books, New York, 1972

Wolfe, Tom, *Mauve, Gloves and Madmen, Clutter and Vine*, Bantam Books, New York, 1977

Wolfe, Tom, *The Electric Kool-Aid Acid Test*, Black Swan Books, London, 1993

York, Peter, *Style Wars: and other options for human behaviour*, Sidgwick & Jackson, London 1980

York, Peter, *Modern Times*, Futura, London, 1985

magazines

Australian Style
PO Box 286, Cottesloe, WA 6011
Tel: 9 384 9206

Axcess Magazine
PO Box 9309, San Diego, CA 92169, USA

Baaschix
5786 Bird Rd., Miami, Florida 33151, USA

Black and White
Studio Magazines, Level 3 Yorkhouse, 101-111 William St., Sydney 2011
Tel: 61 2 360 1422
Fax: 61 2 360 9723

Blow
71 Addison Gdns., London W14 0DT

Blue
Studio Magazines, Level 3 Yorkhouse, 101-111 William St., Sydney 2011
Tel: 61 2 360 1422
Fax: 61 2 360 9723

Blvd.
Postbus 77, 5126 Gilze, Holland

Body Play: & modern primitives quarterly
Insight Books, PO Box 2575, Menlo Park, CA 94026-2575,USA

Colors
Mondadori, CP 1812, 20102 Milan

Cutie
Tel: 3 3234 4621, 3 3239 2510 (Japan)

Dazed & Confused
112 Old St.,London EC1V 1BD

Details
PO Box 58246, Boulder, CO 80322, USA

Don't Tell It
Unit 7, Walmer Studios, 253 Walmer Rd., London W11 4EY

Duo
OCS, 1 Galleywall Rd., London SE16 3PB

Experiment
Ed./Publ. Stephanie Tironelle, Fashion Stockists, London
Tel: 0171 221 3468

The Face
Third Floor Block A, Exmouth House, Pine St., London EC1R 0JL

Fad
PO Box 420-656, San Francisco, CA 94142, USA

Fashion News
2-35 Honmuracho, Ichigaya shinjuku, Tokyo, Zip 162, Japan

Freedom
60-66 Wardour St., London W1V 3HP

Groovy Britains Magazine
The Depot, 29-31 Brewery Rd., London N7 9QH.
Tel: 0171 607 3020

G Spot: the electronic lifestyle magazine
VSW Publications, 25D Copperfield St., London SE1 0EN

i-D Magazine
Universal House, 251-255 Tottenham Court Rd., London W1P 0AE

Interview
PO Box 11292, Des Moines IA 50347-1295, USA

King
Via Stilicone 16, 20154 Milan

The Manipulator
Duisburger Str. 44, 4000 Düsseldorf 30, Germany

Max
70 Rue Compans, 75940 Paris

Mixmag
PO Box 89, London W14 8ZW

Mondo 2000
PO Box 10171, Berkeley, CA 94709, USA

'O' Magazine
'O' Publishing House Ltd., 16th floor, Kinwick Centre, 32 Hollywood Rd., Central, Hong Kong

Oyster
3 D Publishing, 25 Cooper St., Surry Hills, NSW 2010, Australia

Paper
Paper Publishing Co., 529 Broadway, New York, NY 10012

Ritual Magazine
14 Emerald St., London WC1N 3QA

Scene
10 Argyll St., London W1V 1AB

Secret Magazine
PO Box 1400, 1000 Brussels 1, Belgium

Select
Duisburger Str. 44, 40477 Düsseldorf, Germany

Sin Magazine
PO Box 6103, Melbourne, Vic. 3004, Australia.
Tel: 3 957 61032

Sport & Street: collezioni
Zanfi Editori, PO Box 70, 41100 Modena CPO, Italy

Skin Two
Tim Woodward Publishing Ltd., BCM Box 2071, London WC1N 3XX

Sky
Wadhurst, East Sussex TN5 7BR

Soma
285 Ninth Street, San Francisco, CA 94103, USA

Street Beat
PO Box 648, Walnut, CA 91788-0648, USA

U.H.F.
1522-B Cloverfield Blvd., Santa Monica, CA 90404, USA

UK Club Guide
Greenacre Publishing Ltd., 1B Packington Sq., London N1 7UA

Village
Editoriale Italiana, via Tucidide 56, Torre, 20144 Milan, Italy

Wicked Magazine
PO Box 258, Prahran, Vic. 3181, Australia. Tel: 3 952 52088

Zeitgeist
Eclipse Publishing Co. Ltd., 27 Old Gloucester St., London WC1N 3XX

Mary – manager of the BOY shop in London's King's Road. Wearing rubber, net and maribou bodice top and knickers by Ian Wallis for 'Hustle & Coke'.

"You can't put a label on me. I'm just me, having fun and looking gorgeous."

'People nowadays are doing their own thing – pulling in ideas from everywhere – before people were just wearing uniforms, being a punk or whatever. It wasn't very creative or clever. Now style is an art form. Just look at me!'

'Mary', London.
Drawing **Joe Brocklehurst**

contacts

Ang & Billy a.k.a. Lady Bump & Billy Idle (DJ Extraordinaire)
Tel: 0161 736 4421 (Manchester)

Antediluvian Rocking Horse
Tel: 61 395 349540 (Melbourne)

Ashley
Garden Flat, 20 Lonsdale Rd.,
London W11 2DE
Tel: 0171 229 2944

Barbaric Dolls
Mail order: 51 Belgrave St.,
Brighton BN2 2NS

James Barrington
Tel: 0171 794 3205 (London)

Beauty:Beast
2F Tsuji Bldg.,
1-5-17 Nishi-Honmachi, Nishi-ku,
Osaka, Zip 550, Japan
Tel: 6 539 5430 Fax: 6 534 1224

Nicola Bowery-Minty
From Sugar Records

BOY/Ad Hoc
153 King's Rd., London SW3 5TX
Tel: 0171 376 8829

Avril Broadley
2/3 Fareham St., London W1V 3AJ
Tel: 0171 734 4868

Steve Cato
Tel: 0161 226 3749 (Manchester)

Francesco Cavaliere
Tel: 0181 764 8707 (London)

The Cavern
154 Commercial St., London
E1 6NU

C'La Vie
Tel: 213 969 0541 (LA)

Conflicto
Johnstrups Alle 1, st. th.1923,
Copenhagen, Denmark
Tel: 31 350380 Fax: 31 350382

Dave Deacon
He is available at COLD STEEL,
228 Camden High St.,
London NW1 8QS
Tel: 0171 267 7970

Stefano Dati
Fax: 2 783911 (Italy)

Jeremy Deller
121 Woodwarde Rd.,
Dulwich, SE22 8UP

Maria de Marias a.k.a. Lazer
Tel: 0181 888 9365 (London);
tel: 3 4360547 (Barcelona)

Dry 201 Bar
Oldham St., Manchester
Tel: 0161 236 5920

Jonas Ekströmer
Pressens Bild, Stockholm, Sweden
Tel: 8 130 531/8 440 7700

Daniel Faoro
Tel/Fax: 0171 354 3994 (London)

Fin de Siècle
68 Wickham Rd., London SE4 1LS
Internet page: http://www.demon.
co.uk/andys/fds/htm/
Their album, 'End of the Century', is available in Totem International Records.

Gravy
Jack Lefelt
Tel: 212 529 3435 (New York)

The Haçienda
11/13 Whitworth St. West,
Manchester M1 5WG. Tel: 0161 236
5051. Fax: 0161 236 0518

Jon Holderer
Jon Holderer Studio, 31 West 31st
St., New York, NY 10001. Tel: 212
629 4263. Fax: 212 629 0590

Adam Howe
Tel: 0171 490 2829
Fax: 0171 490 2784

James & James
Tel: 0171 732 8191 (London)

Jola
Tel: 0171 358 9028
Mobile: 0973 835795 (London)

Simon King
Tel: 0161 585 201 404
(Manchester). *Thanks to HARRIS DARKROOMS, tel: 0161 236 8709*

Terri King
'KING', 6101 Melrose Ave.,
Los Angeles, California 90038
Tel: 213 464 1786
Make-up artist: Victoria Gunstream.
Assistants to Terri King: Dawne
Aubert/Lena Lecarro.
Model: Hannah Sim with 'C'La vie'
(LA). *Lighting for group shot:* Robbie
E. Caponetto. Chair by Omega
Prophouse in Hollywood.

Gunilla Kjellnäs
Tre Liljor fyra, 113 44,
Stockholm, Sweden
Tel: 8 346638

Klive-D
95 Parkway, Camden,
London NW1 7PP @ Larache
Tel: 0171 267 1097/0171 370 7898
*Processing thanks to West One
Photographic, 66 Brewer St.,
London W1R 3PJ
Tel: 0171 434 4324*

Steve Lazarides
Mobile: 0973 897393

Peter Marchetti
Tel: 0171 358 9028 (London)

Mary McCartney
Alistair Donald. Tel: 0171 437 9520
(London). *With thanks to Zoë Norfolk
for assisting.*

Marcella Martinelli
Tel: 0171 439 2883
Mobile: 0956 605217 (London)

Medieval Magick – Gaile McConaghie
Available at: Hyper Hyper, Unit B5,
24/40 Kensington High St.,
London W8 4PF
and Portobello Arcade, Unit 16,
Portobello Green, 281 Portobello
Rd., London W10 5TZ

Next G+U.R+U Now…Urban Mutation Couture…
Uta Riechers – Martin Wuttke,
August Str. 19, 10117 Berlin
Tel/Fax: 30 282 7741

Nightwave
Fiera di Rimini, Italy
Tel: 541 711711. Fax: 541 711255

Kate Owens
c/o Caroline Elleray
Tel: 0161 237 3403 (Manchester)

Pandora
c/o Bovver Boots,
122A Pearcroft Rd., Leytonstone,
London E11 4DR
Tel: 0181 558 1586

Ted Polhemus
c/o Thames and Hudson

Polly
c/o Broadcasting Company
Tel: 0171 229 8500

R.A.P @ Larache
95 Parkway, Camden,
London NW1 7PP
Tel: 0171 267 1097/0171 428 0263
Fax: 0171 428 0267
Contact: Hassan Hajjaj

Japanese Distributor:
TRIPS COMPANY, Gotanda,
Parkside Building, 1st/3rd Floor,
Higashi, Gotanda, 5-24-9
Shinagawa-ku, Tokyo, Japan
Tel: 3 3448 9071
Fax: 3 3448 9072
Contact: Satoshi Ikuta

Vince Ray
Adult Graphics, Illustration, Dungeon
Murals, Custom Design
Tel: 0171 498 5871

The Rubber Nipple Club
Chancery House, 319 City Rd.,
London EC1V 1LJ

Norbert Schoerner
Tel: 0171 490 2829
Fax: 0171 490 2784

SHEEP
Tel: 0161 445 4460 (Manchester)

Sign of the Times
15 Shorts Gardens, Covent Garden,
London WC2H 2AA
Tel: 0171 240 6694

Skadanks
Ricky. Tel: 212 807 1263 (New York)

Skin Two
23 Grand Union Centre, Kensal Rd.,
London W10 5AX
Tel: 0181 968 9692

Club Submission
DJ Ronski. Tel: 0171 284 2180

Chris Sullivan
The WAG Club, PO Box LB 1106,
London W1A 4WG
Tel: 0171 437 5534

Dorit Thies
Tel: 213 463 1463
Fax: 213 463 7191 (USA)
Colorprint by L.A. Lab, Hollywood

The Torture Garden
B.M. The Torture Garden,
London WC1N 3XX

David Turner
Tel: 01494 483887
(Buckinghamshire)

TuTu
Tel: 0171 274 9240

Twice The Siren
28 Lower Marsh, London SE1 7RG
Tel: 0171 261 0025

Jonnie Vercoutre
Jeepboy Productions, 106 Mays
Lane, Barnet, Herts EN5 2LL

The Wag Club
33/35 Wardour St.,
London W1V 3HB
Tel: 0171 437 5534

Trevor Watson
Saga Centre, 326 Kensal Rd.,
London W10 5BZ
Tel/Fax: 0181 749 2881

Mark Wigan
7 Huguenot House,
19 Oxendon St.,
London SW1Y 4EH
Tel: 0171 839 3589

Zeitgeist
66 Holloway Rd., London N7 8JC
Tel: 0171 607 2977

My thanks to Maria de Marias for her assistance in the preparation of this manuscript, Juliette Dingham for liaising with the photographers, my family for encouragement, Avril Broadley for her design and all the photographers and artists who have contributed their images to this project. Most of all I am indebted to all those who appear in this book – their creativity, daring and rampant exhibitionism a sustaining inspiration.

'No!
Well, fuck me!
Cor, luv a duck!
Anyway, I've gotta go see a man about a dog....'
Drawing **Chris Sullivan**

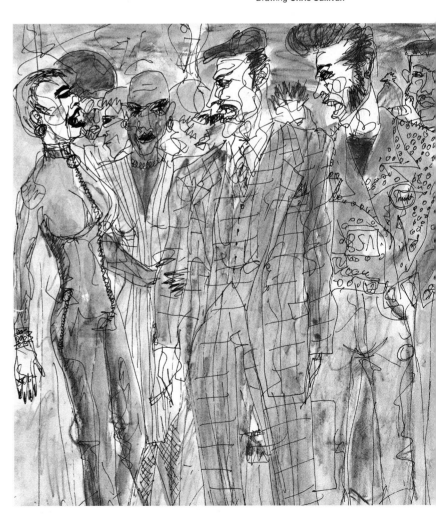